pop art redefined

pop art

redefined

John Russell
Suzi Gablik

Thames and Hudson
London

© John Russell 1969

Printed in Great Britain by Jarrold and Sons Ltd, Norwich

ISBN 0 500 18094 6

Contents

Foreword

This book is intimately related to the exhibition of Pop Art which we were invited, towards the end of 1968, to organize for the Arts Council of Great Britain. Like the exhibition, it aims to redefine the areas in which Pop made a unique contribution; and it sees Pop in terms of formal ideas and not in terms of the jokey, gregarious, eupeptic and loosely organized phenomenon which was seized upon with such relish by the mass media in the early 1960s.

Almost everything seen at the Hayward Gallery in July and August 1969 is reproduced here. The book also reproduces a number of key works which for one reason or another were not available for the show. The book was initially planned as a catalogue to the show and can, indeed, still be so used, since the exhibition-number of each work is given on pp. 233–240. It was soon clear, however, that there would be more text-matter than any catalogue could carry; and since much of it originated in publications now rare or out of print it seemed to us that an anthology of the fundamental texts on Pop would serve a historical purpose for many years to come. We are very grateful to the artists, authors and editors concerned for their permission to reprint the texts in question.

We should like to emphasize that this is not a study of Pop Art in terms of the relative stature of the artists who took part in it. If certain major artists are thinly represented it is because their involvement with Pop seemed to us to have been of only incidental significance to their careers: of the same order, let us say, as Matisse's involvement with divisionism.

Our work had to be done at high speed. That it got done at all was due to the kindness and generosity and readiness to help of many people, both here and in America. Among those who did more for us than could be explained in terms of duty or self-interest we remember especially Lawrence Alloway, Kay Bearman, Richard Bellamy, Michael Brawne, Leo Castelli, Peter Cochrane, Sidney Felsen, Michael Findlay, Robert Fraser, Manuel Gonzalez, John Gordon, Richard Hamilton, Thomas B. Hess, Conrad Janis, Jasper Johns, Jill Kornblee, Philip Leider, Jean Lipman, John McHale, Dorothy Miller, E.J. Power, Robert Rauschenberg, Robert Rosenblum, Gail Scott, Robert C. Scull, Ileana Sonnabend and Maurice Tuchman. Five museums – the Museum of Modern Art, the Whitney Museum, the Albright-Knox Art Gallery, Buffalo, the Los Angeles County Museum and the Art Gallery of Ontario, Toronto – proved generous and uncomplaining lenders. Claes Oldenburg took time off from the preparation of his own retrospective exhibition to design a poster which immortalizes the Hayward Gallery. C.D. Hamilton, Editor-in-Chief of *The Times* and *The Sunday Times*, authorized the subsidy which

made it possible for four of the contributing American artists to be invited to London. Within the Arts Council we had the inestimable advantage of Joanna Drew's experience, resource, unselfishness and delight in hard work. Finally, we should like to thank our publishers, Thames and Hudson, for their patience and support in times of stress, and for the turn of speed which has got this book out faster than anyone had a right to expect.

J. R.
S. G.

Introduction

Suzi Gablik

Antagonism still surrounds the whole subject of Pop Art. However, it is one of the ambitions of both the present exhibition and this book to achieve a reorientation of critical concern. With the exception of Lichtenstein who was given a major retrospective at the Tate Gallery last year, the work of most American Pop artists has hardly been seen in London, and is virtually unknown to the general English public. What little has been seen over the years is mostly a result of the single-handed efforts of Robert Fraser in his gallery on Duke Street, but this accounts of necessity for only a few of the artists, and their work has been shown only on a limited scale. Upon this rests our decision to make an exclusively Anglo-American show. Manifestations of Pop Art have appeared throughout the world, in France, Italy, Germany and Japan, but it was not possible on this occasion to deal with it all. Moreover, the English and the Americans are generally considered to have been the pioneers of the movement, and a significant dynamic of difference emerges when their work is juxtaposed, as has not happened before now. Since each was formed by a particular historical situation and has a distinct character, comparative meanings develop that were previously unclear, when the contexts in which they are used to being seen are altered, and their company varies. A marked disjunction between American and English Pop asserted itself as we applied certain criteria in our choice of works, and this served to emphasize the unsimilar cultural dynamic underlying each.

The first proving-ground in selecting works was visual immediacy. This meant choosing images which were highly specific and uncontrived in relation to their own subject matter: that is to say, images which suggested the world rather than personality. The authentic Pop image exists independent of any interpretations. It is simple, direct, and immediately comprehensible. Among American Pop artists, it was relatively easy to find works in which form and iconography fuse in a single, unified

image: Alex Hay's five-foot enlargement of an ordinary mailing label, for example, or Roy Lichtenstein's giant composition notebook, or Claes Oldenburg's soft typewriter. It should be stated that we afforded priority to this kind of image deliberately, as part of our intention to re-define Pop Art as having a more direct relation to Minimal and Hard-edged abstract art than is frequently admitted.

Pop Art has been handicapped with a freakish and flamboyant history, partly as a result of mishandling in the public news media, so that nearly everyone, including the artists, now responds to it with ambivalence. Certain critics still exclude it from serious consideration, and a proportion of the public think it is some sort of joke. I know of only two endorsements in contemporary criticism which support the notion that Pop and Minimal art have a common denominator. The first is an essay by Robert Rosenblum, appended in this book, which was published as early as 1964 (i.e. five years ago). He states: 'Already the gulf between Pop and abstract art is far from unbridgeable, and it has become easy to admire simultaneously, without shifting visual or qualitative gears, the finest abstract artists, like Stella and Noland, and the finest Pop artists, like Lichtenstein. The development of some of the Pop artists themselves indicates that this boundary between Pop and abstract art is an illusory one.' The second article is a more recent one by Barbara Rose, entitled 'The Politics of Art (II)', published in *Artforum*. She links both Pop and Minimal art to pragmatism and to earlier twentieth-century American art (Precisionism). Rosenblum's point of view was particularly far-sighted with respect to the date it was written and compared to many other opinions that were accumulating around Pop. In 1962, just two years earlier, for example, Max Kozloff had written concerning some recent exhibitions by Pop artists: 'The truth is, the art galleries are being invaded by the pin-headed and contemptible style of gum-chewers, bobby soxers, and, worse, delinquents.' The very title of his article, 'Pop Culture, Metaphysical Disgust, and the New Vulgarians', reflected the unpleasant impression which has irrationally adhered to Pop.

Our primary intention in this exhibition has been to assert the stylistic affinities of Pop Art with certain contemporary abstract art, in the hope of expanding the framework within which Pop has so far been considered. We have therefore tended to choose, *wherever possible*, examples which give visual credence to this particular

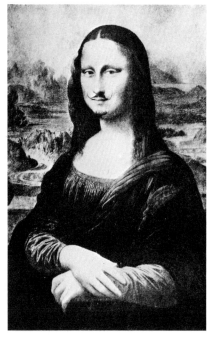

MARCEL DUCHAMP *L.H.O.O.Q.* 1919 Corrected ready-made: reproduction of the *Mona Lisa* to which Duchamp has added a moustache and beard in pencil, $7\frac{1}{2} \times 5$ ins

idea. That is to say, concrete and legible images where colour tends to be flat, emblematic, and impersonally applied, and where the iconography is extremely explicit and usually unified in a single, non-relational image. Certain artists, like Rauschenberg and Rivers, have not been stressed, since their work runs counter to this view, insofar as it is a hybrid form of Pop. Their subject matter often overlaps, but the style is more painterly, diffuse and multi-evocative, whereas the real dynamic of Pop is best realized when style and subject merge in a single, unified *Gestalt*.

It is more difficult among English artists to find works where the style and imagery hold together in this particular way, as their modalities tend more toward the narrative and the picturesque (Phillips and Blake), or toward the autobiographical (Hockney), or toward subliminal and multi-focus imagery (Paolozzi).

It is difficult, therefore, to postulate a stylistic unity among Pop artists. There are, however, a number of thematic unities which apply to both English and Americans, a shared and recurrent iconography, based upon real things which are part of everybody's world, and not just a private world of the artist's. These images are a part of popular culture as presented through the surrogate world of the mass media; for the exhibition we have organized them into a basic schema: household objects, images from the cinema, images found in the mass media (like comic strips and billboards), food (like hamburgers and Coca-Cola), and clothing. Another important category of Pop images is art which makes some reference to other art. Certain Dada and Neo-dada precedents for the kind of irony involved can be cited in this context: for example, the 'L.H.O.O.Q.' of Duchamp, which is the prototype for the parody and manipulation of one artist's work by another (once, as John Cage has pointed out, we only had the 'Mona Lisa' – now we have Mona Lisa with a moustache), and Rauschenberg's erased De Kooning drawing. Art of the past has always contained a certain amount of deliberate quotation or references to specific works by previous artists, but it is among Pop artists that we find such an unqualified appropriation as Lichtenstein's use of Mondrian in 'Non-Objective II'. Sometimes, such a work can issue from an intense love-hate relationship, as with Dine's near-parody of 'stripe' paintings in the saw-horse piece (Plate VI); or, as in the case of the Lichtenstein, the original art work may be used merely as another common object, made familiar through reproductions,

ROBERT RAUSCHENBERG *Erased de Kooning Drawing* 1953 Collection the artist

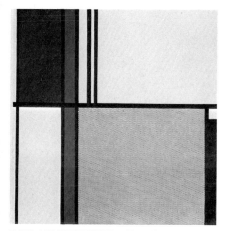

ROY LICHTENSTEIN *Non-Objective II*
1964 Magna on canvas, 48×48 ins
Collection Ileana Sonnabend

in the everyday environment. That is to say, it has become part of a common language understood by everybody.

It is not without significance, for example, that in America so many Pop artists have taken the bathroom as a subject. The aesthetics of Pop contain disturbing elements which have implied a new interchangeability between art and non-art and a new flexibility with regard to subject matter that previously appeared marginal to the fine arts. We approach a time, Marshall McLuhan has pointed out, when the total human situation must be considered as a work of art. The explosion of the advertising and communications industry, and the speed with which images and information now travel through media channels, have resulted in a much broader awareness and a more extended involvement in our total environment. What this means is that it is now possible to know at once everything that is happening in the world, so that experience is all-inclusive and occurs on many simultaneous levels.

For the artist, the implications are that art, too, can no longer restrict its operations. The new media necessitate a restructuring of our thoughts and feelings; they require new habits of attention with the ability to move in all directions and dimensions simultaneously. Since art, like life, must extend its boundaries to deal with changes in the environment, the major issues no longer hinge upon the creation of enduring masterpieces as the unique and solid repositories for human energy. The new problems for art concern the constant redefinition of its boundaries, and a more process-oriented distribution of energy. Relativity and quantum mechanics have effected the shift from a timeless, Euclidean world in which all is precise, determinate and invariable, to a non-static universe where everything is relative, changing and in process. Changes in the way that we live in the world cause changes in the way we do our work, as well as changes in what work we do. Before the electronic age the various channels of information – painting, music, literature – were held in balance and did not infringe upon each other very much. Mass communication, television in particular, appropriates relentlessly from all other media: films, literature, graphic design, theatre, events. It acts as a great leveller, while also providing techniques for combining many separate frames of reference. As a result, widely separated experiences are being brought under one comprehensive and simultaneous formula.

Where art is concerned, canvas, stretchers and paint have not been the notional limits for quite some time. Certain tendencies in contemporary art have evolved an increasingly lifelike format which overlaps into the environment and blurs the distinctions between art and daily life. These tendencies also undo the formal divisions between art forms, and disregard the previous hierarchical separation that has existed between popular culture and fine art. All things being equal, it is not accidental that most Pop artists (especially in America) have been involved since the late 1950s in various environmental and multi-media projects, like happenings, events, performances, films.

It does not bear upon us directly in this context, but should be noted, that a polar tendency in contemporary painting and sculpture now exists in dramatic opposition to the attitudes just described. According to this point of view art and life are judged as wholly separate and as not occupying the same space. The significance of painting and sculpture depends instead upon the purity and integrity of an art which will refer only to itself and will exclude all references to life. This means reducing the perceptual world to the pure sensations produced by form and colour, often to an axiomatic or pre-established structure based on the laws of an internal necessity, not unlike the use of models in science. Like the laws of logic, such axiomatic models owe their necessary truth, not to some unalterable structural features of the world which they might be thought to describe, but to the conventions of language by which they are endowed with meaning. Abstract art has a great deal in common with those principles of modern linguistics which assert that content never has a meaning in itself, but that it is only the way in which the different elements of the content are combined together which gives a meaning. Abstract artists deal with the syntax of painting and the structures of meaning as the *only* valid subject matter for art. At the moment, these two non-complementary attitudes have become mutually hostile to such a degree that an almost schizoid situation has evolved. The two modes have become so dissociated that they barely recognize each other as part of the same continuum.

The aesthetics of Pop, then, concerns (1) the breakdown of the conventions of the picture plane and the use of three-dimensional extensions into the surrounding space, incorporating elements of the actual environment, (2) the substitution of industrial techniques and materials for oil paints and a pre-occupation with man-made

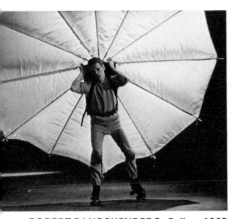

ROBERT RAUSCHENBERG *Pelican* 1963 Performed here with Alex Hay in 1965 at the New York Theater Rally. Photo Elisabeth Novick

ROBERT RAUSCHENBERG *Spring Training* 1965, performed at the New York Theater Rally. Rauschenberg, wearing a white dinner jacket and with a bucket strapped to his waist, pours hot water from a kettle into the bucket which is filled with dry-ice. As the vapours spread, he strums the strings on his jacket to the music of a Hawaiian Hula. Photo Elisabeth Novick

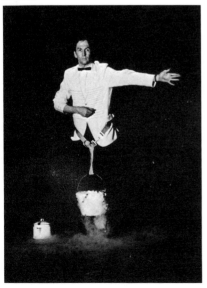

objects as far removed from nature as possible, (3) the erosion of a previously established hierarchy of subject matter (Mondrian and Mickey Mouse are now equally relevant) and the expansion of art's frame of reference to include elements considered until now as outside its range, such as technology, kitsch, and humour, (4) the move away from the private mythologies of Surrealism and the interior monologues of Abstract-Expressionism to a more extroverted and impersonal subject matter associated with the urban environment, and (5) a greater mobility and flexibility toward art in general, whereby every art situation is more total and inclusive of the simultaneous levels which occur in actual experience. 'I am for an art,' declares Oldenburg, 'that does something other than sit on its ass in a museum.'

For the Pop artist, the aesthetic faculties cannot be disengaged from the rest of life. Rauschenberg's assertion that painting relates as much to life as it does to art is by now sufficiently well-known to be part of history, but the influence of his attitudes on Pop Art has been of tremendous importance. Throughout his painting career he has maintained an informal connection with the theatre, and in 1963 he himself performed in his first original multi-media theatre piece entitled *Pelican*, in which he rollerskated together with Alex Hay while both of them had parachutes strapped to their backs and Carolyn Brown danced in toe-shoes. His performance works usually mix professional, trained dancers with non-dancers (and sometimes even with chickens, birds, turtles, dogs, or inanimate objects) in an effort, comparable to his paintings, to break down the barriers between art and actual experience. In all of Rauschenberg's work, whether it is for the theatre or in painting, there is an absence of hierarchy of significant experience; that is to say, no particular experience is given priority or importance over another. His idea that 'there is nothing that everything is subservient to' has been one of the most seminal in contemporary art. It means that each element has equal importance and must sustain itself in time. There is no climax, only equally relevant details. The Pop artist who documents the most ordinary scenes from daily life views the world as a total and inclusive unity in which all parts have total relevance – not just some relevance to the whole. Thus, for the Pop artist, there are no irrelevant details. Objects are particularized, often isolated rather than juxtaposed, in a non-associative and abstract way which has the effect of converting the familiar into the monumental. This

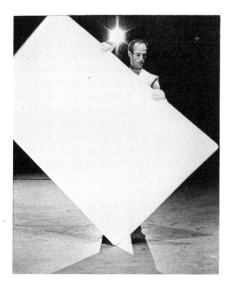

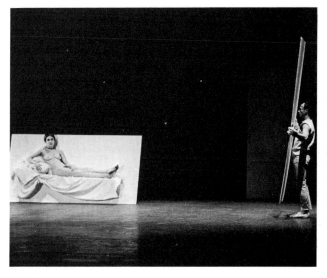

'non-objective' use of objects emphasizes their physicality and their actual form, and the often life-size or enlarged scale reduced compositional elements to a minimum.

Art, then, must have a manifest connection with the environment; it must act directly on experience, instead of being something that stands for it. These were the rudimentary notions from which Pop emerged, together with Happenings and the idea of a painter's theatre in America in the late 1950s. These two phenomena have continued an active co-existence and are strongly related.

Artists as unalike as Morris and Fahlström, whose work has had a tangential relationship with Pop, have been involved in multi-media performances. In the early days of Pop, Dine and Oldenburg were both particularly interested in the idea of a non-verbal theatre, and organized a number of Happenings together. The first was an evocation of the Street. The sources for Dine's Happenings, like *Car Crash*, were American vaudeville (and a desire to show off) and his own nightmares. For Oldenburg, on the other hand, 'the stage=the place where I paint.' In 1961, inspired by the stores in Orchard Street near where he lived, he transformed his studio into a store (i.e. a total environment) and made saleable objects (mostly food and clothing) out of cardboard, old newspaper, burlap, chicken wire, muslin, *papier mâché* and enamel paint. For Oldenburg, this was the ideal situation 'halfway between art and life'. 'Some came in and said: "This is not art, it's a hamburger"; and others said: "This is not a hamburger, it's art."' It was a way

OYVIND FAHLSTRÖM *Kisses Sweeter than Wine* 1966 Robert Rauschenberg as the 'idiot-savant', performed in 9 Evenings: Theater and Engineering at the 69th Regiment Armory, New York City, October 1966. Photo Peter Moore

Demonstration on Sixth Avenue arranged by Oyvind Fahlström. Tape and film of the demonstration were used as part of *Kisses Sweeter than Wine*. Demonstrators are holding placards of Bob Hope and Mao Tse Tung. Photo B. Glushakow

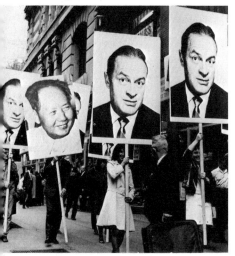

of coming to terms with all the stereotypes and clichés of urban life and extracting some value out of them. In 1962, he staged a Happening there called *Store Days*, billed under The Ray Gun Manufactuing Co. The Store was a place where many things happen, and there were thirteen incidents: 'A customer enters/Something is bought/Something is returned/It costs too much/A bargain!/ Someone is hired (Someone is fired)/The founders. How they struggled. /Inventory/Fire Sale/ Store closed on acct of death in family/The Night Before Christmas/Modeling clothes/A lecture to the Salesmen.' For Oldenburg and other Pop artists, Happenings are one means of relating art more and more to daily experience. 'I'd like to get away from the notion of a work of art as something outside of experience,' Oldenburg has asserted, 'something that is located in museums, something that is terribly precious. . . . I don't think the notion of the detached work of art – this aristocratic work of art – is a very useful notion any more. People don't want that. They suffer with that notion and they would prefer to have a re-definition of art in something closer to themselves.'

Happenings are like a panoramic view of life, but they also assert the autonomy of objects. Although they are essentially independent of conventional art materials, and often involve all the senses at once (synesthesia), Happenings represent a moral and an existential stand even more than a new art form, according to their chief mentor Allan Kaprow. Kaprow, who has been making Happenings since 1957, was active during the perind of the Reuben and Judson galleries in downtown New York during the early sixties, where he and Dine, Brecht, Drexler, Segal, Oldenburg, Whitman and Grooms all showed environmental works and staged Happenings. These spontaneous, improvisational, essentially plotless, 'generated-in-action' theatrical performances were partly inspired, in Kaprow's view, by the work of Jackson Pollock, who had transformed the gestural tactics of Abstract-Expressionism into something like an actual performance. The work of nearly all the Judson and Reuben gallery artists from this period is tinged with left-over Expressionism – a kind of action painting with living materials. Although traces of a vital and organic connection with Abstract-Expressionism remained in strong evidence, these rudimentary beginnings of what subsequently emerged as Pop Art also embodied new values intended to reject the art of the past. The personal hand of the artist was de-emphasized, for example, and

as Lawrence Alloway has pointed out: 'The city with its inhabitants was not only the subject of much of this art, it was also literally, the *substance*, providing the texture and bulk of the material itself.' It was a radical move to leave behind the whole aesthetic baggage of Abstract-Expressionism, in favour of a 'dirty' and ephemeral art. 'I am for an art,' says Oldenburg, 'that embroils itself with the everyday crap and still comes out on top.'

Pop began in America as a phenomenon barely distinguishable from the environment and from random events. It has since evolved a more pragmatic relationship with reality, and assumes forms of extreme literalness and comprehensibility which are directly related to the explicitness of technology. 'Found' and 'ready-made' images borrowed from the mass media are one way for an artist to escape the limitations of his own personality: he is no longer bound by ideas belonging only to him. Comparable to the use of 'found' images and mechanical techniques is the deliberate use of chance methods as still another means of getting away from personal bias. Chance as a planned mode of operation and as a vehicle for the spontaneous derives as much from the improvisational techniques of Pollock on the one hand, as from the ideas of John Cage on the other, whose views on indeterminacy have been so influential. The work of artists like George Brecht and Ray Johnson is important in this regard. Johnson's work has always depended on chance encounters and odd connections. Until recently, he never exhibited in galleries or museums, but would only show his work in places like Grand Central Station or the street. The random arrangement of 'moticos' (a self-invented name for his collages which he stored in cardboard boxes, often cutting them up again later to make new ones) on a dilapidated cellar door in lower Manhattan (see p. 18) may even have been the first informal Happening. Johnson is also responsible for a continuous 'postal Happening' in the form of the New York Correspondence School, whereby cryptic messages are sent out, via the U.S. mails, in the form of clippings, bits of collage, found articles and photographs, all related to the recipient. He was also a pioneer in the use of graphic techniques and images. In 1955, during the heyday of Abstract-Expressionism, he altered a photograph of Elvis Presley (ill. 50) by dripping red paint from the eyes. He called it 'Oedipus' and said, 'I'm the only painter in New York whose drips mean anything.' George Brecht had turned to chance

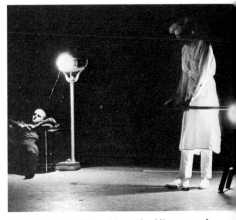

JIM DINE *The Natural History of Dreams* Performed at the New York Theater Rally. Photo Elisabeth Novick

JIM DINE *Car Crash* 1960 Photo John Ross

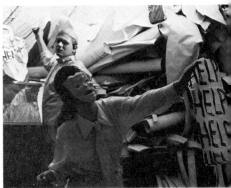

View from the street of Claes Oldenburg's Store, December 1961 Photo Robert McElroy

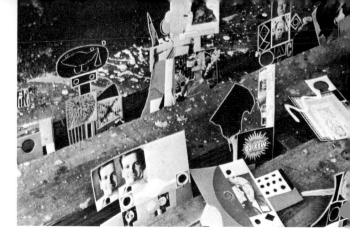

RAY JOHNSON *Moticos* photographed on the street, 1955 Photo Elisabeth Novick

methods in 1955 under the influence of Cage, using random numbers, tables and dice. His work has a special relationship with music. He devises events for which he writes the 'scores', and, since these events are without any prescribed time or place at which or where they are to occur, they are subject to a great many independent chance influences.

To sum up, what I am attempting to suggest here is that the use of chance techniques, or of 'found' rather than invented images, represents in America what really amounts to a moral strategy. In fact, a moral strategy of this kind can be found in all the best American art, whether Pop or not, and is the basis of its strength. By moral strategy I mean any means used to achieve a tougher art, to avoid tasteful choices, and to set the stakes higher. The use of chance for example, means greater risks for the artist, as he willingly forfeits his autonomy and control. The passion to take risks and to relinquish all the controlling factors of one's ego, which is the underlying dynamic of the most high-powered American art – whether abstract or otherwise – runs counter to the basic English character, which is by nature cautious and self-restraining. It makes for an altogether different sort of art, with the one exception of Francis Bacon. Bacon's images are bare and immediate (not unlike American Pop, although different), and bear the high-wire tension of risk and desperation. A gambler by nature, he likes to throw his lot each time on the wheel of fortune, in the hope that he may win. If he does win, and the painting is successful, he thinks of it as the result of luck and chance, but not as something *he has achieved*. Rather, he puts himself in the hands of fate, and for him this represents a way of raising the stakes, so that he just might – if he is lucky – achieve something better by calling into play factors outside of himself.

We can more easily discern the differences between English and American art in general, and Pop art in particular, if we establish that, in America, impersonality as a style is the governing principle, whereas English art is essentially *subjective*. Although there are many iconographic analogies between English and American Pop, the work is basically quite different in character. Compare, for example, Warhol's multiple images of Marilyn with one of Peter Blake's pin-up walls, or 'On the Balcony' (p. 39). The Warhol image is stripped bare of association and metaphor. It appears uncontaminated by history, just as it was 'found' in the mass media. The Warhol takes its chance on an uncertain artistic identity, sacrificing the hand-made original for commercial industrial techniques and mass-production (Warhol does not even need to make them himself). In short, he renounces all the conventions by which art has previously been made. Blake, on the other hand, has carefully chosen the images in 'On the Balcony' and places them so as to give free run to their picturesque and evocative associations. The result is discursive, anecdotal and biographic. There is a

RAY JOHNSON *Moticos* photographed on the studio floor, 1955 Photo Elisabeth Novick

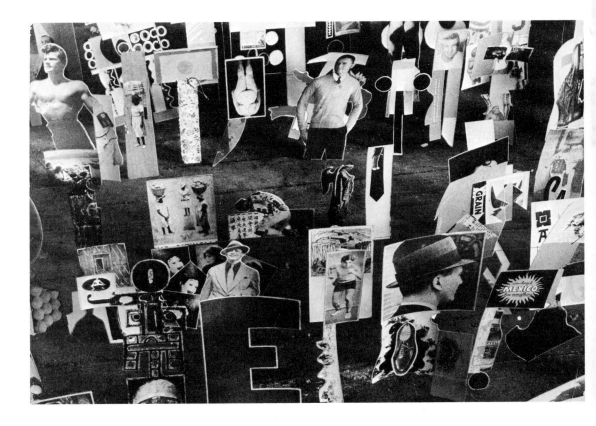

distinct conflict between what is read and what is seen. Artists like Paolozzi and Kitaj, for example, are concerned with the manipulation and transformation of images, which function in the end like coded messages. In general, English Pop is a subjective synthesis of imagery derived from streamlined technology, car styling, sex symbols, cybernetics, and movies – a hybrid overlay of techniques and points of view. American Pop tends to be emblematic and frontal, with non-associative images seen in isolation rather than juxtaposed. English Pop uses multi-evocative, metaphoric and multi-focus imagery rather than whole thematic entities. It sprang originally from polemical debates about American advertising and mass-produced urban culture. It has continued, within the conventions of painting, to deal with the *themes* of technology. As such, it *reflects* the changes in the content of culture since the mid-1950s. American Pop, on the other hand, sprang from the direct experience of Pop culture and technology, and has adapted and incorporated actual industrial processes and techniques into its production. Lichtenstein, for example, uses the commercial Ben-Day technique from photojournalism; Rosenquist, a trained billboard artist, has adapted the technique and scale for his own work; Warhol, after a brief inroad with painting (ills. 77 – 'Popeye' – and 97 '4 Soup Cans') relied wholly on silk-screening and never lifted a brush to canvas again. And therein lies the crucial difference.

The validity of a given cultural style depends largely on its ability to establish fields of potential action for the future. Pop introduced an objectivity into art that is basic to technology, but it simultaneously asserted a vital continuity between life and art that has been radically rejected in the purist attitudes of certain Abstract artists. Already its main methodological assumptions are being expanded into a new dimension by the Minimalists, who have reduced its iconographic content to the essential structures which constitute the language of technology, and by the Situationalists, who explore industrial materials for their inherent properties and act directly upon the environment – by digging a 'sculpture', for example, directly in the desert. An art seems to be evolving now that integrates itself *totally* with the environment. It also integrates conceptual with actual experience, and a high degree of specificity with abstraction. The formal and psychological implications of this are such that perhaps the schizoid splitting which I referred to earlier will eventually be healed.

GEORGE BRECHT *Drip Music* (*Drip Event*)

For single or multiple performance

A source of dripping water and an empty vessel are arranged so that the water falls into the vessel

Second version : Dripping

G. Brecht
(1959-62)

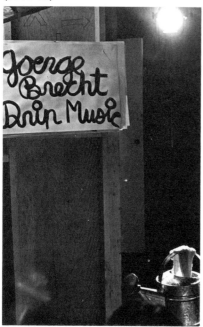

Introduction

John Russell

> [Our intention is] . . . *simply to wake up to the very life we're living.*
>
> JOHN CAGE, 1956

Finding a good artist who will sail under the name of Pop in the year 1969 is about as easy as finding a butcher who will put his best fillet steak on offer as horsemeat. Pop Art has been written off in certain places as 'novelty art' and 'gag art', and no one likes to think that his work is a novelty no longer new or a gag that turns every face to stone.

It is not easy to reconcile this with first-hand experience of the work. Pop has been called vulgar, aggressive, jokey, ephemeral and sensation-seeking. We have tried to present it here, and at the Hayward Gallery, as something quite different – as an art, not seldom, of austerity; an educated art; a responsible art; an art of monumental statement; an affectionate art; and, even, a healing art. If it once had to do with the poetics of the unacceptable, the element of scandal has now fallen away: at nearly ten years' distance we can look again at a Brillo box, or even at one of Erle Loran's elucidations of Cézanne, without risk of apoplexy.

An art of austerity, I said. Many people think, for instance, of Tom Wesselmann in terms of an exuberant sexuality; but anyone who looks without anterior prejudice at the 'Interior No. 3' (1964) (ill. 10) is more likely to think of Mondrian, for the gravity and sobriety of the formal scheme, and, beyond Mondrian, of the funerary stelae on the Street of the Tombs in Athens. An educated art, also: Roy Lichtenstein was once discussed primarily in terms of a calculated affront to the notion of fine art, but once again this element has now fallen way; and we recognize in Lichtenstein (or, for that matter, in Richard Hamilton or Patrick Caulfield) someone who has looked at an immense amount of accredited fine art. These are people who have taken the central question of twentieth-century painting – 'What should a picture be?' – and come up with answers that are anything but coarse, larky, or ephemeral.

A responsible art? Well, my idea of a responsible artist in this context is one who returns us to objective reality,

ROBERT MORRIS *Fountain* 1963 Mixed media, 35×13×14 ins Collection Karl Ströher.
'An art of austerity', exemplified by Robert Morris's early involvement with the common object

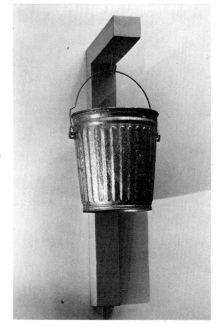

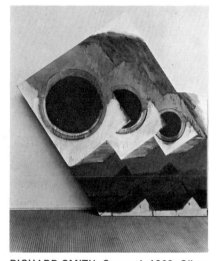

RICHARD SMITH *Staggerly* 1963 Oil on canvas, 89×89 ins Collection Stuyvesant Foundation

JIM DINE *Hat* 1961 Oil on canvas with objects, 56×64 ins Photo Galerie Sonnabend, Paris

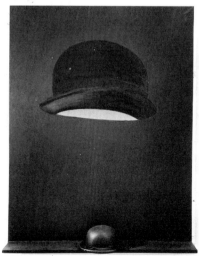

where another would take off into an enfeebling dreamland and do his best to drag us with him. Hogarth, in the portrait of his servants, is a responsible artist, in this sense. The responsibility is towards aspects of life which would otherwise be denied their dignity: casualties, one could say, of the social structure. When George Brecht happened to give George Segal some plaster-impregnated Johnson & Johnson bandages, Segal found that he could make plaster figures which corresponded to attitudes within the sitter for which no other outlet had been found. The truths of the body came out, just as the truths of the face came out when Hogarth put the six servants' heads side by side on the canvas. In an environmental piece like 'The Butcher Shop' (ill. 94), Segal drains away whatever in the given scene is contingent and ephemeral: responsibility is uppermost.

That Pop is an art of monumental statement is in a way too obvious to need saying. But monumentality in this context is not the same thing as aggrandizement. Richard Smith's 'Gift Wrap' (ill. 113) is not impressive because we have never seen a package that size before. It is impressive because it embodies a certain idea of seduction with a force and eloquence that are very difficult to resist. Our English civilization is not one in which 'biggest' and 'best' have always, or often, been synonymous, and a lot of the initial Royal College Pop had the quality of a narrative scaled down and written by hand: 'Gift Wrap' is a later and a majestic exception, one of the first English pictures to work, incontrovertibly, on an American scale.

An affectionate art: no one could mistake the outgoing generosity of Dine, the determination to pass on to others a view of life that is naturally expansive. (This can be seen as much in his poems, by the way, as in his paintings and theatrical events.) Peter Blake, again: there are few painters whose work speaks so directly, whether the subject be the delirious ornamentation of a Kursaal somewhere in Belgium or an imaginary girl wrestler. Pop is not, as many people have supposed, a satirical art: it is an affirmative art, and affection plays a great part in it. Oldenburg's 'Giant gym shoes' (Pl. XI,) the roster of friendship in Tilson's 'A–Z', the Léger-like handshake in Lichtenstein's painting of that name – all these go with a robust and natural enjoyment of the things in life that are open to everyone.

A healing art, therefore: a dis-alienatory, non-discriminatory art: one that binds people together instead of setting them one against the other. This does

not make Pop Art the accomplice of a sick society: Pop artists, as individuals, do not by any means always endorse things as they are. (For this see, for instance, Rosenquist's analysis of the 'F-111' (ill. 123) remember, also, Oldenburg's plain-spoken letter on the subject of Mayor Daley of Chicago.) Pop Art has nothing to do with Dada, nothing to do with nihilism, nothing to do with negativity in any of its forms. As to how it relates to the future, John McHale's 'Plastic Parthenon' can bear witness; but in the present it teaches us to see an august simplicity where others find only matter for wincing. I, for one, am with Oldenburg as regards the Whitmanesque catalogue of affections which is reprinted here on pp. 97–99.

This discussion goes back a long way. Aristophanes knew all about it: no one ever had a more unprejudiced eye and ear for the problems of style and content. Coleridge got the point when he said in his preface to the second edition of *Lyrical Ballads* that 'the proper diction for poetry consists in a language taken from the mouths of men in real life, a language which actually constitutes the natural conversation of men under the influence of natural feelings.' Constable got it, when he said, 'I never saw an ugly thing in my life'. Baudelaire got it, when he said that it was indispensable that an artist should feel around in his own time for the point of maximum sensibility 'since almost all our originality derives from the seal which Time stamps upon our sensations'. Seurat got it, when he only went into the street to look hard at Chéret's posters. Léger was near to Pop as early as 1914, when he accepted billboards as a fact of life, and one to be accepted on a footing of equality. Dubuffet was on a parallel course when he wrote in October 1947 that 'What interests me is not cake, but bread.'

This last remark was dismaying to many people in the France of 1947, and it is still dismaying to people who see art as the cake of life, the segregated treat which consoles them for having to make do with bread that anyone has only to go to the shop to get hold of. To many an anal, nay-saying nature, an either/or situation exists in this matter: cake must ride up front, and bread be put in the boot. When faced with this point of view, I remember two sentences from John Cage's essay on Jasper Johns: 'The situation must be Yes-and-No not either-or. *Avoid a polar situation.*'

'Yes-and-No' in this context does not mean equivocation. It does not propose a poetics of inconsistency.

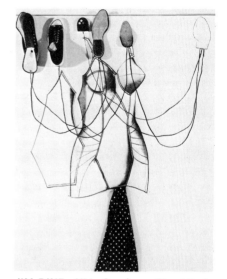

JIM DINE *All in One Lycra Plus Attachments* 1965 Oil on canvas with objects, 48×60 ins Collection Eindhoven Museum

ROY LICHTENSTEIN *Handshake* 1962 Oil on canvas, 32×48 ins Collection Mr and Mrs Victor Ganz

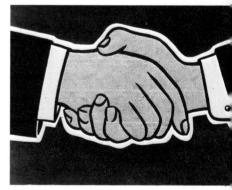

But it does suggest that now, as at any other time, an intelligent man should be able to hold two mutually contradictory ideas in his head and see the point of both. Pop is subversive of the either/or syndrome; and in Johns and Rauschenberg it had in the middle 1950s two people who were in a supreme degree the antithesis of that particular state of mind. I feel about these two artists the way Stravinsky feels about the late Beethoven quartets – that they are 'a charter of human rights, and a perpetually seditious one in the Platonic sense of the subversiveness of art'. If they are only lightly represented in this book, and in the exhibition, it is because the Pop element in their work has never been pursued in itself or for itself. What matters here is that they did, in fact, 'avoid a polar situation'.

This was something new in a field where the either/or cast of mind had long been canonical. In the 1930s, for instance, the Yes-and-No cast of mind was very difficult to justify. The problems of that decade were problems in regard to which no ambiguous or intermediate position could be held: one was for or against Hitler, for or against Franco, for or against Roosevelt. Whoever hedged on those issues was a scoundrel. The 1930s were also a period during which there was a genuine divide between high art and kitsch. The big artist – Braque, Matisse, Bonnard, Klee – was a sainted hermit, rarely seen in forum or stoa and quite untainted by what were to be known twenty years later as 'the mass media'. Even the surrealists, though in principle totally subversive, were in fact among the priests of the temple.

This is the context in which Clement Greenberg published *Avant Garde and Kitsch*. The renewed celebrity of this essay dates from its re-printing in 1961, but it remains a document of the late 1930s – a period at which, as Greenberg says, 'the personal philistinism of Hitler and Stalin was not accidental to the political roles they play' and the abhorrent qualities of the Horst-Wessel song related as much to its part in Nazi mythology as to its purely musical shortcomings. This was the context in which Greenberg spoke of 'that thing to which the Germans give the wonderful name of Kitsch: popular, commercial art and literature with their chromeotypes, magazine covers, illustrations, ads, slick and pulp fiction, comics, Tin Pan Alley musicals, tap dancing, Hollywood movies, etc. etc.'. Kitsch, he said later, is 'vicarious experience and faked sensations . . . the epitome of all that is spurious in the life of our times'.

He also spoke of the precondition for kitsch: 'the

availability close at hand of a fully matured cultural tradition whose discoveries, acquisitions and perfected self-consciousness Kitsch can take advantage of for its own ends'. Between kitsch and high culture the relationship was all take and no give, all looting and debasement and exploitation, with nothing to counterbalance it. The most that could be said in 1939 was that now and then kitsch produced 'something that had an authentic folk flavour'. The rest was petit-bourgeois pap.

A holy war, therefore: an either/or situation in which one was for or against tap dancing in much the same way that one for or against *Finnegans Wake*. One extreme position breeds another, and I have no doubt that the innate intrasigence of American Pop is a reversed image, a positive no less commanding than Greenberg's negative, of the way things looked to a responsible observer in the summer of 1939.

English Pop – the work, not the ideology – is basically much more easy-going than American Pop; but in the England of 1939 the divide between high culture and kitsch was quite as deep as in America. There was no common ground between the people who listened to Elena Gerhardt and the people who listened to Gracie Fields: the differences between 'Sally' on the one hand and Hugo Wolf's 'Auf ein altes Bild' on the other were not negotiable. Cultivated people knew where they were, as between one and the other, just as they knew where they were as between Lutyens's New Delhi and the huge new cinemas which were being designed by Harry W. Weedon. There was a higher life, and a lower one, and from the font onwards people were destined for one or the other. There were amateur anthropologists – Mass Observers, they were called – who looked into the patterns of humble life, much as tourists in New Mexico look into a Hop reservation. But in general it was not the thing to cross the tracks; and when people pelted along the Waterloo Road to see *Coriolanus* at the Old Vic, it never occurred to them to look into the little newsagent's on the corner.

But someone who did look into that newsagent's was George Orwell. 'The general appearance of these shops is always very much the same,' he wrote. 'A few posters for the *Daily Mail* and the *News of the World* outside, a poky little window with sweet-bottles and packets of Players, and a dark interior smelling of liquorice allsorts and festooned from floor to ceiling with vilely-printed twopenny papers, most of them with lurid cover-illustrations in three colours.' Among these papers he singled

out 'the long series of 'Yank Mags' (Fight Stories, Action Stories, Western Short Stories, etc.) which are imported shopsoiled from America and sold at twopence halfpenny or threepence'.

Orwell disliked most of this, but he never patronized it. He applied to it precisely the analytical method which he applied to Dickens. If it was kitsch, he did not call it so: he looked at it, quite calmly and objectively, as something which structured the inner life of millions of people. For them, it was not an alternative to high culture; it *was* culture, in the strict sense, and the only one they had.

Common life and everyday consumptions did, meanwhile, play a part in both English and American art. American painting had a long and honourable tradition of radical social comment. 'People should not have to live like this' is the unwritten sub-title beneath painting after painting by Reginald Marsh, by Kenneth Hayes Miller, by Jack Levine, and by many others. The *tristesse* of waitress and usherette and petrol-station attendant found its ideal interpreter in Edward Hopper. The misuse of life, and the misuse of human opportunity, were accepted as classic themes for American painting as late, even, as 1956, when the American pavilion at the Venice Biennale included pictures like 'Apteka' by Jack Levine, 'Holy Name Mission' by Reginald Marsh, 'The Subway' by George Tooker and 'Orthodox Boys' by Bernard Perlin, every one of which was an indictment of society.

It was an indictment that looked backwards to Dreiser, if not to Engels, for its polemical thrust. In 1956 Levine, Tooker and Perlin were men in their thirties or early forties; but their work had to do with the time when poverty and exploitation were burdens too heavy to shake off and when unemployment was the definitive disaster, the misfortune that branded a man for ever. In England we had no tradition of this sort in painting: a picture like Herkomer's 'On Strike' (1891) speaks for a kind of High Victorian moralizing which went out of English art when Queen Victoria died and re-appeared only briefly and awkwardly in paintings like Glyn Philpot's 'A Street Accident' (1925). The view of English life put forward by Orwell in *Keep the Aspidistra Flying* had no parallel in English art. If one were scouring the 1930s for a portent-picture, Lawrence Gowing's 'Mare Street, Hackney' would probably serve best: a painting in which the ungainly slithering movement of the London tram was re-studied in purely formal terms.

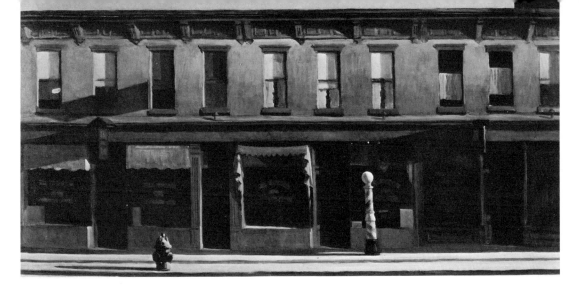

The unacceptable had its place in all these pictures, but it was confined to the subject matter. That subject matter was 'redeemed', for the moneyed patrons of Hopper and the others, by the traditional beauties of the execution. People who would never have let a waitress cross their threshold in life were quite happy to have her on the wall: Hopper had re-classed her. People who would never tread the streets of Hackney were willing, equally, to hang a Gowing: treatment was all. Common life was purified, dandified, and disinfected by art. Content was one thing: style, quite another.

In the context of Pop, all this may seem like pre-history. But the attitudes of 1939 illuminate the degree to which American Pop is the product of a society which has never quite got over a particularly violent civil war, while English Pop has an altogether gentler character: one that is nearer to botanizing, or to word-games, or to high-spirited parody, than to a fight to the death for survival.

Pre-echoes of Pop in its social context cannot usefully be sought much before 1950. Pop seems to me to have sprung from two distinct situations, neither of which was in existence before 1950. One is an economy of abundance, in which the password is 'I consume, therefore I am.' Economies straitened by the Second World War could not have produced Pop. The other determinant historical factor was the predominance in both England and the USA of non-referential abstract painting, and the espousal of that painting by art-officials, by critics, by collectors, by dealers, and by that powerful minority of persons who function in two or even three of these capacities at one and the same time.

EDWARD HOPPER *Early Sunday Morning* 1930 Oil on canvas, 35×60 ins Collection Whitney Museum of Art, New York. Hopper here poeticized the closed store-front, later the preserve of Christo, the water-hydrant, later the subject of an Oldenburg sculpture, and the striped pole, a motif later taken up by Derek Boshier

STUART DAVIS *Odol* 1924 Oil on canvas, 18×24 ins Collection The Downtown Gallery, New York. Already in 1921 Davis had pioneered a favourite Pop subject, the Lucky Strike pack. 'Odol' has precisely the flat, take-it-or-leave-it utterance which Pop took over on a larger scale

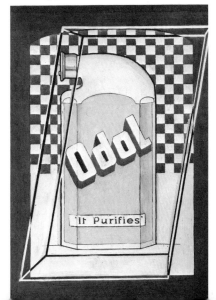

There were, however, one or two artists who produced pre-echoes of Pop. One of them was Stuart Davis; another was Scott Fitzgerald's friend Gerald Murphy; a third was Fernand Léger. The instructive thing is not so much that these pictures came about as that in the case of Davis and Léger they remained isolated examples. Léger's brand of majestic plain speaking, Davis's agility of mind and readiness to make a foray into unknown country – these were better adjusted to art as it already was. There simply was not, in the 1930s, that point of saturation, that super-profusion of messages from the mass media, which made the starting-point of Pop. Nor had art itself been pushed so far in one direction, as was the case in the 1950s, that it had either to run out of steam in the long grass or to come back at top speed and go off in another direction altogether.

For these reasons the following chronology is restricted to (1) events which helped to form the dialectic of Pop, or marked its gradual rise to prominence of one kind or another, and (2) comparative dates in the careers of the major figures concerned. It covers in some detail the ten years from 1952 to 1962. Before that time, pre-echoes were few and largely accidental; after it, the name and the idea of Pop were taken over by auxiliaries and exploiters, while the major artists concerned looked more and more like big individuals and less and less like members of a coalition.

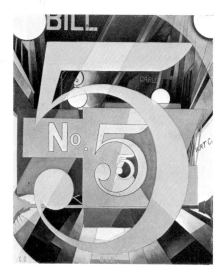

CHARLES DEMUTH *I Saw The Number Figure 5 In Gold* 1949 Oil on board, 36×29 ins Collection the Metropolitan Museum of Art. Alfred Stieglitz Collection. A precursor of Pop subject matter, and the subject of a later act of homage (see pl. VIII) by Robert Indiana

ENGLAND

1952 Independent Group (IG) formed at the Institute of Contemporary Arts (ICA). Committee: Lawrence Alloway, Reyner Banham, Richard Hamilton, John McHale, Eduardo Paolozzi, Toni del Renzio, Peter Smithson.

1952 Joe Tilson at Royal College of Art (till 1955).

1953 Peter Blake at Royal College (till 1956).

1953 Richard Hamilton teaching in Newcastle (till 1966).

1954 Richard Smith at Royal College (till 1957).

1954 IG re-convened.

1954 COLLAGES AND OBJECTS at the ICA (extensive use of Pop material).

1955 February. Richard Hamilton's paintings discussed at IG with particular reference to popular

USA

1950 De Kooning superimposes collaged mouth from Camel advertisement on his 'Study for Woman'.

1951 COMMON ART ACCUMULATIONS at Place Bar, San Francisco.

1951 Roy Lichtenstein paints Americana (till 1957).

1952 Oldenburg enrolls as full-time student at Art Institute of Chicago. Fellow students include H. C. Westermann.

1952–53 Robert Rauschenberg in Italy and North Africa

1952 Hansa Gallery founded (New York co-operative, named after combination of Hans Hofmann's first name and the Hanseatic League).

1954 First assemblages by Ed Kienholz.

1955 Jasper Johns: first Flag paintings.

serial imagery. Later meetings of the IG in 1955 deal with automobile styling, advertising, information theory, Pop music, industrial design.

1955 MAN, MACHINE & MOTION at the ICA, organized by Richard Hamilton. (Twentieth-century images in photograph: speed, stress and man/machine relationships predominant.) Introduction by Hamilton and Lawrence Gowing with notes by Banham.

1956 Blake awarded Leverhulme Research Award to study popular art. Goes to Holland, Belgium, France, Italy.

1956 THIS IS TOMORROW at Whitechapel Art Gallery. Contributors include Hamilton, Paolozzi, Nigel Henderson, Peter and Alison Smithson, John McHale, Theo Crosby, John Voelcker. The city seen (Alloway) as 'a symbol-thick scene, criss-crossed with the tracks of human activity'. Emergence of key-themes of Pop: Marilyn Monroe, giant beer-bottles, ads from cinema marquees, etc. Hamilton's collage 'Just what is it that makes Today's Homes so Different, so Appealing?'.

1956–57 Issues 18–20 of *Ark*, Royal College magazine, edited by Roger Coleman.

1957 Hamilton gives definition of Pop Art in letter to the Smithsons and later paints 'Hommage à Chrysler Corp.'

1957 'But Today We Collect Ads,' article in *Ark* by Peter and Alison Smithson.

1957 Richard Smith shows 'Blue Yonder' at Young Contemporaries show, London.

1957 Blake completes 'On The Balcony' (Tate Gallery) begun in 1955 at Royal College.

1959 Hockney, Boshier, Phillips, Kitaj at Royal College.

1959 PLACE, environmental show by Richard Smith, Robyn Denny, Ralph Rumney. Influence of cinemascope and science fiction.

1959 CLASS OF '59 exhibition (Magda Cordell, John McHale, Eduardo Paolozzi) in Cambridge. Preface by Alloway.

1960 Caulfield at Royal College.

1960 Kitaj wins prize at Young Contemporaries.

1960 Jones briefly at Royal College.

1961 Phillips chairman of Young Contemporaries (the 'Pop year').

1955 Rauschenberg: combine paintings.

1955 Rauschenberg: work with Merce Cunningham dance troupe (till 1964).

1955 Oldenburg edits art column of *Chicago Magazine*.

1955 Rosenquist comes to New York from Minnesota with scholarship to Art Students League.

1956 Wesselmann, a psychology graduate of Hiram College, Ohio, enters Cooper Union School of Art.

1956 Oldenburg employed by Cooper Union Museum Library.

1957 Johns: numbers paintings.

1957 Lichtenstein turns to Abstract-Expressionism.

1958 Johns: paints over comic strip ('Alley Oop') and produces Flashlight and Light Bulb sculptures.

1959 Oldenburg's 'The Street' and Dine's 'The House' at the Judson Gallery.

1959 October. Kaprow's '18 Happenings in 6 Parts' at the Reuben Gallery.

1959 George Brecht: one-man show at the Rueben Gallery.

1960 June. Evening of Sound-Theatre-Happenings at the Reuben Gallery with Dine, Kaprow, Brecht, Robert Whitman.

1960 November. Dine's 'Car Crash' at the Reuben Gallery.

1960 Warhol's 'Dick Tracy'.

1960 Rosenquist develops his Pop style after saving enough money to live on for a year.

1960 December. Dine, Oldenburg and Simone Morris: Happenings at the Reuben Gallery.

1960 Johns: painted bronze ('Ale Cans').

1960 Wesselmann: first 'Great American Nudes' at Tanager Gallery.

1960 NEW FORMS, NEW MEDIA at Martha Jackson Gallery.

1961 Richard Bellamy (Green Gallery) and Leo Castelli begin to promote Pop Art.

1961 Robert Scull begins to collect Pop, in particular from the Green Gallery.

1961 Indiana, Richard Smith and Stephen Durkee show 'premiums' at the Studio for Dance.

1961 Oldenburg's Happenings, 'Fotodeath' and 'Ironworks' at the Reuben Gallery.

ENGLAND (*cont.*)

1961 Richard Smith: 'MM' derived from *Paris-Match* cover of Marilyn Monroe.

1961 Kitaj, Blake & Hockney prizewinners at John Moores exhibition, Liverpool.

1962 BBC TV film 'Pop Goes the Easel' with Boshier, Phillips, Blake and Pauline Boty.

USA (*cont.*)

1961 ENVIRONMENT, SITUATION, SPACE at the Martha Jackson Gallery.

1961 Dine's tie-paintings.

1961 Segal's 'Woman in a Restaurant Booth'.

1961 ART OF ASSEMBLAGE at the Museum of Modern Art.

1961 December. Oldenburg's Store opens at 107 East 2nd Street till January 1962.

1962 Spring. Pop Art covered by *Time, Life, Newsweek*.

1962 January–March. Oldenburg's Ray-Gun Theatre on Lower East Side.

1962 February. Max Kozloff's article 'Pop Culture Metaphysical Disgust and the New Vulgarians' in *Art International*.

1962 February. Rosenquist: one-man show at Green Gallery.

1962 Oldenburg's Happening 'Injun' at Dallas Museum.

1962 July. Warhol's first show: Ferus Gallery, Los Angeles (through Irving Blum).

1962 Wesselmann's Still-Lifes.

1962 Warhol's Marilyn Monroe series and unaltered soup cans

1962 Lichtenstein's 'Portrait of Mrs Cézanne'.

1962 Oldenburg's first one-man show at Green Gallery.

1962 Lichtenstein: one-man show at Leo Castelli Gallery.

1962 Dine: one-man show at Martha Jackson Gallery.

1962 Warhol: one-man show at Stable Gallery.

1962 Wesselmann: one-man show at Green Gallery.

1962 September. G.R. Swenson's interviews in *Art News*.

1962 September. THE NEW PAINTING OF COMMON OBJECTS, organized by Walter Hopps at the Pasadena Art Museum.

1962 November. NEW REALISTS at Sidney Janis Gallery.

Like all things of its kind, this chronology consists of statements which, though individually true, could be collectively false: could lead, that is to say, to untrue or incomplete conclusions.

It takes note, for example, of meetings at which the audience barely reached double figures, while ignoring states of mind and structures of belief which were shared by thousands. It does not chart events of a contrary sort, even if these gave homogeneity to opinions which had previously been scattered and un-formalized: one could instance in England the publication in 1954 of Alloway's *Nine Abstract Artists* or the trend, manifested in the 'Situation' exhibition at the RBA Galleries in 1960, towards a tightly-argued abstract painting. Nothing is said on the American side of Abstract-Expressionism, which looked quite impregnable for the earlier part of the period under review. De Kooning's use of a collaged mouth from a Camel advertisement is noted under the year 1950, but there is no mention of an event which was vastly more important for American painting and not without relevance to the eventual scale of Pop: the break-through to gigantic formats, around that same time, by Pollock, Newman, Rothko and Still.

Nor does the climate of feeling come through. On the English side, and for many though not all of its participants, Pop was a resistance movement: a classless commando which was directed against the Establishment in general and the art-Establishment in particular. It was against the old-style museum-man, the old-style critic, the old-style dealer and the old-style collector. (Banham later described its success as 'the revenge of the elementary schoolboys'.) Much of the English art-world at that time was distinctly and unforgivably paternalistic. Pop was meant as a cultural break, signifying the firing-squad, without mercy or reprieve, for the kind of people who believed in the Loeb classics, holidays in Tuscany, drawings by Augustus John, signed pieces of French furniture, leading articles in *The Daily Telegraph* and very good clothes that lasted for ever.

In America Pop meant not a cultural break, in any broad sense, but cultural continuity. But it did mean a very sharp break with the kind of art that had dominated the American scene for ten years or more and brought America, for the first time, to the forefront of art. It was an internal break, and one which many people construed as treachery. It was treachery to Abstract-Expressionism, as a way of painting, and it was treachery to the moral struggle that the Abstract-Expressionists had

fought and won. George Segal once described what it felt like:

> The Abstract-Expressionists had set up an atmosphere of intense ambition. This was the first time in America, I think, that any American artist felt he could challenge, equal, and surpass an artist from a foreign country. It was much more than chauvinism, because this was right here in our own backyard. This was where we lived. That dream of totality had a lot of sources. I lived in New Jersey at the time, about an hour out of New York, and I was commuting. I met a lot of painters, Kaprow was teaching at Rutgers, and he lived five minutes away from my house. We became friends and belonged to the same gallery. I remember how Kaprow and I went to see Rauschenberg and Johns when they shared quarters in a loft on Wall Street. There was a maverick, heretic feeling in the atmosphere. Everything in the New York galleries at that time was heavily abstract in nature. These men – the Abstract-Expressionists – had fought hard for fifteen or twenty years, and it was a touchy point to win recognition of internal metaphysics. For serious young painters to deny that victory was the equivalent of casting yourself out of any kind of Club Membership. They stripped you of your painter's medals.

Pop in England was, as I have indicated, a facet of a class-struggle, real or imagined. It was a struggle fought by people who were for science against the humanities, for cybernetics against the revival of italic handwriting, for Elvis against pre-electric recordings of Battistini, for American Army surplus fatigues against waistcoats and watchchains, for the analytical study of General Motors advertising against an hour in the print-room at Colnaghi's. Pop did not count 'ephemeral' as an insult. It was for the present, and even more for the future: it was not for the past, and saw nothing to regret in the changes which had come about in England since 1945.

It was also for the application to popular culture of the standards, and of the investigatory techniques, which had previously been thought appropriate only to high culture. The members of the Independent Group had grown up at a time when it was about as easy to see a new copy of *Life* Magazine as it was to pick up a First Folio at W. H. Smith's. Even those who were there at the time have forgotten how limited were supplies of literally everything: food, books, magazines, pictures, air-tickets, foreign currency. First-hand knowledge of life

outside England was very difficult to come by, and I see no reason to think that John McHale exaggerates when he describes the impact of the consignment of American magazines which he brought back with him in 1955.

In the early 1950s both technology and the mass media were very much more advanced in America than they were in England; and there was, then as now, a sense of limitless possibility about American life which does not exist in England, partly because our resources are so much smaller and partly because the events of the last twenty-five years have put us temperamentally on the defensive. It was natural for the Independent Group to look to America, and for Alloway and McHale eventually to emigrate there, just as it was natural for the next generation of English painters to seize the opportunities of crossing the Atlantic which proliferated in the 1960s.

So there was an imaginative involvement with America in the mid-1950s; and there was also a collective delight in the source-material. Painters pounced on the advertisement pages of *McCall's Magazine* the way Dyce pounced on Raphael when he was asked to paint a Madonna. But this was not quite the same as having the material in one's own culture, innately and intrinsically. The very fact that it had to be analysed and redefined and up-graded as an object of serious interest was further proof of its alien character.

A capital document in this context is Richard Hamilton's letters to the Smithsons of 16 January 1957. In this he wrote that Pop Art was:

> 'Popular (designed for a mass audience)
> Transient (short term solution)
> Expendable (easily forgotten)
> Low-cost
> Mass-produced
> Young (aimed at Youth)
> Witty
> Sexy
> Gimmicky
> Glamorous
> Big Business. . . .'

It should be noted Hamilton was not talking about an already-existing body of paintings. No such paintings existed. Pop Art, as an art supposedly distinct from any other, was still unknown. Hamilton was describing the source-material of Pop Art: the things which were to provoke English artists in the way that the sculptures in the Museo Archeologico in Venice provoked the

PETER BLAKE *A Transfer* 1963 Ink, crayon, pencil, 12×10 ins Collection Michael White, London

Venetian masters of the fifteenth and sixteenth centuries. Hamilton was provoked by his own letter, and by the Smithsons' response to it, to paint 'Hommage à Chrysler Corp.' (1957). This picture does not at all correspond to the definition of 'Pop Art' in Hamilton's letter. It is not transient, not expendable, not mass-produced, and not gimmicky. A mass audience would certainly not get the point of a statement which is characteristically complex, fastidious and oblique. Witty and sexy it certainly is, and it may one day be big business. But there is a navigational difference of 180 degrees between the quick-results policy outlined in the letter and the picture itself, with its references to Mondrian, Duchamp and Saarinen and its virtuoso evocation of glossy-magazine printing techniques. ('One passage', Hamilton tells us, 'runs from a prim emulation of in-focus photographed gloss to out-of-focus gloss to an artist's representation of chrome to an ad-man's sign meaning "chrome".') Its relation to the source material is that of an immensely intelligent European outsider who has used a European sensibility to master an unfamiliar situation.

Looking back on this time, Hamilton said later that his paintings had been polemical: 'paintings by and about our society', attempts to capture 'the unique attributes of our epoch' at the points where they were strongest and most evident. English painters remained English, but they felt about the American scene in the late 1950s and early 1960s as Goethe felt about Italy in 1786: 'My passionate desire to see it with my own eyes had grown to such a point,' Goethe wrote from Venice, 'that if I had not taken the decision to come here I should have gone completely to pieces.'

American painters had no such problem, since they were there already, but they did have the problem of how to adapt to it. There was the internal problem of Abstract-Expressionism, which I have already referred to, and there was a social problem, a problem of morality and not of aesthetics. A great many people believed that advertising was morally wrong, that television and cheap movies were a debasement of life, that mass-taste and mass-values were necessarily inferior to minority-tastes and minority-values, and that it was the role of the artist to speak for an élite which kept itself apart from all these things. Civilization meant a highly differentiated society in which people spent a lot of their time marking and upholding tiny nuances of dress and behaviour and taste. People did not like to think that they were part of a largely standardized society. Conceivably, even, the

hold of Abstract-Expressionism upon at least one generation of Americans derives in part from the fact that painting a picture of this sort is a completely unstandardized act: an act which cannot be predicted or repeated. Conversely, the detestation which Pop arouses may be due to a fear, prevalent among those same people, that they will be dragged down from the summits of high art into precisely the environment from which they had been hoping to escape.

It is certain, in any case, that the subject matter of Pop is part of the *tempo primo* of American life. It is part of a Mississippi-like flood of information, cajolery, overstatement and plain bamboozledom from which few Americans are ever free for long. It has a particular significance for Americans who were born – as is the case with most of the American Pop artists – not long after the Wall Street crash and just before the beginning of the New Deal. It was at this hideous period that photographers of genius like Edward Weston and Walker Evans went round and recorded a society that was gradually being skinned down to its bones. Looking at the photograph of a giant coffee-cup which Weston made at this time, we see at once the persistence of big habits of thought, the liking for a single plain monumental image, the determination not to be outdone by a landscape which is on a more than human scale – all the things, in short, which Pop Art has perpetuated. (Set beside a photographic record of an English scene, such

Ramsgate 1967 Photograph by Tony Ray-Jones

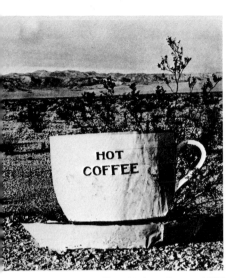

Hot Coffee, Mojave Desert 1937
Photograph by Edward Weston

as the one by Tony Ray-Jones which is reproduced here, the Weston marks the difference between English and American Pop source-material: the one a firm statement with no distractions or inessentials, the other wayward, diffuse, reassuring in scale, multi-focused and fundamentally diffident.)

What we get at second-hand from a master-photographer, the American Pop artists got direct, as an emblem of continuity in life. People who mock the standardized life do not realize to what extent the vivid regularity of an unvarying signal can give comfort and reassurance. Robert Indiana's paintings are sometimes mistaken for simple-minded repetitions of simple-minded motifs: toy pictures that no grown-up would look at twice if he were equal to looking at a Pollock or a Morris Louis. 'USA 666' for instance is a group of five circles, with the letters USA in the top half of each of them and EAT, DIE, 666, ERR, and HUG respectively in the five lower halves. It has a heraldic force, but one could suppose that the words and the figure had been chosen at random. Indiana undeceives us:

'USA 66' is one of six paintings of the incomplete 'Sixth American Dream' and it brings to the 'Dreams' their starkest image: the unmistakable black and yellow high visibility reflex-making of the X-shaped railway crossing danger sign that punctuated the Indiana roads of my youth where instant death befell the occupants of stalled cars, school busses in foggy weather, or of autos racing into serious miscalculations before the onrushing always irresistible locomotive.

But 'USA 666' actually comes from multiple sources: the single six of my father's birth month, June; the Phillips 66 sign of the gasoline company he worked for – the one sign that loomed largest in my life casting its shadow across the very route that my father took daily to and from his work and standing high in a blue sky, red and green as the company colors were at that time but changed upon the death of the founder of the company. It also conjures up Route ≠66, the highway west for Kerouac and other Americans for whom 'Go West' is a common imperative, whereas for a common cold it is 'Use 666', the patent medicine that is the final referent and which on small metal plates affixed to farmers' fences – black and yellow – dotted the pastures and fields like black-eyed susans in perennial bloom, alternating with the even more ubiquitous Burma-Shave advertisements

that brought elementary poetry as well to the farms and byways. In perhaps lesser profusion over the countryside bloomed the EAT signs that signalled the roadside diners that were usually originally converted railway cars of a now-disappeared electric interurban complex taken off their wheels and mounted on cement blocks when the motorbus ruined and put that system out of business in the thirties. In similar cheap cafes my mother supported herself and son by offering 'home-cooked' meals for 25c when father disappeared behind the big 66 sign in a westerly direction out Route ≠66.

This is what I mean by the difference between English and American Pop: it is the difference between the thing chosen, as an act of the intelligence, and the thing lived.

American Pop Art is neither a freak, nor a provocation, nor a perversion, nor a betrayal. It is a natural art, and one that is continuous with American life and continuous with American painting. Roy Lichtenstein stands for Pop – indeed, *is* Pop – for thousands of people who have never looked at his source-material or bothered to study his own career in any detail. Roy Lichtenstein is penetrated by Americana, thought of nothing else for years, and made the move to pure Pop material without any fundamental shift of interest, just as he later moved into an art-historical or art-critical sphere of activity without any evident shifting of gears: on the intermingling of language and content he is difficult to beat. His work is a critique of legend, perhaps, but it is also a critique of printed matter: an investigation of the extent to which printed matter, *whatever its source*, can be made to give out a new resonance. The printed matter in question may be a comic strip, or a reproduction of Mondrian or Monet, or an elucidation of Cézanne. The imagination which goes to work upon it remains the same: there is no grading up or down, with reference to the original image. We are back with Maurice Denis, and the picture is simply an arrangement of flat patches of colour in a certain order.

But it is Warhol, in the end, who annoys people most. We shake our heads when we read of Napoleon III striking out at a Courbet with his riding whip; but if it happened to a Warhol how many would not say 'Serves him right!'? Only those, perhaps, who have actually looked at a painting by Warhol. (See the tribute printed on p. 115 by an artist of a very different persuasion, Larry Bell.) When Warhol first showed pictures like the

R. B. KITAJ *The Ohio Gang* 1964 Oil on canvas, 72×72 ins Collection Museum of Modern Art, New York A classic of Americana re-created at a distance by an American painter in London

TOM WESSELMANN *Still Life No. 50* 1965 Assemblage on wood, 39½ ins in diameter 4 ins deep Collection the artist

Richard Hamilton as spaceman-fullback 1963 Photograph by Betsy Smith

Derek Boshier and David Hockney at the Royal College *c.* 1961 Photograph by Geoffrey Reeve

green Coke-bottle painting from Buffalo which is reproduced on Pl. XIV people could not get beyond the triviality, as they saw it, of the basic motif. But the fact is that any common object, if looked at hard enough and long enough, will lose its temporal identity and become an abstract form. The old-style Coke bottle, then one of the most familiar objects of everyday life, is now extinct: rarer than old Waterford glass, it is charged with nostalgia, like the front page of *The Times* as it was in the 1950s or the penny bus-tickets that a former Director of the British Museum once kept framed in rows in the hall of his house. But the bottle on Warhol's canvas is not a description of something: it *is* something, as absolutely as the chevrons on a Noland of some years back. In the one case, as in the other, what is being asserted in the autonomy of the picture: the two artists are like men who set off in opposite directions and yet arrived at the same destination.

So art is indivisible, after all, and nobody has betrayed it. Warhol's multiple-head portraits relate as much to European multiple-head portraits, like Gainsborough's 'Children of George III', as they do to Polyfoto or photomat pictures. Alex Hay's giant Open-E-Z Bag (ill. 32) is not a brutish joke, but one of the most aristocratic objects lately put on exhibition. The woman in George

Segal's 'Kosher Meat Shop' is not a chalky approximation to something that would be done better at Madame Tussaud's: she has a withdrawn, timeless, unself-conscious quality which calls to mind the Fifth Dynasty 'Girl Working at a Mash Tub' in the Cairo Museum. And if we were to look around in the late 1960s for a painter who had the ambitions that Courbet had when he painted 'L'Atelier' – a picture, that is to say, which aimed to set out the truth about a certain society – I know of no one who has done the job with greater honour than Rosenquist. Americans like Segal and Oldenburg and Kienholz and Rosenquist reveal themselves in their art not just as very good artists but as free and responsible human beings.

The 'F-111' and the 'Portable War Memorial' do, of course, relate to present burdens of conscience which are more onerous by far than any that history has laid upon English Pop artists. Richard Hamilton is a committed artist, in the same sense as his American colleagues, but the general character of Royal College Pop, to which Blake, Hockney, Boshier, Phillips and Allen Jones are prime contributors, was free-wheeling and hedonistic. Early paintings by Hockney, like the one seen in the background of the photograph on p. 38, were like postcards dashed off on the spur of the moment, or travel-notes set down before a new place, or a new person, put them out of mind. What came out of the College between 1959 and 1962 was a contribution to the idea of an England at last recovered from the lethargy of the immediate post-war period. It was an up-dated *As You Like It*, a metropolitan pastoral in which Warhol's road-accidents and evocations of the electric chair had no

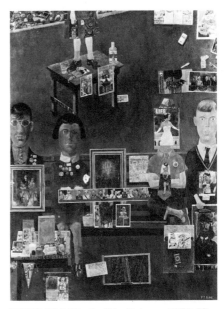

PETER BLAKE *On The Balcony* 1955-57 Oil on canvas, 47×35 ins Tate Gallery, London. Reproduced by permission of the Trustees

Proposed Living Sculpture of Claes Oldenburg on an empty base near Grosvenor Square, London. Photo Hans Hammerskjold, Stockholm

39

echo – unless it was in Bruce Lacey: Lacey's environmental 'The Living Room' was a memorable evocation of the multiple murders which formed so important a part of English folklore in the 1950s.

In many of its aspects, English Pop was painterly, anecdotal, diffuse, jokey, deliberately unfocused: all things which delighted a public that had enough of low-spirited English representational painting. The changes of pace and idiom were particularly exhilarating, and it did not escape a careful observer that a picture by Kitaj or Hockney often carried a considerable learning with complete unpretentiousness. The temper of Pop was quite unlike the traditional temper of English painting: looking at it after reading the *Economist* was like reading Byron's *Don Juan* after a week with the accounts of a near-bankrupt country grocer.

As to 'Which came first?', I don't know that it is a very profitable question. But there is no doubt that the Independent Group did establish a working dialectic for Pop long before Pop as such made its appearance in America, and that Hamilton's alembications of Pop material preceded anything of the kind on the other side of the Atlantic. On the other hand, there never *was* anything of the kind on the other side of the Atlantic, any more than English Pop ever had the concentrated, all-risking unified thrust of American Pop or the symphonic ambitions of the 'F-111'. They were two different animals.

This said, Peter Blake's 'On the Balcony' remains an extraordinary conception for the year 1955 and a small encyclopaedia of themes which were later taken up by both English and American Pop. (It is also an up-dated anthology of the kind of merchandise that George Orwell would have found in the little shops of England if he had been here to revisit them.) In formal terms it owes something to a painting by the American artist Honoré Sharrer, and to that extent it is premonitory of an aspect of Pop with which I can appropriately finish: the Anglo-American entente. I doubt if there was ever a school of painting in which painters of two countries went to work in a spirit of such harmonious good nature. Dine, Kitaj and Oldenburg have contributed a great deal to our understanding of England; I shall never again think of London without remembering what Dine did with Selfridge's pink-rosed wrapping paper and what Oldenburg would have liked to do with Green Park. The 'special relationship' may be outworn in politics, but in art it is completely alive.

Critical statements

The Long Front of Culture
Lawrence Alloway

The abundance of twentieth-century communications is an embarrassment to the traditionally educated custodian of culture. The aesthetics of plenty oppose a very strong tradition which dramatizes the arts as the possession of an elite. These 'keepers of the flame' master a central (not too large) body of cultural knowledge, meditate on it, and pass it on intact (possibly a little enlarged) to the children of the elite. However, mass production techniques, applied to accurately repeatable words, pictures and music, have resulted in an expendable multitude of signs and symbols. To approach this exploding field with Renaissance-based ideas of the uniqueness of art is crippling. Acceptance of the mass media entails a shift in our notion of what culture is. Instead of reserving the word for the highest artifacts and the noblest thoughts of history's top ten, it needs to be used more widely as the description of 'what a society does'. Then, unique oil paintings and highly personal poems as well as mass-distributed films and group-aimed magazines can be placed within a continuum rather than frozen in layers in a pyramid. (This permissive approach to culture is the reverse of critics like T. S. Eliot and his American followers – Allen Tate, John Crowe Ransom, who have never doubted the essentially aristocratic nature of culture.)

Acceptance of the media on some such basis, as entries in a descriptive account of a society's communication system, is related to modern arrangements of knowledge in non-hierarchic forms. This is shown by the influence of anthropology and sociology on the humanities. The developing academic study of the 'literary audience', for example, takes literary criticism out of textual and interpretative work towards the study of reception and consumption. Sociology, observant and 'cross-sectional' in method, extends the recognition of meaningful pattern beyond sonnet-form and Georgian-elevations to newspapers, crowd behaviour, personal gestures. Techniques are now available (statistics, psychology, Motivation Research) for recognizing in 'low' places the patterns and interconnections of human acts which were once confined to the fine arts. The mass media are crucial in this general extension of interpretation outwards from the museum and library into the crowded world.

One function of the mass media is to act as a guide to life defined in terms of possessions and relationships. The guide to possessions, of course, is found in ads on TV and cinema screens, hoardings, magazines, direct mail. But over and above this are the connections that exist between advertising and editorial matter: for example, the heroine's way of life in a story in a woman's magazine is compatible with consumption of the goods advertised around her story, and through which, probably, her columns of print are threaded. Or, consider

the hero of two comparable Alfred Hitchcock films, both chase-movies. In the pre-war *39 Steps* the hero wore tweeds and got a little rumpled as the chase wore on, like a gentleman farmer after a day's shooting. In *North by North West* (1959) the hero is an advertising man (a significant choice of profession) and though he is hunted from New York to South Dakota his clothes stay neatly Brooks Brothers. That is to say, the dirt, sweat and damage of pursuit are less important than the package in which the hero comes – the tweedy British gentleman or the urbane Madison Avenue man. The point is that the drama of possessions[1] (in this case clothes) characterize the hero as much as (or more than) his motivation and actions. This example, isolated from a legion of possibles, shows one of the ways in which lessons in style (of clothes, of bearing) can be carried by the media. Films dealing with American home-life, such as the brilliant women's films from Universal-International, are, in a similar way, lessons in the acquisition of objects, models for luxury, diagrams of bedroom arrangement.

The word 'lesson' should not be taken in a simple teacher-pupil context. The entertainment, the fun, is always uppermost. Any lessons in consumption or in style must occur inside the pattern of entertainment and not weigh it down like a pigeon with *The Naked and the Dead* tied to its leg. When the movies or TV create a world, it is of necessity a *designed* set in which people act and move, and the *style* in which they inhabit the scene is an index of the atmosphere of opinion of the audiences, as complex as a weather map.

We speak for convenience about a mass audience but it is a fiction. The audience today is numerically dense but highly diversified. Just as the wholesale use of subception techniques in advertising is blocked by the different perception capacities of the members of any audience, so the mass media cannot reduce everybody to one drugged faceless consumer. Fear of the Amorphous Audience is fed by the word 'mass'. In fact, audiences are specialized by age, sex, hobby, occupation, mobility, contacts, etc. Although the interests of different audiences may not be rankable in the curriculum of the traditional educationist, they nevertheless reflect and influence the diversification which goes with increased industrialization. It is not the hand-craft culture which offers a wide choice of goods and services to everybody (teenagers, Mrs Exeter, voyeurs, cyclists), but the industrialized one. As the market gets bigger consumer choice increases: shopping in London is more diverse than in Rome; shopping in New York more diverse than in London. General Motors mass-produce cars according to individual selections of extras and colours.

There is no doubt that the humanist acted in the past as taste-giver, opinion-leader, and expected to continue to do so. However, his role is now clearly limited to swaying other humanists and not to steering society. One reason for the failure of the humanists to keep their grip on public values (as they did in the nineteenth century through university and Parliament) is their failure to handle technology, which is both transforming our environment and, through its product the mass media, our ideas about the world and about ourselves. Patrick D. Hazard[1] pointed out the anti-technological bias of the humanist who accepts only 'the bottom rung . . . of the technological ladder of communication', movable type. The efforts of poets to come to terms with industry in the nineteenth century (as anthologized by J. F. Warburg) are un-memorable, that is to

say, hard-to-learn, un-influential in image-forming. The media, however, whether dealing with war or the home, Mars or the suburbs, are an inventory of Pop technology. The missile and the toaster, the push-button and the repeating revolver, military and kitchen technologies, are the natural possession of the media – a treasury of orientation, a manual of one's occupancy of the twentieth century.

Finally it should be stressed that the mass media are not only an arena of standardized learning. Not only are groups differentiated from the 'mass', but individuals preserve their integrity within the group. One way to show this is to appeal to the reader's experience of the media, which he can interpret in ways that differ in some respects from everybody else's readings. While keeping their essentially cohesive function, providing a fund of common information in image and verbal form, the media are subject to highly personal uses. This can be shown by quoting a reader's reaction to a science fiction magazine cover:

> 'I'm sure Freud could have found much to comment, and write on, about it. Its symbolism, intentionally or not, is that of man, the victor; woman, the slave. Man the active; woman the passive. Man the conqueror; woman the conquered. Objective man, subjective woman; possessive man, submissive woman! . . . What are the views of other readers on this? Especially in relation with Luros' backdrop of destroyed cities and vanquished man?'

The commentary supplied by this reader, though cued by the iconography of *Science Fiction Quarterly*, implies clearly enough his personal desire and interest. However, it is no greater a burden of meaning that he puts on the cover than those attached to poems by symbol-conscious literary critics. The point is that the mass media not only perform broad socially-useful roles but offer possibilities of private and personal deep interpretation as well. At this level Luros' cover is like a competitor of the fine arts, in its capacity for condensing personal feelings. However, it is the destiny of the popular arts to become obsolescent (unlike long-lived fine art). Probably the letter writer has already forgotten Luros' cover (from the *early* fifties) and replaced it by other images. Both for their scope and for their power of catching personal feeling, the mass media must be reckoned as a permanent addition to our ways of interpreting and influencing the world.

[1] *Contemporary Literary Scholarships*, ed. Lewis Leary (New York, 1958).

From Cambridge Opinion 17,
Cambridge University, England 1959

The Fine Arts in the Mass Media
John McHale

Historically, in the West, the fine arts have been those channels of communication, painting, sculpture, literature, music and the drama, which served, and were maintained, by an elite topping a vertical hierarchy. Cultural belief and dogma supplied the absolutes, 'eternal beauty', 'universal truth', etc., which accreted into the classical canons by which the arts were judged. In the main,

for their cultivated appreciation, they required an education normally reserved for a privileged elite. The mass of 'groundings' might share in the spectacle, but the full symbolic value of a ritual drama, the complex allegory of a group of statuary or paintings, were beyond them – partially through illiteracy, perhaps also from indifference, lack of identification. The co-existent folk art might share some, or none, of the elite art's qualities. Preferred mobility in such a culture, was one way. What went up – stayed up. The prizes were there.

Invention of printing from movable type, first harbinger of the mass production of identical replaceable culture products, began a cultural revolution which is still on the move. Printed books, Riesman's 'Gunpowder of the Mind', fractured the matrix of classical culture – by changing the media of communication, the 'content', society or culture, was transformed.

But the print-oriented phase generated forces which, in turn, rendered its own cultural assumptions obsolete. The emergent middle classes of the Industrial Revolution rationalized the need for minimal literacy in a growing machine economy, with the pious hope that 'universal education' would make the 'classical heritage' viable for all. The same hope is still reiterated today, when the changes wrought in society have made this 'heritage', where relevant, simply one of a number of possible cultural strategies. Mass production on a phenomenal scale, oriented to mass preference, not elite direction, and the multiplicity of new communicating channels, are producing a culture which bears as little relation to earlier cultural forms as the Atlas rocket does to a wheeled cart. The printed word, once prime medium, takes second place to new uses of aural and visual imagery. By means that have not formerly existed man is given simultaneous global presentation of the events in his culture. In one medium alone, television, his environment is the world, 'brought to his home,' to quote Max Lerner, 'wrapped up in a single gleaming febrile package whose contents change magically and continuously on the quarter and half hour.'

The elite of the earlier vertical society has, in the sense of representing and directing cultural preferences, become simply one of a plurality of elites. These relate, and overlap, horizontally – fashion, sport, entertainment, politics, etc. – and are as diverse, and relatively powered, as their audiences and ingroups can be numbered. The apex of the pyramid has become one node in a mesh of interrelated networks spread over the communications system.

Attempts to locate the fine arts in this new cultural situation have taken many forms. Leaving aside the prophets of doom – who are always around to idyllicize the past, and bewail the passing of ancient virtues – there are other views which are no more realistic even if the more comforting. Representative of the most widely held of the latter is that of Dwight McDonald (A Theory of Mass Culture: *Diogenes*, No. 3, 1953). This, that 'mass culture', imposed on the people by their 'exploiters', battens on 'high culture' for ideas, originality and 'real' culture. The significance of the *avant-garde* is seen as 'a withdrawal from vulgar competition', and Gresham's Law is invoked to underline how the 'bad stuff' (*kitsch*) eventually drives out the 'good' (fine art). Another popular, and associated, viewpoint dodges the contained value judgment but retains the vertical fallacy by suggesting that the fine arts now function as research for the mass arts. The artist's ivory tower is now fitted up as a laboratory, in which

discoveries are made, and visions created, which eventually furnish the new landscape for the masses, i.e. after a certain time-hallowing pause for acceptance, the right angles and flat planes of a Mondrian become the visual environment of a soup ad. Caviare to the general today – corned beef for the millions tomorrow.

Such evidence as could be educed for the above views is accountable for by reason of the omnivorous and massive intake of material processed by the newer channels. A case could be found for due debt, or allegiance, to almost any cultural area or period – but even in evaluating the fine arts we went off the Cultural Gold Standard decades ago, and have long been in a period of convertible currencies. What should not be obscured is, that in being processed and transmitted in different media from which it originates, such 'taken over' material becomes something new, no longer judgeable within its original canon.

This axiom of a change of media affecting form/content is evident even in a borderline case like Malraux's 'Museum Without Walls'. Photography and modern printing techniques produce a new visual image, the 'experience' of which is, in reality, at some remove from that engendered by the original artifact – although this latter experience is also not a constant. Transformation along these lines, occurs, in varying degree, however the fine arts are diffused through mass media channels, and is central to consideration of the theme.

It is claimed, on the positive side, for 'direct' consumption of fine art, that the machine has made possible widespread appreciation of music, cheap literary classics, and enactment of dramatic performances in thousands of movie centres and millions of homes! It should be added that – it is all this, and more besides! Every other sort of product, entertainment, etc., offered by the machine. The point is co-existence of a huge number of available and unconditional choices open to the consumer – a glance at the *Radio Times* will underline this mobile and 'inclusive' aspect of the situation. To like A you don't have to forgo B. The Cliff Richard fan doesn't have to switch off Maria Callas. There is no inherent 'value' contradiction in enjoying both a comic strip and a symphony. The degree to which 'taste' is imposed, by producing for mass demand, is fractional. The mass audience produced for is sufficiently diverse and mobile in itself, to ensure that the products offered for its consumption will exhibit the same range and variety.

It is interesting to consider, though, where some of the examples do line up as 'fine art consumption'. Watching Sir Kenneth Clark and Henry Moore discussing the Elgin Marbles on television may seem an ultimate in fine arts exposure. But it depends on where you sit – otherwise, it may be just another programme – in which two agreeable and cultivated TV personalities chat about some exotically lit statuary. What has been added by transmission through the electronic medium, with mobility of viewing, fancy lighting, etc., is a new experience, with the image of the artifact as one basic element.

Much coverage of fine art in mass circulation magazines can be similarly construed. A Picasso feature in *Life* (or *She*) may carry a consensus of opinion, more descriptive information and less implied aesthetic than a similar feature in an art journal – the full colour illustration is usually more than the latter could afford. But how far is the Picasso read as 'Art', or as yet another, more or less complex, colour spread in a week's democratic selection?

The featuring of single artists in the mass media is pertinent here. It has been pointed out that, 'in the fine arts the creator is acclaimed – in the mass arts, hero, actor, product acclamation is the order, the creator tends to anonymity'. Both trends cross up where the artist is the subject for book, film or feature story. Favouring 'personality', the treatment is often of the 'Inside an Artist' type, e.g. from Modigliani, 'Dissolute Genius of Art . . . just from the way he looked people could guess he was an artist, the tousled hair, the loose silk scarf, the melancholy eyes and poetic face – all made up the classic image of a creative man'. But this kind of 'creativity' stereotype, as in 'Lust for Life', 'Rembrandt', is not so very different from other parallel abstractions in use for 'the classic image of a creative man'.

Occasionally the above area of fine art treatment furnishes striking images of the complexity of the situation under discussion. 'Goya's Girl goes Aloft', is an example – 'flaunting "The Naked Maja" to the skies an airplane tows a banner (replica) over the Los Angeles civic centre'. This was part of the promotion for United Artists film – also used was a reproduction of the painting on a 255 foot by 65 foot billboard over Times Square.

Patronage, of the sort now wielded by the big corporations, often results in the direct appearance of the fine art work in a mass context. Ads, like the series 'Great Ideas of Western Man' by Container Corporation and others, using variously fine art and 'fine' graphics to illustrate the theme in which there is no selling copy but the company name in small print. The odd mural in the factory and sculpture in front of the office building are roughly in the same class. The mixture of motives at work, whilst revealing perception, and altruism maybe, also includes a conscious appreciation of the prestige accruing to the use of fine art in the adumbration of the company brand image.

Where such patronage involves conscious use of a mass vehicle to disseminate 'cultural' ideas and impose 'good taste' on the consumer, it can be more devious. Around mid-1956 a fire was written into the script of 'The Grove Family' television series – so that the 'family' could refurnish their 'home' – through the Design Centre. This was a calculated co-operation between the BBC and the Council of Industrial Design.

Indirect use of fine art material occurs in a variety of contexts, where it is used as a signal to trigger off responses in the areas of 'gracious living', 'prestige', 'status', etc., and to suggest permanence and dignity. In *Vogue* and other glossies, the model poses, eclectically, before an action painting or under the antique columns of the Theatre of Marcellus. Chagall, Marcel Proust and the Brussels Fair will rate full treatments. Further over, in the pulps, the feature is likely to be a new portrait of the Queen, or the Royal Family, but in the furnishing section, the 'ideal home' will show a Braque reproduction in the kitchen, and an 'untidy' late model abstract in the dining alcove. The picture of an elite entertainer's wife on her porch will be shown with the caption, 'A Della Robbia Madonna adorns the entrance of their Palm Desert house'.

They are strong on captions in this section – of the 'Body by Fisher, Artwork by Rembrandt' variety. Greek amphorae used to 'ennoble by time' in a liqueur ad will have full catalogue notes. This 'man of distinction' drinking a particular sherry, is not just sitting in front of a picture, but before 'Goya's "Dona Isabel Cobos de Porcel" by courtesy of the National Gallery, London'.

A sub-category of the above, involves a refinement in symbolic use, where the 'antique' artifact – Venus de Milo, the Parthenon, Rodin's Thinker – or era – the eighteenth century as 'The Age of Elegance' – is repeatedly used as a symbol for the 'classic ideal'. The radiator front of the Rolls, and ' I dreamt I was the Venus de Milo in my Maiden-Form bra', both belong here. The *Galaxy* cover picture of a group of multi-limbed extraterrestrials 'sending up' a version of the Cnidian Aphrodite is a shrewd comment on the relativity of 'the ideal', but depends for its effect, paradoxically, on 'recognition' of the valid symbol. The fact that such images achieve a kind of 'permanent' response, no matter how they are used, is important and worthy of more attention.

Another aspect of 'indirect use', where Art comes gratis as part of the package, is in a current series of ads for G-Plan furniture. Headed 'A New Trend in Furnishing', they show sample interiors – complete with a 'tachiste' painting on the wall. The latest *avant-garde* artwork lending character to a mass product! Such acceleration in acceptance of the 'new', conditioned by the mass media emphasis on topicality, has obvious repercussions on the speed of circulation of the fine art image. It may feed back into the fine arts, effecting a corresponding acceleration in stylistic change. How long can an *avant-garde* stay one jump ahead? That the present speed of communication does affect fine art development is evidenced by the controversy over the Rosenberg writings on Action Painting. Heralding the U.S. movement (in American *Art News*), their acceptance abroad as 'method' gospel gave rise to quite a deal of aesthetic juggling, by painter and critic alike.

To be appropriate to the nature of a relation as diverse as that between the fine arts and the mass media, conclusions can only be offered, in the form of descriptive comment. Any previous traditional standpoint is obviously of limited value in engaging with a phenomenon of such recent growth as the mass media. Where, formerly, the message carried by the fine arts was conveyed in an aura of 'canonized' communication, it is now broadcast among a plurality of messages, couched in different cultural vocabularies. Its transmission, employment and transformation in a number of different contexts need imply no erosion of function or 'vulgarization' of content. It is merely part of the live process of cultural diffusion which, like many other aspects of societal interaction in our period, now occurs in a variety of unprecedented ways.

From Cambridge Opinion 17,
Cambridge University, England 1959

The Plastic Parthenon
John McHale

Our emergent world society, with its particular qualities of speed, mobility, mass production and consumption, rapidity of change and innovation, is the latest phase of an ongoing cultural and social revolution. It has few historical precedents as a cultural context. Industrial technologies, now approaching global scale, linked to an attendant multiplicity of new communications channels, are producing a planetary culture whose relation to earlier forms is as

Vostok or Gemini to a wheeled cart. World communications, whose latest benchmark is Telstar, diffuse and interpenetrate local cultural tradition, providing commonly shared cultural experience in a manner which is un-paralleled in human history. Within this global network, the related media of cinema, TV, radio, pictorial magazine and newspaper *are* a common cultural environment sharing and transmuting man's symbolic needs and their expression on a world scale. Besides the enlargement of the *physical* world now available to our direct experience, these media virtually extend our psychical environment, providing a constant stream of moving, fleeting images of the world for our daily appraisal. They provide *psychical* mobility for the greater mass of our citizens. Through these devices we can telescope time, move through history and span the world in a great variety of unprecedented ways.

The expansion of swift global transportation, carrying around the world the diverse products of mass production technology, provides common cultural artifacts which engender, in turn, shared attitudes in their requirements and use. Packaged foods are as important a cultural change agent as packaged 'culture' in a book or play. The inhabitant of any of the world's large cities – London, Tokyo, Paris, New York – is more likely to find himself 'at home' in any of them, than in the rural parts of his own country; the international cultural milieu which sustains him will be more evident. So-called 'mass' culture, both agent and symptom of this transformation, is yet hardly understood by the intellectual establishments. Past traditional canons of literary and artistic judgment, which still furnish the bulk of our critical apparatus, are approximately no guide to its evaluation. They tend to place high value on permanence, uniqueness and the enduring universal value of chosen artifacts. Aesthetic pleasure was associated with conditions of socio-moral judgment – 'beauty is truth,' and the truly beautiful of ageless appeal! Such standards worked well with the 'one-off' products of handcraft industry and the fine and folk arts of earlier periods. They in no way enable one to relate adequately to our present situation in which astronomical numbers of artifacts are mass produced, cir-culated and consumed. These products may be identical, or only marginally different. In varying degrees, they are expendable, replaceable, and lack any unique 'value' or intrinsic 'truth' which might qualify them within previous artistic canons. Where previously creation and production were narrowly geared to relatively small tastemaking elites, they are now directed to the plurality of goals and preferences of a whole society. Where previous cultural messages traveled slowly along restricted routes to their equally restricted, local audiences, the new media broadcast to the world in a lavish diversity of simultaneous modes. The term 'mass' applied to such cultural phenomena is indicative only of its circulation and distribution. Common charges of 'standardized taste' and 'uniformity' confuse the mass provision of items with their individual and selec-tive consumption. The latter remains more than ever, and more widely, within the province of personal choice – less dictated than ever formerly by tradition, authority and scarcity. The denotably uniform society was the primitive enclave or pre-industrial peasant community, with its limited repertoire of cultural forms and possible 'life style' strategies.

We have, then, few critical precedents with which to evaluate our present cultural milieu. Most of the physical facilities which render it possible have not

previously existed. Their transformative capacities pose more fundamental questions regarding cultural values than may be more than hinted at here.

What are the principal characteristics which differentiate the new continuum from earlier and more differentiated forms? The brief comments, offered below, are only notes towards the development of a more adequately descriptive and evaluative schema. As pragmatic and contextual they relate performance to process in a given situation.

Limiting ourselves to three main aspects, we may consider: one, expendability and permanence; two, mass replication and circulation; and three, the swift transference of cultural forms across and through multicommunication channels. All are associated with varying degrees of accelerated stylistic change and with the co-existence of a huge number of available and unconditional choices open to the participant or consumer, i.e., there is no inherent value contradiction implied in enjoying Bach *and* the Beatles. The situation is characteristically '*both/and*' rather than 'either/or'.

We may consider such expendability and 'mass' replication as concomitant aspects of the same process – the application of industrial technologies to human requirements.

Man has only recently emerged from the 'marginal' survival of a pre-industrial society based on the economics of scarcity values; one in which laboriously made products were unique and irreplaceable. In such conditions, 'wealth' and 'value' resided in material goods and property, as representing survival value – as ideal and enduring beyond individual man.

World society need no longer be based on the economics of scarcity. There is a revolutionary shift to a society in which the only unique and irreplaceable element is man. This is one of the main points about automation. In previous periods, objects, products, resources, etc. tended to have more importance in sustaining the societal group than individual man. Man was, in a sense, used most prodigally in order that the idea of man might survive. The material object was unique. Man was expendable. Now, through developed industrialization the object may be produced prodigally. The product is expendable – only man is unique. In fully automated process the only unique resource input is information – organized human knowledge. Automation returns value into man.

Intrinsic value becomes, then, a function of the human use-cycle of an object or process. Use value is now largely replacing ownership value. We note this, for example, in the growth of rental and service – not only in automobiles and houses, but in a range from skis to bridal gowns – to 'heirloom' silver, castles and works of art. The vast range of our personal and household objects may, also, when worn out, lost or destroyed, be replaced by others exactly similar. Also, and importantly, when worn out symbolically, i.e. no longer fashionable, they may be replaced by another item, of identical function but more topical form. Swift obsolescence whilst indefensible, or impossible, in earlier scarcity economies is a natural corollary of technological culture.

Within this process, there are relative time scales of use and consumption. A paper napkin, a suit, a chair or an automobile are, variously, single and multiple use items with possible identical replacement. A building and a painting may be respectively unique and irreplaceable. The latter have different time scales of

'consumption', but the terms of style change still limit them to more or less given periods of currency. How long does an art work remain viable – before it is 'museumized' into a different category? What is the status of the original with facsimile multi-color reproduction? Most of Europe's main cathedrals, if destroyed, may now be reconstructed from their detailed photogrammetric records.

Then there are also the cycles of use and re-use of materials. In creating or producing we, in effect, only re-arrange some local material resource in a quite temporal sense. The metals in a cigarette lighter today may be, variously, within a month or a year, part of an auto, a lipstick case or an orbiting satellite. Such accelerated turnover of materials in manufacture underlines the relative temporality of all 'permanent' artifacts.

The capacity of the industrial process to replicate exactly by machine process, not only new products, but also, and with equal success, old products from earlier traditions, is a quality which has bothered aesthetes from the onset of the Industrial Revolution. They have tried to overcome this, mainly, by restricting the scope of machine process through various idea systems – like 'beauty as the promise of function', 'truth to materials', 'form follows function', etc. The loose amalgam of such ideas is often called the 'machine aesthetic'. Although claiming moral relevance this remains a 'visual' aesthetic criterion, dependent on taste. When new materials may be synthesized with any particular 'truth', surface, texture or performance characteristics required, and when their strengths and functions are at the molecular level and quite subvisible, such criteria are no more moral or true than any other *stylistic* preference.

Generalizing broadly on this aspect of the difference between the physical use-function and the symbolic status-function of cultural objects, one may indicate two associated trends. On the one hand, the swift growth of the museum, devoted to the permanent preservation of cultural artifacts of past and present; and, on the other, the corresponding trend towards more expendable artifacts in the present environment. We seem to reconstruct and 'permanentize' the past as swiftly as we move forward into a more materially 'ephemeral' present and future.

Linking these two trends is an interesting preoccupation with the 'image of permanence past' which is evinced in various modes. For example, in fine art, sheer size as substitute monumentality lends an aura of permanence, or the expendable 'junk trouvé' is immortalized in bronze. Time-stopping, as in Segal's figure groups or Kienholz's full-size replica of 'The Beanery', shares a certain affinity with reconstructed Williamsburg. In the general media-continuum, the past vies with the present and future for the most lavish treatment. *Life* magazine covers the *Bible*; the movie spectacular, 'Genesis', and a European 'son et lumière', or Disneyland or Freedomland, USA, you have, '. . . a chance to live through those past moments that made our nation(s) great. See Old Chicago burn down – every twenty minutes – even help put out the fire! Visit the Civil War, and escape narrowly as the blue and gray shells just miss your wagon!'

The replication of 'permanence past' may be seen to operate in a variety of ways. Often the more ephemeral the product, e.g. fashion, cosmetics, etc., the more its symbolic context is 'ennobled by time' and by the appropriate

mythological or antique image. The Venus de Milo, the Parthenon, the eighteenth century as the 'Age of Elegance' are used in a manner which differs from simpler Victorian eclecticism, but depends on a reliable grammar of common symbols to evoke responses of 'dignity, permanence and worth'.

The 'Plastic Parthenon' is a metaphorical question about the ikonic function of sacred and secular symbols. How may we now regard the expendable replicas of permanent and unique objects? How may we evaluate the ways in which symbolic 'value' may be transferred in different forms, materials and at different size and time scales in quite different media?

The transference of symbolic 'affect' through replication has always worked for sacred objects. Replicas of gods and saints, and of their relics, carried the same magical powers as the originals.[1]

This question of 'value' is one of the central dialogues of our period. We may approach it from another viewpoint in the ikon-making function. Without lengthy discussion we may note that such ikons or 'ideal referent' images were earlier provided by local fine/folk arts, in relation to prevailing religious belief and ritual. Today, as human consciousness is expanded electronically to global inter-linkage, we may see, hear, experience more in a single life-span than ever before.

Such rapid frequency changes in the human condition generate, in turn, a rich profusion of symbolic images which enable man to locate in, learn and adapt to his evolving society. These are now conveyed in the multiple mass-communication channels, within which we may include the marginally differentiated fine and folk arts. The constant re-creation and renewal of such images matches up to the requirements of a highly mobile and plastic environ – providing a replaceable, expendable series of ikons. These referent images of human action and experience take their character from the processes and channels which carry them, requiring no act of faith for their acceptance. Though individually fleeting, they achieve ikonic status by enormous concurrent circulation of typically repeated themes and configurations.

Secular by definition, but mythological in function, such ikons are typically of man (woman) associated with specific symbolic objects and contexts. In an earlier study[2] some major themes were identified, e.g., the mechano-morphic focus on new man/machine complexities: the rituals of the 'big' (movie) screen and the 'telemathic' actuality of the 'little' (TV) screen: the 'star' ikon and the contrastingly 'real' birth-death-life images which flow through the media channels. All the extremities of the human condition, the significant gestures and socio-cultural rhetorics, are encapsulated in a stream of ephemeral ikons, whose only constant in a pragmatic performance-relation is to immediate or projected human experience.

The speed, range and visual immediacy of such images enables them to diffuse swiftly through local cultural tradition – causing equally swift changes in social attitudes and cultural forms. Two recent and extreme examples may be of interest here: one, the influence of a dime store Halloween mask as engendering a new mask-making ritual among primitive Eskimos,[3] and the other, a sociological comment on how the TV Western movie 'has become in Asia the vehicle of an optimistic philosophy of history',[4] in reversing the classic ritual drama in which the good were so often masochistically defeated.

This interpenetration, rapid diffusion and replication is most evident in the position of fine art in the new continuum. Transference through various modes changes both form and content – the new image can no longer be judged in the previous canon. The book, the film of the book, the book of the film, the musical of the film, the book, the TV or comic strip version of the musical – or however the cycle may run – is, at each stage, a transmutation which alters subtly the original communication. These transformative changes and diffusions occur with increasing rapidity. Now, in the arts, an *avant-garde* may only be *avant* until the next TV news broadcast or issue of '*Time/Life/Espresso*'. Not only pop but op, camp and super-camp styles and 'sub-styles' have an increasingly immediate circulation, acceptance and 'usage' whose feedback directly influences their evolution. We might formally say that they become 'academic' almost as they emerge, but this notion of academy versus *avant-garde* elites is no longer tenable, and may take its place with the alienated artist and other myths.

The position seems more clearly one in which the fine arts as institution may no longer be accorded the prime role in conveying the myths or defining the edge of innovation in society. The visionary 'poetry' of technology or its 'symphonic' equivalent is as likely to be found on TV, or in the annual report of an aerospace company, as in the book, art gallery or concert hall. The arts, as traditionally regarded, are no longer a '*canonical*' form of communication. Their canonizing elites and critical audiences are only one sector of a network of ingroups who variously award an Oscar, Golden Disc or Prix de Venise to their choices.

Such comment on fine art as institution in no way denigrates the personally innovative role of the artist. At best, in presently destroying the formal divisions between art forms, and in their now casual moves from one expressive medium to another, individual artists demonstrate new attitudes towards art and life. Theirs is, '. . . in effect, a denial of specialization by an insistence on the fusion of all arts but one . . . an erasure of all boundaries between arts and experience'.[5] Various intuitive jumps in art may anticipate not only new institutional art forms, but also new social possibilities, e.g., Duchamp's isolation of *choice* as the status giving, creative gesture; the development of works involving the spectator in creative interaction.[6] These presage electronic advances towards a more directly participative form of society, e.g., computerized voting, TV forums, polls, etc.

As the apparatus of cultural diffusion becomes increasingly technological, its 'products' became less viewable as discrete, individual events, but rather more as related elements in a continuous contextual flow, i.e., the book-novel as compared to TV. The artwork, as, for example, in Rauschenberg-type 'Combines', moves toward a continuous format, juxtaposing 'still' images with live radio and TV sets in the same piece, which characteristically spill out of the frame into the general environment.

The future of art seems no longer to lie with the creation of enduring masterworks but with defining alternative cultural strategies, through series of communicative gestures in multi-media forms. As art and non-art become interchangeable, and the masterwork may only be a reel of punched or magnetized tape, the artist defines art less through any intrinsic value of art object than by furnishing new conceptualities of life style and orientation. Generally, as the

new cultural continuum underlines the expendability of the material artifact, life is defined as art – as the only contrastingly permanent and continuously unique experience.

[1] e.g., after Buddha died in the fifth century, his body relics were divided up again and again, but there were still not enough remains to supply all the shrines in the land – so an elaborate system of 'reminders' was set up. A 'reminder' was a shrine that contained no actual relics – but was an exact replica of one which did. There are many such traditions in which the image or replica of a sacred relic was no more than a 'reminder', but also carried the same magical power as the original.

[2] John McHale, 'The Expendable Ikon 1 and 2', *Architectural Design* (London), Feb./March 1959. See also McHale 'The Fine Arts and Mass Media', *Cambridge Opinion* (Cambridge), no. 17.

[3] Sarkis Atamian, 'The Anaktuvuk Mask and Cultural Innovation', *Science*, March 1966, no. 3716.

[4] Lewis Feuer, 'A Critical Evaluation', *New Politics*, Spring, 1963.

[5] Daniel Bell, 'The Disjunction of Cultural and Social Culture', *Daedalus*, Winter, 1965.

[6] Lawrence Alloway, L'Intervention du Spectateur', *L'Architecture d'Aujourd'hui*, July 1956.

Dotzero Magazine, *Spring 1967*

Pop Art and Non-Pop Art
Robert Rosenblum

So sensitive are the art world's antennae to the symptoms of historical change that, in 1962, when some New York galleries began to exhibit pictures of vulgar subject matter, a new movement, Pop Art, was instantly diagnosed and the mindless polemics began. As usual, the art in question was seldom looked at very closely and questions of definition and discrimination were ignored. Instead, things were quickly lumped together into a movement which called for wholesale approval or rejection. Presumably, one had to take sides, and various critics were considered to be either vigorously for or against it. But what was 'it'? Considering that 'it' was equated with viewpoints as divergent as those of Barry Goldwater and Terry Southern, one suspected that less violent politicking and more temperate thinking and seeing were in order. In fact, the term Pop Art soon blanketed a host of artists whose styles, viewpoints and quality could hardly have been more unlike. When one insisted that names be named, things got foggier. Were Rivers, Rauschenberg, Johns Pop artists? Well, yes and no. And what about Marisol, George Segal, Peter Saul? Well, maybe. But arguments, without names and definitions, continued.

If some common denominator was felt to run through all these artists thoughtlessly bracketed together, it was probably a question of subject matter. But here was an odd turn of aesthetic events. How, after all the formalist experience of our century, could a new kind of art be defined on this basis alone, and didn't this give rise to contradictions? If admirers of de Kooning usually scorned Andy Warhol, hadn't both artists painted Marilyn Monroe? And were Warhol's Coca-Cola bottles really to be mentioned in the same breath as George Segal's or Rauschenberg's? Using iconographical criteria, Pop Art produced illogical groupings, but logic never seemed to bother the art-political parties that insisted on condemning or praising Pop Art without saying what it was. Writers who could never have paired two 1930s' artists of the urban scene, Reginald Marsh and Stuart Davis, because their pictures looked so different, had no trouble pairing new artists who had in common only the fact that, on occasion, they depicted George Washington, dollar bills, or sandwiches.

If Pop Art is to mean anything at all, it must have something to do not only with *what* is painted, but also with the *way* it is painted; otherwise, Manet's ale

bottles, Van Gogh's flags, and Balla's automobiles would qualify as Pop Art. The authentic Pop artist offers a coincidence of style and subject, that is, he represents mass-produced images and objects by using a style which is also based upon the visual vocabulary of mass production. With such a criterion, the number of artists properly aligned with the movement dwindles rapidly. Thus, when Rivers and Rauschenberg introduce fictive or real cigarette wrappers and news photos into their canvases, they may be treading upon the imagery of Pop Art but in no way touching upon the more fundamental issue of style. Painting as they do with techniques dependent on de Kooning's dedication to virtuoso brushwork and personal facture, they cling to pictorial formulae of the 1950s that are, in fact, largely rejected by the younger artists of the 1960s. Even some of these still offer a hybrid mixture of Pop subject and non-Pop style, as in the case of Peter Saul, who fuses Donald Duck and TV commercials with Gorky; or Wayne Thiebaud, who arranges cafeteria still-lifes under a creamy impasto of pastel sweetness derived from Diebenkorn. And in the case of the recent work of Jasper Johns, who may have fathered Pop painting in his early flags and Pop sculpture in his ale cans, there is the curious phenomenon of increasingly wide discrepancy between the geometrically lucid objects represented and the abstract painterly milieu that clouds them.

In terms of definition, and not necessarily of quality, the real Pop artist not only likes the fact of his commonplace objects, but more important, exults in their commonplace look, which is no longer viewed through the blurred, kaleidoscopic lenses of Abstract-Expressionism, but through magnifying glasses of factory precision. When Roy Lichtenstein paints enlarged Ben-Day dots, raw primary colors, and printer's ink contours inspired by the crassest techniques of commercial illustration, he is exploring a pictorial vocabulary that would efface the handicraft refinements of chromatic nuance, calligraphic brushwork, and swift gesture pursued in the 1950s. When Andy Warhol claims he likes monotony, and proceeds to demonstrate this by painting ten times twenty cans of Campbell's soup, he uses the potential freshness of overt tedium as an assault upon the proven staleness of the de Kooning epigones' inherited compositional complexity. When James Rosenquist becomes infatuated with the color of Franco-American spaghetti or a slick-magazine photograph of a Florida orange, he employs these bilious commercial hues as tonics to the thinning blood of chromatic preciosity among belated admirers of Guston or Rothko. And when Robert Indiana salutes the heraldic symmetry, the cold and evenly sprayed colors of road signs, he is similarly opposing the academy of second-hand sensibility that inevitably followed the crushing authority of the greatest Abstract-Expressionists.

Thus, artists like Lichtenstein, Warhol, Rosenquist, Indiana, Wesselmann, the recent Oldenburg (but not Rivers, Rauschenberg, Johns, Dine, Thiebaud, Marisol) all share a style that would stem the flow of second-generation adherents to the styles of the American old masters of the 1950s. It is no accident that most pictorial values affirmed by the older generation have been denied by the newer one. A late Romantic imagery referring to remote myth and sublime nature is replaced by machine-made objects from ugly urban environments. Gently stained or shaggily encrusted brushstrokes are negated by an insistence upon hygienic, impersonal surfaces that mimic the commercial techniques in

which several Pop artists were, in fact, professionally trained (Rosenquist, as a billboard artist; Warhol, as a fashion illustrator). Structures of shifting, organic vitality are challenged by regularized patterns of predictable, mass-produced symmetry. Colors of unduplicable subtlety are obliterated by the standardized harshness of printer's red, yellow and blue.

This historical pattern of rejection is familiar. One thinks particularly of the Post-Impressionist generation, when an artist like Seurat controverted Impressionism through an almost mechanized system of brushstrokes, colors, shapes, contours and expressions, often inspired by such 1880s' Pop imagery as fashion plates and posters. In the case of the 1960s' Pop artists, this rebellion against the parental generation carried with it an espousal, both conscious and unconscious, of the grandparental one. In fact, any number of analogies can be made between the style and subject of Pop artists and of those modern masters active between the wars. The purist, machine-oriented shapes and imagery of Léger, Ozenfant, Le Corbusier, and De Stijl are often revived in the current enthusiasm for poster-clean edges, surfaces and colors (Lichtenstein, for example, provides many parallels to Léger's industrial images of the 1920s and has twice paraphrased Mondrian's black rectilinear armatures and primary hues). More particularly, American art before Abstract-Expressionism has begun to strike familiar chords, so that artists like Charles Demuth, Joseph Stella, Stuart Davis and the newly resuscitated Gerald Murphy all take on new historical contours as predecessors, when considered in the light of the 1960s. (Davis's Cubist Lucky Strike cigarette wrapper of 1921 suddenly becomes a prototype for Warhol's flattened Campbell's Soup can; Stella's 'Brooklyn Bridge' and Demuth's 'I Saw the Figure Five in Gold' are explicitly restated by Indiana; Niles Spencer's and Ralston Crawford's immaculate cityscapes and highways are re-echoed in Allan d'Arcangelo's windshield views.) Even Edward Hopper, whose 1964 retrospective occurred at a time of maximum receptivity (in 1955, he might have looked merely provincial), has taken on the stature of a major pictorial ancestor. His poignant, American-scene sentiment of the 1930s and 1940s survives not only in those inert, mummified plaster figures of George Segal who suffocate amid the ugliness of coke machines and neon signs, but also in the poker-faced exploitation by anti-sentimental Pop artists of the anaesthetizing blankness and sterility of a commercial America. And the time may soon come too, when the WPA mural style of the 1930s will look like a respectable grandparent to Rosenquist's public billboard imagery of giant urban fragments.

If the most consistent Pop artists can be located in the heretic position of refusing to believe in those aesthetic values of the 1950s which, with the irony of history, have suddenly become equated with venerable humanist traditions rather than with chimpanzee scrawls, are they, in fact, so singular in their rebellion? The most vigorous abstract art of the last five years has also stood in this relation to the oppressive grandeur of de Kooning, Pollock, Kline, Guston, Rothko, Still and Newman, and soon the cleavage between Pop art and non-Pop Art (solely an iconographical, not a stylistic, distinction) will no longer seem real. So obtrusive was the subject matter of Lichtenstein's or Warhol's first Pop paintings that spectators found it impossible to see the abstract forest for the vulgar trees. Anybody, we heard, could copy a comic strip or a soup can, the implication being that, as in the case of criticism directed against Caravaggio

or Courbet, the Pop artist dumbly copied ugly reality without enhancing it by traditional pictorial idealizations. Yet disarming subject matter has a way of receding so rapidly that it becomes well-nigh invisible. When first exhibited, the early flags of Jasper Johns looked like such unadulterated replications of the Stars and Stripes that most spectators dismissed them as jokes of a Dadaist trickster. Today, within a decade of their creation, the same flags look like old-master paintings, with quivering, exquisitely wrought paint surfaces not unlike Guston's, and with formal distinctions that permit us to talk casually about Johns's white flags, grey flags, or flags on orange grounds just as we might talk about Matisse's blue, red, or green still-lifes. In the same way, the initially unsettling imagery of Pop Art will quickly be dispelled by the numbing effects of iconographical familiarity and ephemeral or enduring pictorial values will become explicit. Then, one hopes, the drastic qualitative differences among Pop artists should become clear even to those polemicists who think all Pop Art is either good, bad, or irrelevant.

Already the gulf between Pop and abstract art is far from unbridgeable, and it has become easy to admire simultaneously, without shifting visual or qualitative gears, the finest abstract artists, like Stella and Noland, and the finest Pop artists, like Lichtenstein. The development of some of the Pop artists themselves indicates that this boundary between Pop and abstract art is an illusory one. Thus, Indiana began as a hard-edged abstractionist in the vein of Ellsworth Kelly and Leon Polk Smith. That he then introduced highway words like E A T or U S A 66 into his emblematic geometries should not obscure the fact that his pictures are still essentially allied to Kelly and Smith, who, for purposes of art-political argument, would be forced to run on another ticket. And some of the recent landscapes of Lichtenstein, if taken out of context, might even be mistaken for chromatic abstractions or new optical paintings. This party-split between Pop and non-Pop Art – the result of argumentative factions and rapid phrase-makers – is no more real than the line one might draw between, say, the abstract work of Léger and Stuart Davis and the work in which their urban subject matter is still clearly legible. Pop imagery may be momentarily fascinating for journalists and would-be cultural historians, but it should not be forgotten that the most inventive Pop artists share with their abstract contemporaries a sensibility to bold magnifications of simple, regularized forms – rows of dots, stripes, chevrons, concentric circles; to taut, brushless surfaces that often reject traditional oil techniques in favor of new industrial media of metallic, plastic, enamel quality; to expansive areas of flat, unmodulated color. In this light, the boundaries between Pop and abstract art keep fading. Al Held's giant paintings recall abstract billboards; Krushenick's blown-up, primary-hued patterns look like image-less comic strips; Dan Flavin's pure constructions of fluorescent light tubes smack of New York subways and shop windows. Art is never as pure or impure as aesthetic categories would make it. Who would want to separate Mondrian's 'Broadway Boogie-Woogie' from its urban inspiration? Who would want to ignore the geometric rightness of Hopper's realist wastelands? For the time being, though, we shall go on hearing wearisome defences of and attacks upon some vague domain called Pop Art, a political slogan that can only postpone the responsibility of looking at, defining, and evaluating individual works by individual artists.

From Art and Literature 5, *Summer 1964*

Statements by artists

Derek Boshier
Richard Smith

Boshier's paintings are, in part, social statements that can be as anonymous as an editorial. References are particularized ('Sharpsville', 'Gagarin', '50 megaton bomb') not big white (or big black) universals. Events are out of the headlines before the paint dries. All the elements in the paintings are taken from material in a printed format, nothing 'from life'. This reflects the method by which we acquire facts in these post information-explosion days. The paintings sometimes take the form of something else – an envelope, a jigsaw puzzle, a snooker table – so that the paint area is basically an object. These objects gather extraneous information. An envelope carried about serves many purposes: it collects telephone numbers, maps of how to get to places, drawings of and for things – rather like a table littered with consciously or casually collected expend-ibilia in no readable sequence. There is an equality of emphasis on every element with no particular clue to reading left to right, top to bottom or inside out. The elements have the appearance of being selected for a somewhat oblique appro-priateness rather than purely visual interest, though they often fill both func-tions. They are painted deadpan with the paint surface rather tough and battered, lacking felicity. The separate objects are similar as pieces of a jigsaw puzzle in scale. They are distributed in a random way, some float, some snap together, some overlap, some appear in think-balloons, some are reversed-newsprint images transferred to patches of paint – Gagarin's Mona Lisa smile, a model-girl hip swinging forward.

Some of the themes are recurring like Americanization. Stars and stripes eat into an 'England's Glory' matchbox, or a Cuban flag; the Union Jack is cornered by two Pepsi-Cola bottle tops. Whether this Americanization is welcomed, deplored or just accepted is left in the air. Also in the air are the space subjects he tackles. The interest is not, it appears, to glorify modern technology. The fact that there is a space race is shown some concern: the space heroes are important but other heroes get equal billing in the cosmos. Boshier echoes Caroline Kennedy's question to John Glenn, 'Where's the monkey?' No monkey but Abe Lincoln, Nelson and K. and K. and even cosier artifacts are out there. An energy breakfast-food spouts rockets, ready to lift off. They are familiar but also sinister, like finding a Coke bottle in the Gobi desert, or a beer can on the moon. In Boshier's space a redskin might also bite the moon's dust. This space belongs to most everyone but more to superman (supersuperman?) than to the readers of *Galaxy Science Fiction*. With Buddy Holly also in orbit, the elements yaw around a colourful chart even more casually than the NASA public relations department would have us believe.

Boshier's paintings are like Claes Oldenburg's happenings. Photo-death and

Ironworks in one episode of which a DAR-type woman holds up junk objects labelled USA while a drum majorette salutes and a wounded veteran finds it hard to sit down. They are both social comment in mad, comic terms.

Billy Wilder says, 'One thing I dislike more than being taken too lightly is being taken too seriously.'

Ark 32, Journal of the Royal College of Art, Summer 1962

Joe Brainard

Extracts from a diary

Aug. 4 Today went to the Museum of Modern Art to see the mummified remains of the actual asp that Queen Cleopatra used to kill herself with: a most interesting object.

Aug. 5 Today went to the Museum of Modern Art to study Excalibur, with which King Arthur proved his right to Kingship, and to sip coffee in the Museum's sculpture garden. I found the sword to be a most unusual object.

Aug. 6 Today I thought. A rusty old sword and a dead snake? Are they kidding? Where are the real treasures of yesterday?

Aug. 7 Today I went to the Metropolitan Museum of Art to look at the *real* treasures of yesterday. Their major treasures are quite exciting. I found their minor treasures rather unexciting.

Aug. 8 Today I thought seriously about Excalibur and decided it could just as easily have been Prince Valiant's or even Flash Gordon's. I have definitely decided this to be a minor treasure.

Aug. 9 Today I decided that perhaps minor treasures are not so minor after all. So I ran to the Museum of Modern Art to study with a new light the mummified remains of the actual asp that Queen Cleopatra used to kill herself with only to find out that the exhibition had been returned to India. I was most upset so I ran home and read *Sunday After The War* by Henry Miller, of course. I found it a very exciting and major work of writing.

Aug. 10 I want to be alone.

Aug. 11 I spent most of today reading Henry Miller's *Tropic of Cancer*. I discovered it to be even more major than *Sunday After The War*.

Aug. 12 Today being Sunday, and all, I read the *Journal American* comic section. Strange as it might seem for me, I rather enjoyed it. Upon serious study I discovered that Walt Disney is taking over with five big series: 'Uncle Remus', 'Big Red', 'Donald Duck', 'Mickey Mouse', and 'Scamp'. I find 'Scamp' to be the most unusual, and 'Big Red' the most exciting. Ripley's 'Believe It or Not' section stated much to my amazement that a girl in the Fon tribe of Africa is engaged at the age of six to a boy of sixteen, but before they can be married the youth (boy) must work eight years for the bride's father as a plow hand! I found this most stimulating! It's also interesting to note that Sam Francis has

done a painting called 'Big Red'; the same title as Walt Disney's comic series. I've been seriously contemplating the connection with no positive results.

Aug. 13 Today I bought some 'Hy Tone' wide line ruled notebook paper to write on and three rubber faucet washers. I only needed one, but they're so inexpensive and so easy to lose I decided to play it safe. I read today where 'Hy Tone' has become America's most popular school supplies. This is interesting, because I've personally been using them for years. I did a painting called 'Big Red' today, which only confuses the problem. But I must have unconsciously arrived at the title, for the painting is only 8 in. by 10 in. and mostly in different shades of black with green or yellow.

Aug. 14 I painted ten paintings today all called 'Big Red on Hy Tone'. It's interesting to note that three of these are self-portraits, and that one of these three is obviously very major. I decided to destroy the other nine, even though five of these nine might easily be considered minor works. But instead I gave them to Ted, a poet friend of mine who married Sandy Alper: age 19. It's interesting to note that Ted is 27 and that I'm 20. But I've been unable to draw any obvious conclusions other than the fact that my parents were married at an earlier age than Ted's. It would help if I also knew when Sandy's parents were married.

Aug. 15 Today I am truly horribly upset because Marilyn Monroe died, so I went to a matinee B-movie and ate King Corn popcorn. I decided never ever to paint again. The Movie, *Tarzan Gets Married*, I had seen before at an earlier age. But I couldn't remember who he married.

(Jane)

George Brecht
A questionnaire on Pop

1 What is it?
Fencing and dancing. Sports. Hand-in-hand.
2 How do you recognize it?
Traps. Road-markers.
(A nail in the wall is vertical if the wall is horizontal.)
3 What has it to do with us?
Showering cleans dirt off skin.
4 Where does it end?
Four-o-clocks are quieter than alarm clocks, but don't wake you up as easily.
5 How do you recognize a Pop artist on the underground?
Rings linking wheels, amphibians and stones. A nail points to the base of a tower. Time flies between an anvil and a footprint.
(Four of these questions and one of the answers were proposed by Anna Lovell; four of the answers and one of the questions by George Brecht, using the Universal Machine, page 71 of the *Book of the Tumbler on Fire*.)

George Brecht
Event Scores

STOOL

on a white stool

a black-and-white-striped cane

oranges in a paper bag

SAXOPHONE SOLO

● trumpet

G. Brecht
1962

KEYHOLE

through either side

INSTRUCTION

● Turn on a radio.

At the first sound, turn it off.

THREE GAP EVENTS

● missing-letter sign

● between two sounds

● meeting again

To Ray J.
Spring, 1961
G. Brecht

TWO VEHICLE EVENTS

● start

● stop

Summer, 1961

THREE LAMP EVENTS

● on.
off.

● lamp

● off. on.

"It is sure to be dark
if you shut your eyes."(J. Ray)

Summer, 1961

TWO DURATIONS

● red

● green

NO SMOKING EVENT

Arrange to observe a NO SMOKING sign.

● smoking

● no smoking

FIVE EVENTS

● eating with

● between two breaths

● sleep

● wet hand

● several words

POSITION

● an insect nearby

MIRROR

● reflecting

● reflecting

THREE WINDOW EVENTS

opening a closed window

closing an open window

SINK

● on a white sink

toothbrushes

black soap

Jess Collins
A Tricky Cad

One surprisingly curmudgeony Fraternity Sunday in 1953 Tricky Cad scrambled out of Chester Gould's *Dick Tracy*, afterwards to concentrate (undertaking 8 cases) in demon-stration of the hermetic critique lockt up in Art, here Popular. Also here was a bad case of sincerest-form-of-flattery; later, not amusing to the originator.

Given the journalistic-fact, no augmentations were made of text, image, line, punctuation, excepting the underlying addition of paste. Yes: cutting com-pressions, with scissors via maxmister. Mimetic method kept true to material within arbitrary units – by episode, by day, week, month, or full story. During the *tantric* process, correspondences came in a counterpoint of rhymes echoing events of the World, personal events, and predictions of the crime.

Art is somehow getting-to-the-heart-of-it-all. Tricky Cad detected that in every aesthetic-analyst is a lay-anaesthetist, *c* being the speed of light.

(Feb 69)

Jim Dine
interview with G. R. Swenson

What is your attitude to Pop Art?
I don't feel very pure in that respect. I don't deal exclusively with the popular image. I'm more concerned with it as a part of my landscape. I'm sure everyone has always been aware of that landscape, the artistic landscape, the artist's vocabulary, the artist's dictionary.
Does that apply to the Abstract-Expressionists?
I would think so – they have eyes, don't they? I think it's the same landscape only interpreted through another generation's eyes. I don't believe there was a sharp break and this is replacing Abstract-Expressionism. I believe this is the natural course of things. I don't think it is exclusive or that the best painting is being done as a movement. . . . Pop Art is only one facet of my work. More than popular images I'm interested in personal images, in making paintings about my studio, my experience as a painter, about painting itself, about color charts, the palette, about elements of the realistic landscape – but used differently.
The content of a Pollock or a de Kooning is concerned with paint, paint quality, color. Does this tie you to them in theory?
I tie myself to Abstract-Expressionism like fathers and sons. As for your question, no. No, I'm talking about paint, paint quality, color charts and those things objectively, as objects. I work with the vocabulary that I've picked up along the way, the vocabulary of paint application, but also the vocabulary of images.

One doesn't have to be so strict – to say, 'Let's make it like a palette', and that's it. . . . It always felt right to use objects, to talk about that familiarity in the paintings, even before I started painting them, to recognize billboards, the beauty of that stuff. It's not a unique idea – Walker Evans photographed them in 1929. It's just that the landscape around you starts closing in and you've got to stand up to it.

Your paintings look out and still make a statement about art?

Yes, but a statement about art the way someone else talks about new Detroit cars, objectively, as another kind of thing, a subject.

Not as both subject matter and content?

No.

Abstract-Expressionism tended to look in?

Yes.

Is this the difference between your work and theirs?

I don't know what the difference is. Certainly Abstract-Expressionism influenced me, particularly Motherwell. I think he's continually growing and making problems. His paintings meant a lot to me, especially 'Pancho Villa Dead or Alive' and the 'Je t'aime' paintings, although it now seems a bit strange to write it in French. Still, the climate Motherwell has to live in is rarer and he has to do that for his style, the idea of style, this hothouse flower – but really that's all frivolities compared to the real structures he sets up.

Style as a conscious striving for individuality?

I suppose so. I'm only interested in style, as content at least, if it makes the picture work. That's a terrible trap – for people to want to *have style*. If you've got style, that means you've only got one way to go, I figure; but if you've got art, if you've got it in your hands going for you, style is only an element you need to use every once in a while. The thing that really pulls a painting out is you, if you are strong, if it's your idea you're wanting to say – then there's no need to worry about style.

Do you feel related to Dada?

Not so much, although I never saw any reason to laugh at that stuff. It seemed the most natural thing in the world to have that fur-lined teacup.

It wasn't anti-art?

No, not at all. I thought it was just a beautiful object; it wasn't anti-art at all. Some of my friends used to say I was square because I was interested in art. Jan van Eyck and Rogier van der Weyden are great favorites of mine. I'm interested in the particular way they manipulate space. With Northern painting there's more than just seeing it. . . . And I love the eccentricity of Edward Hopper, the way he puts skies in. For me he's more exciting than Magritte as a Surrealist. He is also like a Pop artist – gas stations and Sunday mornings and rundown streets, without making it Social Realism. . . . It seems to me that those who like Hopper would be involved with Pop somehow. Or those who like Arthur Dove – those paintings of sounds, fog horns, the circle ideas that were meant to be other things. There's a real awareness of things, an outward awareness. . . .

Actually I'm interested in the problem and not in solutions. I think there are certain Pop artists who are interested mainly in solutions. I paint about the problems of how to make a picture work, the problems of seeing, of making

people aware without handing it to them on a silver platter. The viewer goes to it and is held back slightly from being able to get the whole picture; he has to work a little to deal with the problems – old artistic problems, that particular mystery that goes on in painting.

You once said that your audience tends to concentrate too much on the subject matter in your work.

They can't get past it? Well, that's their tough luck. I was talking about the big audience. The smaller audience gets through it and lives with it and deals with it, just like things coming up all day – in a shooting gallery, you know, things keep popping up to shoot at. And some guys can't shoot, that's all; they can only stand there with a gun in their hands. I'm interested in shooting and knocking them all down – seeing everything. . . . But the statement about bridging the gap between art and life is, I think, a very nice metaphor or image, if that's what you'd call it, but I don't believe it. Everybody's using it now. I think it misleads. It's like the magic step, like – 'Oh, that's beautiful, it bridges art and life.' Well, that's not so. If you can make it in life – and I don't say that's easy to do – then you can make it with art; but even then that's just like saying if you make it with life then you can make it as a race-car driver. That's assuming art and life can be the same thing, those two poles. I make art. Other people make other things. There's art and there's life. I think life comes to art but if the object is used, then people say the object is used to bridge that gap – it's crazy. The object is used to make art, just like paint is used to make art.

Does Pop Art serve a social function? Is it a comment?

There are only a handful of people who seem to understand what I'm doing, so I'm certainly not changing the world. People confuse this social business with Pop Art – that it's a comment. Well, if it's art, who cares if it's a comment. If you write some fantastically obscene thing on a wall, that may be an even better comment, but I'm not sure *that's* art. I'm involved with formal elements. You've got to be; I can't help it. But any work of art, if it's successful, is also going to be a comment on what it's about. I'm working on a series of palettes right now. I put down the palette first, then within that palette I can do any- thing – clouds can roll through it, people can walk over it, I can put a hammer in the middle of it. . . . Every time I do something, the whole thing becomes richer; it is another thing added to the landscape. But once I've done something, I'm no longer interested in it as a problem. It just becomes another facet of my work. I'm interested in striving to do something tougher.

From 'What is Pop Art?' Interviews with eight painters (Part I). Gene Swenson, Art News, November 1963

Jim Dine
questions put by Kenneth Koch

Test in Art

I One hour. Answer any 16 questions.

1 What is your favorite color? Circle right answer.
Blue Red Gold Silver Other *FLESH*

2 What was your favorite color when you were a child?
Green Purple Orange Tan Silver Magenta Gold
Red Turquoise

ll of them

3 What are three shapes that you are interested in putting into your work at the present time? Circle correct answers and add others if necessary in the space below.
Hammer Potato Necktie Baseball Eagle-head Mothball Broom Handlebar Cactus Bed Cork

hearts

4 Circle those works in the following list which you now like more than you did in the past. Draw a single line under those you now like less than you did in the past. Answer only for works about which you had definite feelings at both times.

poems

L'Arlésienne White on White The Madonna of the Rocks
Cleopatra's Needle The Spirit of the Dead Watching
Les Saltimbanques The Birth of Venus
The Battle of San Romano Hide and Seek
Le Déjeuner sur l'herbe The Parthenon
Portrait of Gertrude Stein David (Michelangelo)
David (Donatello) Jane Avril at the Moulin Rouge
Andromeda (Rubens) The Music Lesson (Vermeer)
The Land of Cockaigne The Concert (Caravaggio)
Venus (Titian) The Scream (Munch)
Add others below if desired.

won't answer too literary!

Which of the changes you have indicated do you regard as permanent, as definitive? That is, which of the works underlined do you feel sure you will never be able to like as much as you once did? Indicate these by adding two evenly spaced lines to the one you have already drawn under them. For works you feel sure you will always like more than you once did, draw two additional circles around the one you have already.

5 In the following list of writers and composers, are there any whose esthetic aims you consider to be similar to yours? Circle those that apply.

John Cage Sinclair Lewis John Donne Igor Stravinsky
Aleister Crowley Pablo Neruda T. S. Eliot
Jorge Luis Borges Anton Webern Aaron Copland
Leo Tolstoy Allen Ginsberg Arnold Schönberg
Samuel Beckett Robert Frost Edith Wharton
Vladimir Mayakovsky James Joyce Rene Char

HAVE no idea about similar aims but I have loved Borges & mayakovsky

Add here the names of any writers or composers not included in the above list whose esthetic aims you find similar to yours.

LORCA, LENNON-McCARTNEY, JERRY LIEBER

6 Name two or three artists of the past whom you would expect to like your work.

7 Which of the following "movements" in art seem to you to have made the most genuine contributions to art in the past 25 years?
Pop Op Magic Realism Abstract-Expressionism
Hard-Edge Painting

8 In an exhibition which was to represent the greatest achievements in painting of the past 400 years, what ten artists would you feel it most essential to include?

Can't take the chance

9 Would your list of personal favorites among artists differ from the above list in any way? *YES*

10 Give an example of a minimal change you would make in a specific work by another artist so as to make it a work of your own.

11 Which of the following words would you most like to have used about your work by a critic whose opinions you respect? Circle 5-10. Which would you least like to have used about you? Draw a single line through 5-10.

experimental childlike witty versatile refreshing agonizing brittle horsey courageous fraudulent jazzy gutsy stinky rubbery underrated Surreal Cubist (hairy) gallant polite effervescent European twentieth-century twenty-first century Sixtiesish Fortiesish Etruscan effeminate brutal hard cold hot passionate dead (alive) human complex bare necessary new actual phenomenal beautiful cruel base vapid interesting mercenary vulgar expensive cheap (purple) sleepy dirty sexy hard-headed determined swirling rich insane devout

12 Has any critic influenced the way you paint? If so, explain briefly how.

NO

13 Aside from official criticism, are there any isolated remarks people have made which have influenced your work? If possible, give two or three of these remarks here.

N.O. —COULD

14 If you could have your most recent painting placed anywhere you liked, where would you hang it?

iN my house

15 Is there any object now in general use (such as an automobile, fountain pen, bed, etc.) which you would be interested in redesigning? Explain.

TOPCOATS, SUITS, SHOES, VESTS, TIES, SHIRTS, CUFFLINKS, BELTS, ASCOTS, EARRINGS, SWEATBANDS, KNAPSACK, ETC.

16 If you could redesign any building in the world, which one would you choose?

the testor's apartment

17 Imagining that anything is possible, what commission for a work of painting, sculpture or architecture would you like most to be given right now?

I would like all the billboard space between any 2 towns.

18 In the space provided below, draw a hammer, a scissors and a star, or any other three objects that interest you at the present time.

—TRIANGLE
—finger
HOLE

19 If the three objects in the drawing could speak, what do you imagine they would say about this test?

SWELL, UNBELIEVABLE CAN'T STOP!

Jim Dine
Oyvind Fahlström

Three studies for a child's room

1. Is the imprint of a child's hand on a canvas a 'fact' or an 'object'? Is it an 'event'? Is it a 'popular' or 'vulgar' way of painting?

Toaster

If there is a gap between life and that part of life called art there may be a point in making a painting of a sunset by starting from a sunset rather than from paintings of sunsets, as Malraux supposes a painter to do. In that case the painter might even cut a hole in the canvas to incorporate the sunset. This would, in principle, be the standpoint of Jim Dine. In a toaster-painting a toaster can be used and the painting will appear partly toasted, partly burned.

He would, nevertheless, not fool himself by believing that the toaster he used still is 'life'. In his painting 'Lawn-mower' Dine lets the painting (by its proportion and position) mow rather than the person. Art pushes life. But life also pushes; the only place where the canvas is painted is in the area where (the handle of) the lawn-mower touches the canvas. And the lawn-mower has no traces of grass, it has smear-traces of green paint. Art mows art. At most, Dine's work may shorten the distance to that improbable point where one may as well say, 'art and that part of art called life', where there will be no parts, only a whole – a point where civilization, in Freudian terms, would not tend to stimulate and materialize the death-instinct but to enforce life as pleasure. This seems to mean that society would not increase recreation without having anything, including art, to fill it with, but that society would make both work and recreation a pleasure through morals, drugs or genetics. In the meantime the artist continues to act in the gap between life and art, double-dealing, as he has always done, between life as pleasure and life as adaptation to society. This double-dealing has in the last years been brought to a critical point by the New York artists who introduce elements from life and society into their works.

This does not mean that Dine wants to tell us something about society or say something for or against it, even though he, in his latest work, has focused on that primeval unit of society, the family. Just as in his previous works much of his material consists of objects seen as 'extensions and projections of ourselves' (J. W. Kluver), here the room-elements project the *home*.

In the home of Dine's paintings there is little stress laid on beds, stoves and pots and pans. For living and eating there is one room or suite of rooms. For children's play there are four rooms. For cleanliness there are three showers and five bathrooms.

Flesh bathroom. Black bathroom No. 1

2. The equivalence in a painting of all materials and of all ways of representation can be emphasized by tautology. No contradiction can exist between electric light and painted light-beams. Which is most real – the immaterial light from the lamp or the representation of light in exquisite smear-palpability of paint?

Dine often writes on the painting the name of an object represented or present beyond doubt in the painting. Does the impact of this tautology reside in the

demonstration of the obvious (as it has been said about Dine's work)? Or does the redundancy rather stress the subjective convention of our concepts, the absurd frailty of the tie between word and object – the impossibility of reaching any object, be it light or paint, be it in 'life' or in 'art'?

Black bathroom No. 2

3. Poetry will arise neither from overstatement nor from understatement but from superstatement.

This concentration of statement has also been achieved by Jasper Johns. In his first well-known works he imprisons the paint-statement within the outlines of the fact; the flag is a painting and vice versa and so on.

Dine separates, stating paint in one place and fact in another, emphasizing how interchangeable these concepts are. Unlike Rauschenberg, who separates but tends to neutralize all statements through a pattern of relationships and thus achieves a state of total weightlessness of his elements, Dine often compresses the weight of his statement into one massive tautology. In the case of his home-paintings the statement may even be tripled. The room-paintings will hang in a room in the owner's home.

Four rooms. Black bathroom No. 2

4. Concentration implies limitation and this is apparent in many respects. Although one of the pioneers of happenings, Dine does not intend the spectator to participate in his work by manipulating objects, etc. His tools are frozen to immobility, firmly glued and screwed to the canvas. The aesthetic experience of 'Four Rooms' (with armchair) involves only looking, not sitting. His room-paintings are not intended to constitute an 'environment'; they are separate and self-sufficient.

Furniture, protruding tools, etc. do not make up elements of sculpture. Dine occasionally tries to make a sculpture, for example by painting directly on furniture, but he usually ends up by leaving the piece or by fastening it to a canvas. Like a Western gunman Dine prefers to meet the threat of the spectator's eye with his rear covered. His unflat paintings, with pleasant paradox, are flattened cubes (rooms); the washbasin against a patch of black paint becomes a *drawing*, the white of the porcelain acting as a part of the 'paper'.

Shower No. 1, Green shower. Double red bathroom. Toaster

5. Limitations occur within the paintings and form situations involving limits. The various areas correspond to concepts and as one area is followed by another, different consequences arrive for the other elements in the work. Similarly if I go from a child's room to a bathroom, I will be changed by the different situation. In the paintings the influence can always be directed both ways. A different concept or situation will change the toaster or vice versa. The green shower will change into a lamp. This is not a surrealist metamorphosis. Within the unity of the image each element retains its identity and material quality; only the notion of distributing water has been switched over to that of distributing light by a stroke of clean, meaningless madness (reminiscent of the mad connections in 'Wiring . . .'). There is also unity in time; the paintings are not extended into phases of action (if light can be turned on, it is always turned on).

One might be reminded of Duchamp's door that can be open and shut at the same time. But Dine's paradoxical unity seems to be a means, not an end. He is not witty. He invents; he does not ironize. Dine, too, a year ago, made a

door-piece. It consists of three doors, heavily painted in black, lying with slight displacement, one on top of the other, closing each other, opening to nothing. Neither does Dine criticize – the kind of bathroom fixture, by means of which Duchamp made a sensation in 1917, is only hinted at by the paper-roll in Dine's bathroom-paintings.

Flesh bathroom

6. Poetry will arise from monumental directness and clarity – so monumental that the obvious becomes doubtful, 'impossible'. Yet it is there. A toothbrush given the impact of an Egyptian pyramid will make us doubt both. The monumentality still does not mean overstatement; it isn't achieved by making the toothbrush extra big or extra stylized, but by presenting/representing it extra toothbrushy (both in substance and in meaning).

Flesh-tie. Three studies for a child's room

7. Dine makes 'flesh-ties' and 'flesh bathrooms'. By incorporating objects into our lives we leave our traces on them. By leaving smear-traces on objects Dine incorporates them into his art. The traces are the signs of possession, of unity. The trace also stands for the object and thus again is separate from the object. By imprinting one of his children's hands against the canvas (in 'Three Studies For A Child's Room') Dine links to the first painting act, the cave-man's supposed discovery of representation, of painting as an act of exteriorization. Dine's acts are discoveries of incorporation. Both reveal the primeval thrill of seeing sameness in non-identity.

Reprinted from catalogue of Sidney Janis Gallery, February 1963

Oyvind Fahlström
Take Care of the world

1 ART: Consider art as a way of experiencing a fusion of 'pleasure' and 'insight'. Reach this by impurity, or multiplicity of levels, rather than by reduction. (The fallacy of some painting, music, etc.; *satori* by mere reduction. The fewer the factors, the more they have to be 'right', 'ultimate'.)

The importance of bisociation (Koestler). In painting, factual images of erotic or political character, for example, bisociated, within a game-framework, with each other and/or with 'abstract' elements (character-forms) will not exclude but may incite to 'meditational' experiences. These, in turn, do not exclude probing on everyday moral, social levels.

This would equally hold true for theater. In two short plays of mine. *The Strindberg Brothers* and *Hammarskjold on God*, performed in Stockholm, dance-like 'pure' sequences are interlocked by an actual interview with an aged couple on the cost of living and a representation of the Swedish Crown Prince burning himself as a Buddhist monk. An interview with a sex-change case in both documentary and pure sound (yells).

Ultimately, the goal will be to reach 'The un-natural'.

2 GAMES: Seen either as realistic models (not descriptions) of a life-span, of the Cold War balance, of the double-code mechanism to push the bomb button

– or as freely invented rule-structures. Thus it becomes important to stress relations (as opposed to 'free form' where everything can be related to anything so that in principle nothing is related). The necessity of repetition to show that a rule functions – thus the value of space-temporal form and of variable form. The thrill of tension and resolution, of having both conflict and non-conflict (as opposed to 'free form' where in principle everything is equal).

Any concept or quality can be a rule, an invariable. The high notes or yells of the sex-change interviewer in *The Strindberg Brothers* (see section 1 above), replacing and cued to the exact length of her questions, constitute a rule, as well as the form-qualities of a painted, magnetized metal cut-out. The cut-out is an invariable as form, outlook. As long as another element is not superimposed on it, the cut-out will never vary visually, but its meaning will vary depending on its position. Rules oppose and derail subjectivity, loosen the imprinted circuits of the individual.

3 MULTIPLES: Painting, sculpture, etc., today represent the most archaic art medium, depending on feudal patrons who pay exorbitantly for uniqueness and fetish magic: the 'spirit' of the artist as manifested in the traces of his brushwork or at least in his signature (Yves Klein selling air against a signed receipt in 1958).

It is time to incorporate advances in technology to create mass-produced works of art, obtainable by rich or not rich. Works where the artist puts as much quality into the conception and the manufacturer as much quality into the production, as found in the best handmade works of art. The value of variable form: you will never have exactly the same piece as your neighbor. I would like to design an extensive series of puppet games, sold by subscription, in cut-out sheets; or 3-D dolls (BARBIES FOR BURROUGHS project). And robot theatre: elements arrange themselves by computer programming.

4 STYLE: If bisociation and games are essential, style is not. Whether a painting is made in a painterly, in a hard-edge graphic or in a soft photographic manner is of secondary interest, just as documentary, melodramatic and dance-like dimensions can interweave in a play. I am not much involved in formal balance, 'composition' or, in general, art that results in mere decorative coolness (art that functions primarily as rugs, upholstery, wallpaper). Nor am I concerned with any local cute Pop or camp qualities *per se*, be they the thirties, comics, Hollywood, Americana, Parisiana, Scandinavianisms.

5 ESSENTIALS: In order to seem essential to me, a material, content or principle does not only have to attract me 'emotionally', but should concern matters that are common and fundamental to people in our time, and yet be as 'fresh', as untainted by symbolism, as possible. I deplore my incapacity to find out what is going on. To find out what life, the world, is about, in the confusion of propaganda, communications, language, time, etc.

Among the things I am curious about just now: where to find (and make a film of) the life geniuses, individuals who manage to put the highest degree of artistry (creativity, happiness, self-fulfillment) in every phase of their living. What are the relations and possibilities in art-and-technology, new media? Chemical/electrical brain stimulation and ESP. Opera-theater-happenings-dance. Europe-Russia (? China); isolate and incite the USA. Concerts (dance, music, lectures, etc. of the Cage-Rauschenberg type) in Russia. 'Political'

performances in China – the nonparadox of presenting the official outlook with the aesthetic conventions of New York performances, and vice versa.

6 RISK REFORMS: Attitude to society: not to take any of the existing systems for granted (capitalist, moderately socialized or thoroughly socialized). Refuse to presume that 'sharpness' of the opposite systems will mellow into a worthwhile in-between. Discuss and otherwise influence the authorities towards trying out certain new concepts.

The reforms mentioned below are of course not proposed with the huge, rigid warfare states like China, Russia or the USA in mind, but rather small welfare states like Sweden, groping for goals. The reforms are all more or less risky – which should be considered an asset; they will appear not as another series of regulations, but as events that might somewhat shake the chronic boredom of well-fed aimlessness and shove the country in question into international prominence.

7 ARMS: Complete and unilateral disarmament (apart from a small permanent force submitted to the United Nations). Small countries will soon have to make the choice between this and acquiring nuclear weaponry anyway. The risk of disarming is minimal, as only other small countries now (or even later with nuclear arms) can be deterred. This step would, among other things, release tax-income, man- and brainpower for other reforms.

8 TERROR: Instead of prisons, create forcibly secluded, but large very complete (both sexes) and very 'good' communities (everyday Clubs Méditerranés) where offenders could gradually find satisfying ways of living without offending society. The risk would of course be the suffering of victims, with potential offenders no longer deterred (a '10th Victim' situation?).

Value is having to find out what makes a 'good' community; corralling the discontented part of the population; finding out if punishment deters; finding out if a major part of the population will turn criminal in order to be taken care of in a closed community rather than live in the open one.

9 UTILITIES: Free basic food, transportation and housing paid through taxes. Risk: 'No one will care to work.' Value: true equality – everyone paying taxes according to what he or she earns. As opposed to the present token equality, where an apple costs differently to each buyer.

10 PROFITS: Steer away from redundant, self-revolving production (five to ten different companies producing the same detergent – competition mainly on the level of marketing gimmicks) by letting government agencies assign projects to the two or three most qualified bidders (like military contracts plus limited competition). What to be produced thus will be decided centrally by the country; how to produce, by the manufacturer; and how to divide the profits, by manufacturers and workers. An attempt to combine planning and incentive. The risk of less variety and lack of incentive outweighed by the chance to diminish the alienation in ordinary blindfolded work; of replacing publicity with information; and primarily to divert brain- and manpower to neglected fields like housing, pleasure, education, etc.

11 POLITICS: Government by experts and administrators. Delegate the shaping of policies and the control of experts to a body of 'jurors' replaced automatically at given intervals, chosen from outstanding persons in all fields. Abolish politicians, parties, voting. Perhaps have referendums. Voting and

active participation on regional, labor and such levels where participation is concrete and comprehensible.

Find and channel some geniuses into creative administrative and diplomatic work, instead of excluding them from such leadership. Risk: nothing can be worse than the power games on local and global levels between smalltime politicians whose sole expertise lies in acquiring and keeping power.

12 PLEASURE: 'The ecstatic society.' Research and planning in order to develop and mass produce 'art' as well as 'entertainment' and drugs for greater sensory experiences and ego-insight. New concepts for concert, theater and exhibition buildings; but first of all pleasure houses for meditation, dance, fun, games and sexual relations (cf. the 'psychedelic discothèque' on the West Coast, and the multiscreen discothèques of Murray the K and Andy Warhol). Utilize teleprinter, closed-circuit TV, computers, etc., to arrange contacts, sexual and other.

Incite to creative living, but also approve 'passive' pleasures by means of new drugs – good drugs, i.e. strong and harmless, instead of perpetuating the use of our clumsy, inherited drugs, liquors, stimulants. Refine the activating (consciousness-expanding) new drugs. And develop euthanasia drugs to make dying easy, fast and irrevocable for terminal cases and prospective suiciders.

The risk of people not caring to work any more would be eliminated by the fact that people would have superficial benefits attractive enough to make it worthwhile to work in order to obtain them.

Oyvind Fahlström
Robert Rauschenberg

The logical or illogical relationship between one thing and another is no longer a gratifying subject to the artist as the awareness grows that even in his most devastating or heroic moment he is part of the density of an uncensored continuum that neither begins with nor ends with any decision or action of his.

I recognize the acceptance of this fact in the work of Fahlström whose characters in a plot of painting can take any shape, responding to the openly established dramatics of the picture map. They are free to operate, cooperate, incorporate, collide or collapse, always responding locally without a tasteful sense of the compositional four sides of the canvas, which seems to serve only as the sheet of paper needed to record any information. The technique is what happens as well as happening, supporting its own identity and individual quality, but remaining as vulnerable as the sign it defines. One can be aware in a painter like Fahlström of the probable frustration he experiences in not being able to extend the scale of his signs to invisibility and continue. The use of the familiar is obscure, the use of the exotic is familiar. Neither sacrifices completely its origin, but the mind has to travel to follow just as the eye has to change to focus. In the end a viewed painting has been an invitation not a command, but painted in such a way that it cannot be seen unless the rules of the concept are

admitted. There is no separation between the literal and literary. No competition exists between the physical character of the materials and the function of the signs. Both remain lively impure.

Art and Literature 3, *Autumn-Winter 1964*

Oyvind Fahlström
Suzi Gablik

An anecdote tells how Gainsborough once exclaimed of Reynolds, 'Damn him, how various he is!' If we take imagination to mean the power of putting reality to one's own uses (Caligula, for example, made his horse a senator for life), in the case of Fahlström it might be that we would ask, has something that ought to be in the picture escaped our attention?

The world, says Wittgenstein, is everything that is the case. Begin anywhere with a chair leaning on the world. Include the ability to proceed; references to a rope being cut, the horizon, E S P or Krazy Kat; bottlenecks or a trapdoor; the life of Mao Tse-tung as a good horse opera. An earthquake sets the entire globe to oscillating like a bell for weeks. Time is merely a device to keep everything from happening at once. When our intentions go down to zero, suddenly then we notice that the world is magical (Cage).

Like Joyce, Fahlström is the 'bringer of plurabilities'. Joyce, like Fahlström, had the original labyrinth in mind. *Ulysses* emerges out of *A Portrait of the Artist As a Young Man* and *Dubliners, Finnegans Wake,* that 'cycological' novel, is a further development of *Ulysses.* It is all part of an elaborate design, as with Fahlström, a complex system of changing relations.

In mathematics and poetry there exists the property of expansiveness: the method for expanding any function is by using derivative functions.

Analyses of Fahlström's paintings reveal a detailed structure of analogies, parallels or correspondences. In the cyclical recurrence of elements everything depends on an invisible principle, on patterns of relationship, on the connection of part with part. And one can be aware in a painter like Fahlström, says Rauschenberg, of the probable frustration he experiences in not being able to extend the scale of his signs to invisibility and continue.

Fahlström never studied painting, but began his career as a writer. As a journalist he published articles about comic strips as a medium between the short story and the movies. Why not study the comic strips as moral landscapes expressing local impulse and motive? (McLuhan.)

He also wrote concrete poetry, using language freely and nonsymbolically to break down habitual structures of grammar. Withholding syntactical connections achieved a richer implication: total experience rather than a rational, sequential one only. He still loves making inventories of words, like Rabelais and Joyce, cataloguing by vowels of onomatopoeic sounds from comic strips or bird-watcher's manuals. These become synthesized into a kind of monster language, or dialect, created as if by electronic means.

Extract from 'Fahlström: A place for everything'. Suzi Gablik, Art News, *October 1966*

Richard Hamilton

An exposition of $he

In an old Marx Bros. film (and this is the only memory I have of it) Groucho utters the phrase 'Women in the home' and the words have such power that he is overcome, he breaks the plot to deliver a long monologue directed straight at the camera. Sentiment is poured towards the audience and is puddled along with devastating leers and innuendos. This vague recollection of Groucho was revived when I began to consider the frequency with which advertising men are faced with the problem of projecting the w.i.t.h. image. 'Women in the home' was a possible title for '$he', which is a sieved reflection of the ad man's paraphrase of the consumer's dream (see pp. 74–75).

Art's Woman in the fifties was anachronistic – as close to us as a smell in the drain; bloated, pink-crutched, pin-headed and lecherous; remote from the cool woman image outside fine art. There she is truly sensual but she acts her sexuality and the performance is full of wit. Although the most precious of adornments, she is often treated as just a styling accessory. The worst thing that can happen to a girl, according to the ads, is that she should fail to be exquisitely at ease in her appliance setting – the setting that now does much to establish our attitude to woman in the way that her clothes alone used to. Sex is everywhere, symbolized in the glamour of mass-produced luxury – the interplay of fleshy plastic and smooth, fleshier metal.

This relationship of woman and appliance is a fundamental theme of our culture; as obsessive and archetypal as the Western movie gun duel. 1–6 reveal some basic features. 1 The caress. Characteristic posture: inclination towards the appliance in a gesture of affectionate genuflexion. Possessive but also bestowing. She offers the delights of the appliance along with her other considerable attributes. A job, like Dad's. Mum too has a uniform, discreetly floral apron equals pin stripe or grey flannel. Bell provides the communications system to plug her into the home industry network. 3 Empire builder. Stockpiled cake mixes filed for easy reference: she commands the lot. 4 and 5 Is it *me?* The appliance is 'designed with you in mind' – but are you the girl next door in a party hat or the svelte job that goes with the 'Sheer Look'. Within a few years the Frigidaire image of itself can change quite a bit. 6 The source of the overall layout of '$he' is this brilliant high shot of the cornucopic refrigerator – a view that uses a photographic convention from the auto ads. The cadillac pink colour of this particular model of RCA Whirlpool's fridge/freezer was adopted with enthusiasm for the painting. The woman is an interesting deviation from the norm – matronly, if not downright motherly – she contributed little.

In spite of their contrived sophistication, my paintings are, for me, curiously ingenuous (like Marilyn Monroe). At first sight it is easy to mistake their intention as satirical. It looks as though – and some of the references to the first six illustrations may seem to confirm the view – the painting is a sardonic comment on our society. But I would like to think of my purpose as a search for what is epic in everyday objects and everyday attitudes. Irony has no place in it except in so far as irony is part of the ad man's repertoire. My woman may seem exotic but, thanks to mass reproduction and wide distribution, she has become

1

2

3

4

6

MAKES EVERY
CORNER COUNT!

5

7

PICKS UP MORE
DIRT...FASTER!

New Westinghouse
Speed Cleaner!

9

10

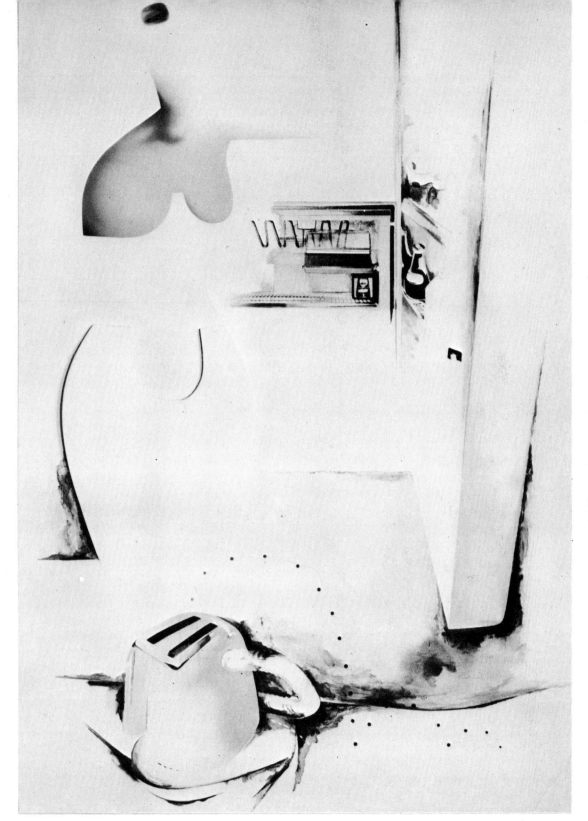

RICHARD HAMILTON
'Component parts' of $he.
(see pp. 73–76)

RICHARD HAMILTON $he 1958–
61 Oil cellulose, collage on panel,
48×32 ins

domesticated. She owes much to 7, an *Esquire* photograph of 'starlet' (?) Vikky Dougan in a dress concocted by her publicist Milton Weiss. Miss Dougan specializes in modelling backless dresses and bathing costumes. The only pin-up I can remember making a greater impact in art circles was Brigitte Bardot spread piecemeal through *Reveille* (October 1957) – the gimmick of make-your own-lifesize-BB gave it an understanding edge. I first saw Miss Dougan decorating a wall in the Smithson's home. I gained my copy from a student's pinboard in the Interior Design Department of the Royal College. Lawrence Alloway gave me the data on her – the photograph had impressed him sufficiently to regard it as a fileworthy document. It turned up again recently as one of a group of pin-ups in a painting by Peter Phillips.

Miss Dougan's back, although too good to miss, was not quite what was needed; a rotation of the figure gave the best of both worlds plus. The shoulders and breasts, lovingly air-brushed in cellulose paint, were done with one eye on 7 the other on the Petty[1] girl. Her breasts can be seen in two ways, one reading provides a more sumptuous profusion of flesh than the other. The cleavage on the backside suggested an apron effect in negative; this was nice – an apron, however minute, is fundamental to the woman-in-the-home image. This area is in shallow relief, $\frac{1}{8}$ in. ply sanded down at the lower edge to merge into the panel. The relief retains some subtleties of modelling which are not perceptible in the photograph – in fact, they can best be explored by sensitive fingers rather than the eye.

A supplementary detail from the double-spread ad which also contained 6 was of the automatic defrosting system 8. This was photographed, blown up and pasted into the painting.

Two other advertisements, 9 the Westinghouse vacuum cleaner and 10 General Electric small appliances, combined to make the remaining feature of '$he', the device in the foreground compounded from toaster and vacuum cleaner. The refrigerator stands for major appliance, the small mobile units were incorporated to extend the range to minor. They also provide the opportunity for a plastic elaboration which gratifies my own aesthetic needs. The ad for the Westinghouse vacuum cleaner 9 demonstrates an endearing characteristic of modern visual technique which I have been at pains to exploit – the overlapping of presentation styles and methods. Photograph becomes diagram, diagram flows into text. This casual adhesion of disparate conventions has always been a factor in my paintings. I want ideas to be explicit and separable so the plastic entities must retain their identity as tokens. The elements hold their integrity because they are voiced in different plastic dialects within the unified whole.

The picture was worked on, on and off, for about two and a half years. Towards the end Herbert Ohl from Ulm visited me in London bringing a little gift from Germany for the English pop artist, an advocate of what, at the Hochschule für Gestaltung, they strangely termed 'the blau-jinx philosophy'. It was a winking plastic eye and within minutes of its arrival it was cellotaped into position on the painting, waiting to be inlaid and carefully sprayed to smear the rectangular block into the surrounding surface. The wink, unhappily, is impossible to reproduce.

[1] A celebrated American 'pin-up' artist. Architectural Design, *October 1962*

David Hockney
Richard Smith

In Hockney a monster Typhoo Tea or Alka-Seltzer packet is a souvenir which could take its place in the Lost and Found columns along with other things of sentimental value. The scale makes an object take its correct place in the memory-pattern of his mainly autobiographic paintings – like ribbon-tied letters or 'the tinkling piano in the next apartment'. Hockney's cartoon technique is a legitimate use of a known, readily readable convention. The figures, spindle-legged and beetle-bodied, have many cousins in contemporary graphics but they serve his purpose, for within the conventions is enough room for him to move.

Hockney's paintings have the look of an ad-man's Sunday painting. This is not a criticism for it demonstrates that there is now the possibility of a two-way exchange between the selling-arts and the fine. The selling-arts have been borrowing consistently from the fine since (at least) *fin-de-siècle* styling. For painters needing a myth-loaded imagery, twentieth-century painting is not too hot a source: the Surrealists provide a great fund of erotic images, sharp focus and automatic techniques, but, compared with the vast image-fountain of twentieth-century popular art, it is scant. Written messages play an important part in Hockney's paintings. Sometimes they are no more than a title but on occasion the painting is covered with words overloading the image like screen credits. Hockney as a personality is bound up with his paintings. The paintings can serve as letters, or diary-jottings or mementoes: the figures *are* portraits; events portrayed *did* happen; someone *did* dance the cha-cha at three in the morning. A curtain of fantasy is drawn between the spectator and the painter but the curtain is part of the structure which is as essential as Bardot's towel. Hockney's range is maybe narrow as the lapels of his jacket but within his terms he has made a highly successful, personalized statement. How he develops cannot be known but his world (or half-world) is not closed.

Ark 32, Journal of the Royal College of Art, Summer 1962

A Letter to David Hockney
Larry Rivers

Dear David,

We might as well begin by asking some personal questions. This will postpone for a few inches or pages my deciding first what meaning this exchange might have outside of personal aggrandizement and then how we should proceed.

We met one evening at the ICA in London in May 1962. I delivered for you and some two hundred others a pretty sad talk about the difficulty of recognizing 'art' in my own work – my difficulty! After a lot of undressing I went on to predict that soon, by unavoidable and rapid evolution, the concerns and enthusiasm of the 'young' would hardly touch me, oh and a lot more

blah blah blah until the last tear. I remembered that you had very blond hair that looked touched up and that when you were on your feet you looked down toward the floor quite a bit. Maybe my one-hour vaudeville routine was embarrassing. I think I was in my 'I'm nothing! What is art? My enemies have been right all along and now everyone knows it and soon everyone will forget me' mood and the prepared rundown of this mood written in Paris where I'm deaf was more for mother's shoulder than for a group of grown ups waiting to be excited . . . not that it wasn't full of the 'troof' mind you. But many members of the London Art and Lit scene had already told me about how 'mad and interesting' you were. 'Mad and interesting' is just-reporting. When I visited Cecil Beaton, alongside a large little known work of mine I saw one of your paintings. It had a funny head in it. Kasmin, your gallery dealer, came to see me in Paris and when your name came up he just happened to have five hundred photos of your work in his inside pocket. So meeting you was getting a look at the center of all these emanations. Now remarks about spiritual and visual affinities with just a tiny bit of malice can be reduced to silly murmurs but while and after looking at these black and whites, considering our age differences and geographical dispositions, I did think that we walked the same gangplank and gang in the plank is used in the German sense of the word. A U S G A N G – 'the way out' – I suppose that could be a question even before the supposedly personal ones.

Did something like that pass through your mind on first looking into a Larry Rivers?

Anyway some personal questions!

One minute!

In order to make this double interview interesting for me and readable to 'our vast public both here and abroad' I think our questions should go anywhere . . . anywhere and that our natural strength and cunning combined with a sense of the absurdity of this situation will enable us to answer A N Y that come along. I should have a photo of you in front of me, please send one and if you can spare a few of your work.

I think you are older than you look. . . .

How old are you?

Would you prefer to have your work thought beautiful or interesting?

If you can figure it out and bear answering – why?

After seriously examining my face for hairs winging their way out of my nose or the rate the dark hairs of my head are leaving and not being replaced or for a moment the condition of the oval I'm looking at: its surface, breadth, eyebags, etc., I almost always act as if it is an impossible burden to really look like what I look like. I can't understand exactly what I'm up to but I begin making faces and usually ones that make me uglier than I am or imitations of individuals that arouse our sympathy.

When you are dressing for the evening in front of the mirror, shaving or making your tie, what are some of the things you do with your face? And what are some of the thoughts that go through your mind?

Can you think in what way these moments in front of the mirror and the things you do there (please describe) might with your translation be a factor in your work? (After all Tolstoy that marvelous heavyweight maintained a man's

character develops from a reaction to his own face) and don't we agree that ART IS CHARACTER?

I have a painting of yours in mind which has on its left a male figure perhaps a magician or hypnotist. The head with eyes glaring is bent and the arms are up and thrown forward. Two inches from the outspread fingers are 'rays' painted like lightning bolts which seem to be overcoming the victim on the right. I liked it. It was a curious mixture. The head of the male figure looked like something George Grosz paintings would have chosen from the bars in Berlin in the twenties. The rest of the figure clothed in black was painted with little more than the desire to be recognized as a figure. The 'rays' from the fingers were a painter's version of things we've seen all over the place: the comics, newspaper cartoons, the movies, etc. The place you chose for the pigment and the physical relationship between the various parts seemed like a sensitive digestion of certain abstract paintings but brought to a halt by the limits of your interest in the commonly experienced subject. I hope my view doesn't make you run for cover. I think I brought it up to make myself feel better about certain criticism directed at my work. It would be too easy to call them fools even though I know those that are (maybe square is better) but no more or less than myself do you know what 'ART' is and so don't you think we are teased into working by the desire for the physical realization of the peculiar and complicated phenomena residing in our experience ???? Today's last but not least. . . . If you become conscious of what you are up to, however you conceive this and realize you are already becoming the maker of a recognizable product do you become uncomfortable and begin looking for ways out?

Dear David: I'm not sure how you are going to respond or if this kind of thing is up your alley as we say here. If you want to go along in somewhat the same way, that is with statements questions reflections etc. it's O.K. but you can alter the pattern in any way you wish. So good luck. One more thing if you are coming east soon let me know, perhaps we can do a face-to-facer.

Larry Rivers

Art and Literature 5, *Summer 1964*

Robert Indiana
interview with G. R. Swenson

What is Pop?
Pop is everything art hasn't been for the last two decades. It is bascially a U-turn back to a representational visual communication, moving at a break-away speed in several sharp late models. It is an abrupt return to Father after an abstract fifteen-year exploration of the Womb. Pop is a re-enlistment in the world. It is shuck the Bomb. It is the American Dream, optimistic, generous and naive. . . .

It springs newborn out of a boredom with the finality and over-saturation of Abstract-Expressionism which, by its own aesthetic logic, *is* the END of art, the glorious pinnacle of the long pyramidal creative process. Stifled by this

rarefied atmosphere, some young painters turn back to some less exalted things like Coca-Cola, ice-cream sodas, big hamburgers, super-markets and 'EAT' signs. They are eye-hungry; they pop. . . .

Pure Pop culls its techniques from all the present-day communicative processes: it is Wesselmann's TV set and food ad, Warhol's newspaper and silk-screen, Lichtenstein's comics and Ben Day, it is my road signs. It is straight-to-the-point, severely blunt, with as little 'artistic' transformation and delectation as possible. The self-conscious brushstroke and the even more self-conscious drip are not central to its generation. Impasto is visual indigestion.

Are you Pop?

Pop is either hard-core or hard-edge. I am hard-edge Pop.

Will Pop bury Abstract-Expressionism?

No. If A-E dies, the abstractionists will bury themselves under the weight of their own success and acceptance; they are battlers and the battle is won; they are theoreticians and their theories are respected in the staidest institutions; they seem by nature to be teachers and inseminators and their students and followers are legion around the world; they are inundated by their own fecundity. They need birth control.

Will Pop replace Abstract-Expressionism?

In the eternal What-Is-New-in-American-Painting shows, yes; in the latest acquisitions of the *avant-garde* collectors, yes; in the American Home, no. Once the hurdle of its non-objectivity is overcome, A-E is prone to be as decorative as French Impressionism. There is a harshness and matter-of-factness to Pop that doesn't exactly make it the interior decorator's Indispensable Right Hand.

Is Pop here to stay?

Give it ten years perhaps; if it matches A-E's fifteen or twenty, it will be doing well in these accelerated days of mass-medium circulation. In twenty years it must face 1984.

Is Pop aesthetic suicide?

Possibly for those Popsters who were once believing A-Eers, who abandoned the Temple for the street; since I was never an acolyte, no blood is lost. Obviously aesthetic 'A' passes on and aesthetic 'B' is born. Pity more that massive body of erudite criticism that falls prostrate in its verbiage.

Is Pop death?

Yes, death to smuggery and the Preconceived-Notion-of-What-Art-Is diehards. More to the heart of the question, yes, Pop does admit Death in inevitable dialogue as Art has not for some centuries; it is willing to face the reality of its own and life's mortality. Art is really alive only for its own time; that eternally-vital proposition is the bookman's delusion. Warhol's auto-death transfixes us; DIE is equal to EAT.

Is Pop easy art?

Yes, as opposed to one eminent critic's dictum that great art must necessarily be *difficult* art. Pop is Instant Art. . . . Its comprehension can be as immediate as a Crucifixion. Its appeal may be as broad as its range; it is the wide-screen of the Late Show. It is not the Latin of the hierarchy, it is vulgar.

Is Pop complacent?

Yes, to the extent that Pop is not burdened with that self-consciousness of A-E, which writhes tortuously in its anxiety over whether or not it has fulfilled Monet's

Water-Lily-Quest-for-Absolute/Ambiguous-Form-of-Tomorrow theory; it walks young for the moment without the weight of four thousand years of art history on its shoulders, though the grey brains in high places are well arrayed and hot for the Kill.

Is Pop cynical?

Pop does tend to convey the artist's superb intuition that modern man, with his loss of identity, submersion in mass culture, beset by mass destruction, is man's greatest problem, and that Art, Pop or otherwise, hardly provides the Solution – some optimistic, glowing harmonious, humanitarian, plastically perfect Lost Chord of Life.

Is Pop pre-sold?

Maybe so. It isn't the Popster's fault that the A-Eers fought and won the bloody Battle of the Public-Press-Pantheon; they did it superbly and now there *is* an art-accepting public and a body of collectors and institutions that are willing to take risks lest they make another Artistic-Oversight-of-the-Century. This situation is mutually advantageous and perilous alike to all painters, Popsters and non-Popsters. The new sign of the Art Scene is BEWARE – Thin Ice. Some sun-dazed Californians have already plunged recklessly through.

Is Pop the new morality?

Probably. It is libertine, free and easy with the old forms, contemptuous of its elders' rigid rules.

Is Pop love?

Pop *is* love in that it accepts all . . . all the meaner aspects of life, which, for various aesthetic and moral considerations, other schools of painting have rejected or ignored. Everything is possible in Pop. Pop is still pro-art, but surely not art for art's sake. Nor is it any Neo-Dada anti-art manifestation: its participants are not intellectual, social and artistic malcontents with furrowed brows and fur-lined skulls.

Is Pop America?

Yes. America is very much at the core of every Pop work. British Pop, the first-born, came about due to the influence of America. The generating issue is Americasm [*sic*], that phenomenon that is sweeping every continent. French Pop is only slightly Frenchified; Asiatic Pop is sure to come (remember Hong Kong). The pattern will not be far from the Coke, the Car, the Hamburger, the Jukebox. It is the American myth. For this is the best of all possible worlds.

From 'What is Pop Art?' Interviews with eight painters (Part I). Gene Swenson, Art News, November 1963

Jasper Johns
interview with G. R. Swenson

What is Pop Art?
There has been an attempt to say that those classified under that term use images from the popular representations of things. Isn't that so?
Possibly. But people like Dine and Indiana – even you were included in the exhibitions. . . .
I'm not a Pop artist! Once a term is set, everybody tries to relate anybody they can to it because there are so few terms in the art world. Labeling is a popular way of dealing with things.
Is there any term you object to?
I object to none any more. I used to object to each as it occurred.
It has been said that the new attitude toward painting is 'cool'. Is yours?
Cool or hot, one way seems just about as good as another. Whatever you're thinking or feeling, you're left with what you do; the painting is what you've done. Some painters, perhaps, rely on particular emotions. They attempt to establish certain emotional situations for themselves and that's the way they like to work.

I've taken different attitudes at different times. That allows different kinds of actions. In focusing your eye or your mind, if you focus in one way, your actions will tend to be of one nature; if you focus another way, they will be different. I prefer work that appears to come out of a changing focus – not just one relationship or even a number of them but constantly changing and shifting relationships to things in terms of focus. Often, however, one is very single-minded and pursues one particular point; often one is blind to the fact that there is another way to see what is there.
Are you aspiring to objectivity?
My paintings are not simply expressive gestures. Some of them I have thought of as facts, or at any rate there has been some attempt to say that a thing has a certain nature. Saying that, one hopes to avoid saying I feel this way about this thing; one says this thing is this thing, and one responds to what one thinks is so.

I am concerned with a thing's not being what it was, with its becoming something other than what it is, with any moment in which one identifies a thing precisely and with the slipping away of that moment, with at any moment seeing or saying and letting it go at that.
What would you consider the difference between subject matter and content, between what is depicted and what it means?
Meaning implies that something is happening; you can say meaning is determined by the use of the thing, the way an audience uses a painting once it is put in public. When you speak of what is depicted, I tend to think in terms of an intention. But the intention is usually with the artist. 'Subject matter'? Where would you focus to determine subject matter?
What a thing is. In your Device paintings it would be the ruler.
Why do you pick ruler rather than wood or varnish or any other element?
What it is – subject matter, then – is simply determined by what you're willing to say it is. What it means is simply a question of what you're willing to let it do.

There is a great deal of intention in painting; it's rather unavoidable. But when a work is let out by the artist and said to be complete, the intention loosens. Then it's subject to all kinds of use and misuse and pun. Occasionally someone will see the work in a way that even changes its significance for the person who made it; the work is no longer 'intention', but the thing being seen and someone responding to it. They will see it in a way that makes you think, that is a possible way of seeing it. Then you, as the artist, can enjoy it – that's possible – or you can lament it. If you like, you can try to express the intention more clearly in another work. But what is interesting is anyone having the experiences he has.

Are you talking about the viewer or the artist?

I think either. We're not ants or bees; I don't see that we ought to take limited roles in relationship to things. I think one might just as well pretend that he is the center of what he's doing and what his experience is, and that it's only he who can do it.

If you cast a beer can, is that a comment?

On what?

On beer cans or society. When you deal with things in the world, social attitudes are connected with them – aren't they?

Basically, artists work out of rather stupid kinds of impulses and then the work is done. After that the work is used. In terms of comment, the work probably has it, some aspect which resembles language. Publicly a work becomes not just intention, but the way it is used. If an artist makes something – or if you make chewing gum and everybody ends up using it as glue, whoever made it is given the responsibility of making glue, even if what he really intends is chewing gum. You can't control that kind of thing. As far as beginning to make a work, one can do it for any reason.

If you cast a beer can, you don't have to have a social attitude to beer cans or art?

No. It occurs to me you're talking about *my* beer cans, which have a story behind them. I was doing at that time sculptures of small objects – flashlights and light bulbs. Then I heard a story about Willem de Kooning. He was annoyed with my dealer, Leo Castelli, for some reason, and said something like, 'That son-of-a-bitch; you could give him two beer cans and he could sell them.' I heard this and thought, 'What a sculpture – two beer cans.' It seemed to me to fit in perfectly with what I was doing, so I did them – and Leo sold them.

Should an artist accept suggestions – or his environment – so easily?

I think basically that's a false way of thinking. Accept or reject, where's the ease or the difficulty? I don't put any value on a kind of thinking that puts limits on things. I prefer that the artist does what he does than that, after he's done it, someone says he shouldn't have done it. I would encourage everybody to do more rather than less.

From 'What is Pop Art?' Interviews with eight painters (Part II). Gene Swenson, Art News, February 1964

Jasper Johns
sketchbook notes

Make neg. of part of figure & chair. Fill with these layers – encaustic (flesh?), linen, Celastic. One thing made of another. One thing used as another. *An arrogant object.* Something to be folded or bent or stretched. (SKIN?) Beware of the body and the mind. Avoid a polar situation. Think of the edge of the city and the traffic there. Some clear souvenir – A photograph (A newspaper clipping caught in the frame of a mirror) or a fisherman's den or a dried corsage. Lead section? Bronze junk? Glove? Glass? Ruler? Brush? Title? Neg. female fig.? Dog? Make a newspaper of lead or Sculpmetal? Impressions? Metal paper bag? Profile? Duchamp (?) Distorted as a shadow. Perhaps on falling hinged section. Something which can be erased or shifted. (Magnetic area) In *WHAT* use a light and a mirror. The mirror will throw the light to some other part of the painting. Put a lot of paint & a wooden ball or other object on a board. Push to the other end of the board. Use this in a painting. Dish with photo & color names. Japanese phonetic 'NO' (possessive, 'of') stencilled behind plate?. Determine painting size from plate size – objects should be *loose* in space. Fill (?) the space loosely. RITZ (?) CRACKERS, 'if the contents of this package have settled', etc. Space everywhere (objects, no objects), MOVEMENT. Take flashlight apart? Leave batteries exposed? Break orange area with 2 overlays of different colors. Orange will be 'underneath' or 'behind'. Watch the imitation of the shape of the body.

The watchman falls 'into' the 'trap' of looking. The 'spy' is a different person. 'Looking' is and is not 'eating' and 'being eaten'. (Cézanne? – each object reflecting the other.) That is, there is continuity of some sort among the watchman, the space, the objects. The spy must be ready to 'move', must be aware of his entrances and exits. The watchman leaves his job & takes away no information. The spy must remember and must remember himself and his remembering. The spy designs himself to be overlooked. The watchman 'serves' as a warning. Will the spy and the watchman ever meet? In a painting named SPY, will he be present? The spy stations himself to observe the watchman. If the spy is a foreign object, why is the eye not irritated? Is he invisible? When the spy irritates, we try to remove him. 'Not spying, just looking' – Watchman.

Color chart, rectangles or circles. (Circles on black to white rectangles.) Metal stencil attached and bent away. OCCUPATION – Take up space with 'what you do'. Cut into a canvas & use the canvas to reinforce a cast of a section of a figure. The figure will have one edge coming out of the canvas 'plane' & the other edge will overlap cut or will show the wall behind. A chain of objects (with half negative?) Cast RED, YELLOW, BLUE or cut them from metal. Bend or crush them. String them up. (OR) Hinge them as in FIELD PAINTING. Bend them. Measurements or objects or fields which have changed their 'directions'. Something which has a name. Something which has no name. Processes of which one 'knows the results'. Avoid them. City planning, etc.
One thing working one way
Another thing working another way.
One thing working different ways
at different times.

Take an object.
Do something to it.
Do something else to it.

,, ,, ,, ,, ,,

Take a canvas.
Put a mark on it.
Put another mark on it.

,, ,, ,: ,, ,,

Make something.
Find a use for it.
AND/OR
Invent a function.
Find an object.

<div align="right">Art and Literature 4, Spring 1965</div>

Ray Johnson
Suzi Gablik

Like information in newspapers, the images on a movie screen, the collages of
Ray Johnson are continually changing and new ones come to take their place.
Ultimately they take the form of mailings, surprises, presents which he distri-
butes complexly according to the rules of a private game. It is a question of
waiting, not for time to finish the work, but for time to indicate something
one would not have expected to occur. Winslow Homer sometimes waited a full
year for the sea or the sun or moonlight to be right for his purpose. In the end
they are more involved with intimacy than with public occasion. Art concerns a
highly personal encounter with the spectator and what is said, after all, is quite
second hand if said to someone else. 'But I'll get you,' he claims, 'if it takes a
day, a week, or a year. I'll cut you up . . . and if I can't do it myself I'll find
someone who can.'

<div align="right">'Ray Johnson'. Suzi Gablik, Location, Summer 1964</div>

Ray Johnson
extract from the New York Correspondence School

Reptile Recovering in Bed of Begonias
Right now, the happy owners of Feather the boa constrictor report that Feather
appears only slightly ruffled and, though still a bit weak, is recuperating quickly
from the clobbering which two months ago left her ribs and vertebrae broken

and her mouth a bloody pulp. The five-foot boa constrictor got her lumps during a short-lived sortie into the wilds of a strange back yard in Huntington. The snake strayed from the home of Mr and Mrs John K. Best, where she is a family pet. The Bests know Feather is harmless but the man who found her in his yard didn't and wasn't about to find out the hard way. He tried to do her in with the two likeliest weapons he could find – an ax and a baseball bat. At one point during the one-sided struggle, the bat got rammed down the reptile's throat. For a while, Feather couldn't constrict and also, because of the bust in the mouth with the bat, had to be force-fed ground steak. Now she's sliding around in her usual herpetological fashion and is feeding herself the regular boa's diet; one mouse and two hamsters already have helped satisfy her hunger. 'She's still getting fan mail,' Mrs Best said gleefully. 'We've got her confined to the flower room where I keep my house plants in the winter. She's lying all over them and raising havoc with the plants, but she's having a ball. You should see her.' Yep, we sure should.

– Karen Tyler
Newsday, a newspaper
December 11, 1968

December 16, 1968
Dear Feather (c/o Mr and Mrs John K. Best, 29 Lewis Court, Huntington, L.I., N.Y.),

I've never written a letter to a boa constrictor before. I hope you have recovered from being attacked by an ax and a baseball bat.

When you are feeling better I wonder if I can visit you and pose for some photographs? In 1965, I was photographed with another boa by Fred McDarrah of the *Village Voice* which was publicity for my book published by the Something Else Press *The Paper Snake*.

I was asked today by the University of British Columbia in Vancouver, Canada to participate in a *Concrete Poetry Show* next March which will feature letters and material from the New York Correspondence School, of which I am the founder (explanatory material enclosed).

The first collage-painting I do for this show will be the item I noticed in *Newsday* in the What's Your Problem column about Feather the boa constrictor and I hope to do other paintings using photos of you.

Please let me know how you are feeling, and what you think of my plans to document you for the exhibition in Vancouver.

Most Sincerely, Ray Johnson

December 16, 1968
Dear Miss Tyler (Karen Tyler, 'What's Your Problem', *Newsday*, 550 Stewart Avenue, Garden City, N.Y. 11530):

I read with interest your article about the boa constrictor named Feather in December 11th issue of *Newsday* and have just written to Feather hoping she can pose for some photographs soon since I plan to collage-document your article and my letter to Feather into a painting to be exhibited at the University of British Columbia in Vancouver, Canada next March in a *Concrete Poetry Exhibition*.

The New York Correspondence School has been asked to participate in the STILT MEETING to be held on the Central Park Mall (Fifth Avenue and 72nd Street) on October 26th from 2–4 p.m. (canceled if bad weather). You are asked to bring stilts, children on stilts, wear costumes, masks, bring packages, bundles, surprises and envelopes. There will be percussion music. Attach bells to stilts. Bring a post card.

Will Steve Tyson, 1043 Newport Ave,#4, Long Beach, California make the biggest pair of stilts in the world? Will Richard C, 34 Montrose Court, Johnson City, Tennessee 37601 make a fake pair of stilts? Will Harry Soviak, 331 East 89 St, NYC make fur lined stilts for Caterine Milinaire, fashion editor of the New York Magazine? Will Editor Philip Leider put a pair of stilts on the cover of Artforum? Will critic Lawrence Alloway, 330 West 20 St, NYC find that stilts are objectless art? Will Diane Arbus, 120 East 10 St, NYC photograph a midget on a pair of stilts? Will George Ashley, Hertz, 660 Madison Ave, NYC invite Janis Joplin to wear her garters on a pair of stilts? Will Bill Berkson, 124 East 57 St, NYC be the best-dressed man on stilts? Will poet Carol Berge, Hotel Chelsea burn her stilts? Will May Wilson, Grandma of the Underground wear a stilt stilt stilt necklace? Will Mary Bauermeister cover her stilts with drinking straws? Will Little Richard appear on 'jubilant tutti-frutti' stilts? Will David Bourdon wear his green shoes with green stilts? Will Robin Richman's from Life stilts cast a shadow? Will Betsy Baker of Art News be the tallest girl on stilts? Will Bill Copley appear on stilts edged in black? Will John Weber wrist hairs Dwan Gallery have hairy stilts? Will John Evans, 101 Ave B, Apt 8, NYC tattoo his stilts? Will Dr Alvin Friedman-Kien, 199 Second Ave, NYC bring stilts with high blood pressure? Will Richard Merkin, 500 West End Ave, NYC make boop boopy doo stilts for his poetic muse Virginia Fritz? Will Grace Glueck send over a giraffe on stilts? Will Flavia Gag, Box 91, Lake Como, Florida 30257 send millions of stilts? Will John Wilcock Other Stilts be there? Will Ronald Gross, 355 Eighth Ave, NYC write a poem about stilts? Will Marcia Marcus, 703, East 6 St, NYC do a portrait of Henry Geldzahler on stilts? Will Marcia Herscovitz, 356 West 20 St, NYC bring purple velvet stilts? Will Stuart Horn, Northwest Mounted Valise, 44 Winthrop Road, Short Hills, N.J. bring plastic stilts? Will Ara Ignatius, 137–20th St, Union City, N.J. bring Pucci stilts? Will Charlotte Gilbertson, Iolas Gallery, 15 East 55 St, NYC kiss Harold Stevenson on stilts? Will John Perrault, 242, West 10 St, NYC appear on a pair of mysterious stilts? Will Linda Rosenkrantz, Parke-Bernet Gallery, 980 Madison Ave, NYC walk and talk on stilts? Will Jerry Schatzberg, 333 Park Avenue South, NYC bring Faye Dunaway on stilts? Will Fred McDarrah, 64 Thompson St, NYC photograph Andy Warhol on stilts? Will Multiples, 929 Madison Ave, NYC do an edition of stilts? Will Sam Wiener, 504 La Guardia Place, NYC 10012 bring stilts covered with mirrors? Will Patricia Johanson, c/o Kermin, 234 West 21 St, NYC lay her stilts on the ground? Will Charlotte Moorman, 752 West End Ave, NYC play her cello on a pair of stilts?

Edward Kienholz
Suzi Gablik

At their more hectic moments, the tableaux of Kienholz seem to approach, in rather lurid-spectral fashion, a catalogue of horrors. But the convulsiveness of his imagery stems more from an irrepressible sense of violation than it does from some theatrical misanthropy or passionately cynical burlesque. The theme of man's lack of spiritual value is savagely intoned throughout most of the apparently indigestible mass of his work. ALL HAVE SINNED reads with exquisite sagacity a sign hung above the mantle in his house, and a small button attached to the corner adds, 'Control Yourself.'

The idea of the tableau, with all of its programmatic and environmental ramifications, is traceable to those makeshift Nativity Scenes and other spectacles Kienholz saw as a child in church performances and grange meetings. ('You were allowed fifteen seconds to look before the curtain fell.') He remains something of the zealot, determined to elicit the truth, to assault our moral laxity and to throw off the weight society has laid upon man. The unleavened purposefulness of his art bears down upon its varied subjects in hot protest and implied moral rebuke, without either the satiric or the anarchic humor of the Surrealists, but with vehemently demonstrative personal feeling. Yet his wild and bitter pathos is not the symptom of a morbid ferocity, bent on executing a police report or some sort of naturalistic novel. Those vivid and fearful scenes, which at times almost impair one's faculties, are redeemed by their passionate straightforwardness and a loyalty to actual life. They are never the hideous absurdities, say, of Lord Byron who, according to Swinburne, indulged himself in lava kisses, baby earthquakes and walls that have scalps. Kienholz's raffish herd emerges unseasonably from the suburbs of hell; his personages are actualized archetypes of man's deliberately fallen and perverted nature. They have been reduced by fate to submissive despair or spirit-broken acquiescence, and to feelings that run to unprofitable seed. Man's disfigurement comes from his capacity for tragic error, a capacity which has permitted him to garble and to falsify the fact of death so that fear of death no longer seems the uneasy impulse for all that we do. (Death and vulgarity, according to Oscar Wilde, are the only two facts the nineteenth century was unable to explain away.) For Kienholz, art is an instrument to be put to special use: if it can revise human understanding, it can change the world. In instructing man that he need not unresistingly accept his unhappy fate, he proposes that there is, after all, no incurable disgrace.

Extract from 'Crossing the Bar', Suzi Gablik. Art News, October 1965

Roy Lichtenstein
Richard Hamilton

Roy Lichtenstein, Oldenburg, Warhol, Rosenquist and Jim Dine have gained their exalted position in the international art scene very rapidly. It wasn't so long ago that a curator of painting at the New York Museum of Modern Art

was publicly complaining that whatever it was that they were doing it wasn't making art. The basis of Peter Selz's contention was that an artist must transform his source material in some very tangible way and this necessary transformation was not evident in the work of the so-called 'Pop' artists. I doubt if any museum official anywhere would now be so rash as to suggest that 'Pop Art' is not art or that an aesthetic transformation has not occurred. Most artists dislike the label 'Pop' when it is applied to them but Lichtenstein accepts it fairly happily. Of the Pop artists, I suspect Lichtenstein is the only one who would have some interest in this question of transformation, in particular of just how little of a transformation will make sense, because he has been more concerned than the others with consideration of this issue as a factor in his work. Between Dine – deeply involved (so much so it worries him) with the sensual aspects of his medium, whether paint, object or plumbing – and Warhol, who would regard the whole controversy as silly, there is a lot of room for manoeuvre.

Lichtenstein's early work, or at any rate the earliest by which his present style can be recognized (he thinks of himself as schooled in Abstract-Expressionism), pedantically excludes attributes that we normally expect in a work of art. His method of composition then ('Roto Broil', 'Tire', 'Ice Cream Soda', 'Hot Dog', 'Ball of Twine' are examples) was to ignore the problem by placing the image centrally and symmetrically on a stark ground in the middle of the canvas. What he paints is often a whole object offered in such a way that we resist thinking of it as 'Still Life' – there is no support for the illustrated object so the canvas bears the blazon in a quite heraldic manner. His forms are described in a fashion consistent with this style – linear treatments, coarse as in naïve illustrations for line reproduction or the more skilfully explicit old-time mail order catalogue draughtsmanship. There is no encouragement to think of the line as painted at all. The mark imitates a line drawn with a pen but magnified. Although it must be painted, all brushstrokes, or indeed any signs that the marks are made by hand, are smoothed away. Where colour is applied, usually through a perforated screen, its is invariably an even tint filling in an area enclosed by a line that has grown to the proportions of a form in itself. His major concern appears to be with the task of depicting a figurative subject in such a way as to adhere to the two dimensional integrity of the canvas and in these preoccupations he poses as an abstract artist like Mondrian or Vantongerloo (a disguise from which he later emerges). The clinical picture planning, in which he parallels these artists, repudiates physical virtuosity in aggressive conflict with his immediate New York stock.

Warhol also specifically rejects the Abstract-Expressionist's love of paint. Oldenburg, Dine and Rosenquist all used the language of Pollock and de Kooning, albeit for very different purposes. Both Lichtenstein and Warhol betray awareness of their predecessors only by a meticulous contradiction of their attitudes and techniques. Warhol, in the Campbell's Soup series, set aside subtle pictorial arrangements and exquisite paint quality as though they were an extrovert self-indulgence. In their preference for banal themes they even go some way to eliminate subject matter. The familiarity of hot dog or Coke bottle makes choice an irrelevance; they are more concerned with the style of its intermediary treatment than the object itself. Curiously enough, if Warhol's aim is frankly seditious, to pervert and destroy older aesthetic viewpoints,

another aura is given off by Lichtenstein. This is partly the consequence of his technical detachment but not less it is due to the emotional remoteness of his pictures. Under the flippant surface Warhol seethes like Goya; Lichtenstein is more like Ingres. Though the comic strip heroines drip tears in great blobs he doesn't move us to pity. There are many sad and sadistic images (a boot smears flesh on a hand that grasped a gun) which merely cause us to smile – they are like the old horror comic joke of a man hanging by his fingers from the top of a cliff while his tormentor stands over him with a knife saying, 'If you want to die with your hands on, drop.' His aerial battles and explosions are no more a condemnation of war than a glorification of it. They excite a purely aesthetic response. He's really cool.

An objective of making art without actually seeming to try pervades Lichtenstein's work at every level. After proving that composition is unnecessary he went on to make rather careful organizations of his pictures using an almost photographic technique of close-up. Composition starts with the definition of boundaries, the relationship of the formal elements to the edges of the canvas. After the very first of the comic strip paintings whole frames are no longer treated as autonomous objects. What Lichtenstein gives is part of a frame, as though he drew boundaries around a detail before blowing it up. At this point choice is exercised in a very critical way, as for a photographer the options are manifold. Using a readymade drawn environment filled with ersatz human incident he can zoom into these dramas isolating an expression, a mood, an event, even a thought. It's like pressing the button but since this pseudo world is static he can really get those edges where he wants them and his refined skill in the artistic placement of the image within the frame carries a great deal of what we recognize as quality in a Lichtenstein.

A feature common to all Pop Art is a readiness to move freely between different conventions and different imagery. A Rosenquist gives an experience analogous to that of looking through a magazine. The jolt from page to page doesn't come as a shock because we know the form. Each page is another story in a new way. Rosenquist, Wesselmann, Kitaj and Peter Blake tend to make their statements in this discretely sequenced way, but Lichtenstein opposes the narrative character of his sources, the progressive frames of a real comic strip, by making his pictures a completely integrated whole. His two-panel pictures, even the diptych 'Step-on can', where an action is demonstrated in two successive frames don't deny this principle – nor does the use of text in balloons; the image is always treated as a totality.

Most art of the past accepted a role as provider of a simulation of direct visual experience of nature until the twentieth century, when a complete revision of our understanding of what perception was affected art so profoundly. Artists then retired from nature into conceptualizations and abstraction and failed to notice that the visual world was becoming something radically else. The surprising thing is that it took until the mid-fifties for artists to realize that the visual world had been altered by the mass media and changed dramatically enough to make it worth looking at again in terms of painting. Magazines, movies, TV, newspapers, and comics for that matter, assume great importance when we consider the percentage of positively directed visual time they occupy in our urban society. So much of what we look at is sieved and screened and scanned

in the process of conversion to another dimensionality. TV has only one dimension most of the time, for the linear stream of electrons needs to be reconstituted into two dimensions before a picture can be made. It is its appreciation of the multi-dimensionality of our modified world that makes recent art exciting and the more important figures have all contributed to that understanding. Even Oldenburg, whose sources are entirely in the round, harasses our sensibility with the squeeze he can put on space by warping it with false perspective. Pop mainly uses source material that has been already processed into some two-dimensional medium. Most of this processing is photographic and photography has some status as a stimulus for art – Lichtenstein's sources are graphic and as such haven't the same degree of respectability. They were that much more shocking at first sight.

More than anyone, Lichtenstein is true to the mass media because of the way he persuades that his sources are flat. When he works in three dimensions he does so only to examine the paradox of applying flat conventions to a more elaborate surface. His cups and saucers and the bust of a blonde girl are about two-dimensional language interacting with three-dimensional structures. One of his most haunting images is of a girl's head seen from the back, she holds a hand mirror reflecting her face so that the conflict between the flatness of treatment and the requirement of reading the picture in spatial layers is very disturbing. The remarkable series of print multiplies in which he uses flat treatments on a plastic sheet, with a built-in stereoscopic depth continue the play with that paradox. Another example, quite devastating in its simplicity, is the 1965 painting 'Landscape with column', which consists of a canvas divided horizontally into two nearly equal flat areas; from the side of the lower half a piece of column protrudes an end in crude perspective projection.

Lichtenstein has said that his choice of subject matter has something to do with realism. Yet his realism seems to have less to do with 'a preoccupation with everyday life' than with his steadfast candour of treatment. What is realistic about the versions of Mondrian or Picasso is that they are not copies of paintings – they have been removed from that reality by the processing they received in the course of reproduction. What Lichtenstein makes perfectly clear is that all his subjects are made as one before he touches them. Parthenon, Picasso or Polynesian maiden are reduced to the same kind of cliché by the syntax of print: reproducing a Lichtenstein is like throwing a fish back into water. The 'Brush-strokes' are more real (and at the same time less consistent) because they appear to derive from an actual brushmark rather than a secondary source. It is also difficult to concede that Courbet-type realism can be a strong motivation for an artist whose attachment to ideas about style seems inevitably to lead to a high pitch of mannerism. Moments in *Rebecca of Sunnybrook Farm*, revived on television the other evening, displayed how apt is his appreciation of style; I could have sworn I saw his 'Modern sculpture' behind Shirley Temple.

The wonderful things in his work are notions about the conflict of flatness and illusory space, but superficially the concern is with style. It is a curious fact that these obsessions, a Baroque love of decoration and a delight in illusion, often go together. In any essentially mannerist art it is in the extremity of the stance that the glory lies – Lichtenstein is marvellously extreme.

Studio International, *January 1968*

Roy Lichtenstein

interview with G. R. Swenson

What is Pop Art?

I don't know – the use of commercial art as subject matter in painting, I suppose. It was hard to get a painting that was despicable enough so that no one would hang it – everybody was hanging everything. It was almost acceptable to hang a dripping paint rag, everybody was accustomed to this. The one thing everyone hated was commercial art; apparently they didn't hate that enough either.

Is Pop Art despicable?

That doesn't sound so good, does it? Well, it *is* an involvement with what I think to be the most brazen and threatening characteristics of our culture, things we hate, but which are also powerful in their impingement on us. I think art since Cézanne has become extremely romantic and unrealistic, feeding on art; it is utopian. It has had less and less to do with the world, it looks inward – neo-Zen and all that. This is not so much a criticism as an obvious observation. Outside is the world; it's there. Pop Art looks out into the world; it appears to accept its environment, which is not good or bad, but different – another state of mind.

'How can you like exploitation?' 'How can you like the complete mechanization of work? How can you like bad art?' I have to answer that I accept it as being there, in the world.

Are you anti-experimental?

I think so, and anti-contemplative, anti-nuance, anti-getting-away-from-the-tyranny-of-the-rectangle, anti-movement-and-light, anti-mystery, anti-paint-quality, anti-Zen, and anti all of those brilliant ideas of preceding movements which everyone understands so thoroughly.

We like to think of industrialization as being despicable. I don't really know what to make of it. There's something terribly brittle about it. I suppose I would still prefer to sit under a tree with a picnic basket rather than under a gas pump, but signs and comic strips are interesting as subject matter. There are certain things that are usable, forceful and vital about commercial art. We're using those things – but we're not really advocating stupidity, international teenager-ism and terrorism.

Where did your ideas about art begin?

The ideas of Professor Hoyt Sherman (at Ohio State University) on perception were my earliest important influence and still affect my ideas of visual unity.

Perception?

Yes. Organized perception is what art is all about.

He taught you 'how to look'?

Yes. He taught me how to go about learning how to look.

At what?

At what, doesn't have anything to do with it. It is a process. It has nothing to do with any external form the painting takes, it has to do with a way of building a unified pattern of seeing. . . . In Abstract-Expressionism the paintings symbolize the idea of ground-directedness as opposed to object-directedness. You

put something down, react to it, put something else down, and the painting itself becomes a symbol of this. The difference is that rather than symbolize this ground-directedness I do an object-directed appearing thing. There is humor here. The work is still ground-directed; the fact that it's an eyebrow or an almost direct copy of something is unimportant. The ground-directedness is in the painter's mind and not immediately apparent in the painting. Pop Art makes the statement that ground-directedness is not a quality that the painting has because of what it looks like. . . . This tension between apparent object-directed products and actual ground-directed processes is an important strength of Pop Art.

Antagonistic critics say that Pop Art does not transform its models. Does it?
Transformation is a strange word to use. It implies that art transforms. It doesn't, it just plain forms. Artists have never worked with the model – just with the painting. What you're really saying is that an artist like Cézanne transforms what we think the painting ought to look like into something he thinks it ought to look like. He's working with paint, not nature; he's making a painting, he's forming. I think my work is different from comic strips – but I wouldn't call it transformation; I don't think that whatever is meant by it is important to art. What I do is form, whereas the comic strip is not formed in the sense I'm using the word; the comics have shapes but there has been no effort to make them intensely unified. The purpose is different, one intends to depict and I intend to unify. And my work is actually different from comic strips in that every mark is really in a different place, however slight the difference seems to some. The difference is often not great, but it is crucial. People also consider my work to be anti-art in the same way they consider it pure depiction, 'not transformed'. I don't feel it is anti-art.

There is no neat way of telling whether a work of art is composed or not; we're too comfortable with ideas that art is the battleground for interaction, that with more and more experience you become more able to compose. It's true, everybody accepts that; it's just that the idea no longer has any power.

Abstract-Expressionism had an almost universal influence on the arts. Will Pop Art?
I don't know. I doubt it. It seems too particular – too much the expression of a few personalities. Pop might be a difficult starting point for a painter. He would have great difficulty in making these brittle images yield to compositional purposes. . . . Interaction between painter and painting is not the total commit-ment of Pop, but it is still a major concern – though concealed and strained.

Do you think that an idea in painting – whether it be 'interaction' or the use of commercial art – gets progressively less powerful with time?
It seems to work that way. Cubist and Action Painting ideas, although originally formidable and still an influence, are less crucial to us now. Some individual artists, though – Stuart Davis, for example – seem to get better and better.

A curator at the Modern Museum has called Pop Art fascistic and militaristic.
The heroes depicted in comic books are fascist types, but I don't take them seriously in these paintings – maybe there is a point in not taking them seriously, a political point. I use them for purely formal reasons, and that's not what those heroes were invented for. . . . Pop Art has very immediate and of-the-moment meanings which will vanish – that kind of thing is ephemeral – and Pop takes advantage of this 'meaning', which is not supposed to last, to divert you from

its formal content. I think the formal statement in my work will become clearer in time. Superficially, Pop seems to be all subject matter, whereas Abstract-Expressionism, for example, seems to be all aesethetic. . . .

I paint directly – then it's said to be an exact copy, and not art, probably because there's no perspective or shading. It doesn't look like a painting *of* something, it looks like the thing itself. Instead of looking like a painting *of a* billboard – the way a Reginald Marsh would look – Pop Art seems to be the actual thing. It is an intensification, a stylistic intensification of the excitement which the subject matter has for me; but the style is, as you said, cool. One of the things a cartoon does is to express violent emotion and passion in a completely mechanical and removed style. To express this thing in a painterly style would dilute it; the techniques I use are not commercial, they only appear to be commercial – and the ways of seeing and composing and unifying are different and have different ends.

Is Pop Art American?

Everybody has called Pop Art 'American' painting, but it's actually industrial painting. America was hit by industrialism and capitalism harder and sooner and its values seem more askew. . . . I think the meaning of my work is that it's industrial, it's what all the world will soon become. Europe will be the same way, soon, so it won't be American; it will be universal.

From 'What is Pop Art?' Interviews with eight painters (Part I). Gene Swenson, Art News, *November 1963*

Robert Morris

on drawing

Scratches made while on the train, in a plane, a hangover from the High Renaissance where every telephone number and coffee stain (by the right person) revealed the inner or under or deeper or less disguised and more naked creative nerve – so many little exposed nerves; see them trembling beneath the neuritis and neuralgia of the cross-hatching. Personally, I always use a 6B pencil so it will smear easily. All of one's casual genius goes into drawings so it's better to get some extraneous diversionary information down along with the kernel idea; a friend's name, a doctor's appointment, a grocery list. If none of this is available numbers will do. This gives the impression that artists think in abstract terms. But there is a limit. Algebra is out, or statistical equations. Better to cultivate a certain awkwardness and blunt, left-handed effort like that needed to open a stuck closet door. I term this the lurching effect. The expressive content comes in miniaturizing this lurch (cf. Levi-Strauss) into the 'erotic doily effect'. This is something like the Doppler effect experienced visually. I couldn't explain it. It is always necessary to date the drawing. If necessary, pre-date it. No one will know and one can mention outlandish early inventions on panels with no fear of being unable to document them. In this way one can

invent one's entire youth as one goes along. Perspective is bad, almost as bad as shading. Drawing should reveal the momentary, involuntary fit of creative seizure. The best way to emphasize this is to consider the type of paper. Duchamp preferred menus but times have changed. Personally, I think old hardware bills are an advance. I always carry a few in case of seizures. There are, of course, many other considerations as one goes deeper; explores and probes the some-what forbidding, pulsing nerve of creativity that the off-hand drawing reveals. However, this can be but a brief note. On the whole the artist should try for that effect of the cloudy idea becoming clear but not too clear (an old saying of the Sung painters), a straining toward the light, a revelation in the face of enormous handicaps. One should try for that quality that a total spastic might reveal while juggling with all the skill and malice of W. C. Fields. And remember, it is better to have drawn and lost than not to have drawn at all.

Malcolm Morley
statement

I have no interest in subject matter as such or satire or social comment or any-thing else lumped together with subject matter. I like the light in Corot. There is only Abstract Painting, I want works to be disguised as something else (photos) mainly for protection against 'art man-handlers'. I order the source photo by phone by describing the surface configuration such as, 'Send me up a four-color print that has small multiple details in one part and a larger detail in another (like sky).' I accept the subject matter as a by-product of surface. I work against the theory of constancy, i.e., the grass feels green when walking in a park at night. That's why I paint upside down.

Claes Oldenburg
On the Bedroom

'Bedroom' was made in Los Angeles in the fall of 1963. It was a radical departure from the work I had been doing. A deliberate reversal of values which was underlined and helped by a move from New York to Los Angeles. I conceived of these cities – at other ends of the nation – as opposites in every possible way (fictionalizing the differences into black and white). That there are opposites I don't believe but I do believe it as an artistic working principle.

Geometry, abstraction, rationality – these are the themes that are expressed

formally in 'Bedroom'. The effect is intensified by choosing the softest room in the house and the one least associated with conscious thought. The previous work had been self indulgent and full of color, the new work was limited to black and white, blue and silver. Hard surfaces and sharp corners predominate. Texture becomes *photographed* texture in the surface of the formica. Nothing 'real' or 'human'. A landscape like that on the cover of my old geometry book, the one that shows the Pyramids of Egypt and bears the slogan, 'There is no royal road to geometry.' All styles on the side of Death. The Bedroom as rational tomb, pharaoh's or Plato's bedroom.

'Bedroom' is a large object in many parts. It was made with an actual room in mind which originally was part of the giant object. This room (the front room at the Sidney Janis Gallery) cannot be transported, only approximated, and so many 'realistic' details will always be missing: the air-conditioner, for example, which kept the place cool, or the door marked 'private'.

'Bedroom' marked for me (and perhaps others) a turning point of taste. It aligned me (perhaps) with artists who up to then had been thought to be my opposites. But the change of taste was passed through the mechanism of my attitude, which among other 'rules' insists on referring to things – by imitating them, altering them and naming them.

'Bedroom' might have been called composition for (rhomboids) columns and disks. Using names for things may underline the 'abstract' nature of the subject or all the emphasis can do this. Subject matter is not necessarily an obstacle to seeing 'pure' form and color. Since I am committed to openness, my works are constructed to perform in as many ways as anyone wants them to. As time goes on and the things they 'represent' vanish from daily use, their purely formal character will be more evident: Time will undress them. Meanwhile they are sticky with associations, and that is presumably why my 'Bedroom', my little gray geometric home in the West, is two-stepping with Edward Hopper. To complete the story, I should mention that the 'Bedroom' is based on a famous motel along the shore road to Malibu, 'Las Tunas Isles', in which (when I visited it in 1947) each suite was decorated in the skin of a particular animal, i.e., tiger, leopard, zebra. My imagination exaggerates but I like remembering it that way: each object in the room consistently animal.

I am trying to experience the shape of experience and let you tell me yours and help me too. One style won't do; every man has many styles in him and the old art school injunction to find your style and stick to it may not be so useful. Perhaps not even commercially. I was trying to turn myself inside out and I have always been able to manage changes. All the fun is locking horns with impossibilities – for example: combining our notions of sculpture with our notions of a simple 'vulgar' object: hamburger or bedroom. The subtleties and strategies of this struggle elate me; I fence with definitions – this way that way – point here point there – and then out of the studio and a run down to the Pacific surf (cold at that time of year). But the finished work is not a problem; it is my solution. A problem to others perhaps. If they care they must retrace my steps. Back at the beginning is a pigheaded 'rule', a decision whose consequences are unpredictable. The rule is pursued firmly – the facts yield or shape themselves about the resolution. The solution is dazzling (if it comes) for the reason that the proposition is absurd. Art as sport.

Claes Oldenburg
I am for an Art . . .

I am for an art that is political-erotical-mystical, that does something other than sit on its ass in a museum.

I am for an art that grows up not knowing it is art at all, an art given the chance of having a starting point of zero.

I am for an art that embroils itself with the everyday crap & still comes out on top.

I am for an art that imitates the human, that is comic, if necessary, or violent, or whatever is necessary.

I am for an art that takes its form from the lines of life itself, that twists and extends and accumulates and spits and drips, and is heavy and coarse and blunt and sweet and stupid as life itself.

I am for an artist who vanishes, turning up in a white cap painting signs or hallways.

I am for art that comes out of a chimney like black hair and scatters in the sky.

I am for art that spills out of an old man's purse when he is bounced off a passing fender.

I am for the art out of a doggy's mouth, falling five stories from the roof.

I am for the art that a kid licks, after peeling away the wrapper.

I am for an art that joggles like everyones knees, when the bus traverses an excavation.

I am for art that is smoked, like a cigarette, smells, like a pair of shoes.

I am for art that flaps like a flag, or helps blow noses, like a handkerchief.

I am for art that is put on and taken off, like pants, which develops holes, like socks, which is eaten, like a piece of pie, or abandoned with great contempt, like a piece of shit.

I am for art covered with bandages. I am for art that limps and rolls and runs and jumps. I am for art that comes in a can or washes up on the shore.

I am for art that coils and grunts like a wrestler. I am for art that sheds hair.

I am for art you can sit on. I am for art you can pick your nose with or stub your toes on.

I am for art from a pocket, from deep channels of the ear, from the edge of a knife, from the corners of the mouth, stuck in the eye or worn on the wrist.

I am for art under the skirts, and the art of pinching cockroaches.

I am for the art of conversation between the sidewalk and a blind man's metal stick.

I am for the art that grows in a pot, that comes down out of the skies at night, like lightning, that hides in the clouds and growls. I am for art that is flipped on and off with a switch.

I am for art that unfolds like a map, that you can squeeze, like your sweetys arm, or kiss, like a pet dog. Which expands and squeaks, like an accordion, which you can spill your dinner on, like an old tablecloth.

I am for an art that you can hammer with, stitch with, sew with, paste with file with.

I am for an art that tells you the time of day, or where such and such a street is.

I am for an art that helps old ladies across the street.

I am for the art of the washing machine. I am for the art of a government check. I am for the art of last wars raincoat.

I am for the art that comes up in fogs from sewer-holes in winter. I am for the art that splits when you step on a frozen puddle. I am for the worms art inside the apple. I am for the art of sweat that develops between crossed legs.

I am for the art of neck-hair and caked tea-cups, for the art between the tines of restaurant forks, for the odor of boiling dishwater.

I am for the art of sailing on Sunday, and the art of red and white gasoline pumps.

I am for the art of bright blue factory columns and blinking biscuit signs.

I am for the art of cheap plaster and enamel. I am for the art of worn marble and smashed slate. I am for the art of rolling cobblestones and sliding sand. I am for the art of slag and black coal. I am for the art of dead birds.

I am for the art of scratchings in the asphalt, daubing at the walls. I am for the art of bending and kicking metal and breaking glass, and pulling at things to make them fall down.

I am for the art of punching and skinned knees and sat-on bananas. I am for the art of kids' smells. I am for the art of mama-babble.

I am for the art of bar-babble, tooth-picking, beerdrinking, egg-salting, in-sulting. I am for the art of falling off of a barstool.

I am for the art of underwear and the art of taxicabs. I am for the art of ice-cream cones dropped on concrete. I am for the majestic art of dog-turds, rising like cathedrals.

I am for the blinking arts, lighting up the night. I am for art falling, splashing, wiggling, jumping, going on and off.

I am for the art of fat truck-tires and black eyes.

I am for Kool-art, 7-UP art, Pepsi-art, Sunshine art, 39 cents art, 15 cents art, Vatronol art, Dro-bomb art, Vam art, Menthol art, L&M art, Ex-lax art, Venida art, Heaven Hill art, Pamryl art, San-o-med art, Rx art, 9.99 art. Now art, New art, How art, Fire sale art, Last Chance art, Only art, Diamond art, Tomorrow art, Franks art, Ducks art, Meat-o-rama art.

I am for the art of bread wet by rain. I am for the rats' dance between floors. I am for the art of flies walking on a slick pear in the electric light. I am for the art of soggy onions and firm green shoots. I am for the art of clicking among the nuts when the roaches come and go. I am for the brown sad art of rotting apples.

I am for the art of meowls and clatter of cats and for the art of their dumb electric eyes.

I am for the white art of refrigerators and their muscular openings and closings.

I am for the art of rust and mold. I am for the art of hearts, funeral hearts or

sweetheart hearts, full of nougat. I am for the art of worn meat-hooks and sing-ing barrels of red, white, blue and yellow meat.

I am for the art of things lost or thrown away, coming home from school. I am for the art of cock-and-ball trees and flying cows and the noise of rectangles and squares. I am for the art of crayons and weak grey pencil-lead, and grainy wash and sticky oil paint, and the art of windshield wipers and the art of the finger on a cold window, on dusty steel or in the bubbles on the sides of a bathtub.

I am for the art of teddy-bears and guns and decapitated rabbits, exploded umbrellas, raped beds, chairs with their brown bones broken, burning trees, firecracker ends, chicken bones, pigeon bones and boxes with men sleeping in them.

I am for the art of slightly rotten funeral flowers, hung bloody rabbits and wrinkly yellow chickens, bass drums & tambourines, and plastic phonographs.

I am for the art of abandoned boxes, tied like pharaohs. I am for an art of watertanks and speeding clouds and flapping shades.

I am for U.S. Government Inspected Art, Grade A art, Regular Price art, Yellow Ripe art, Extra Fancy art, Ready-to-eat art, Best-for-less art, Ready-to-cook art, Fully cleaned art, Spend Less art, Eat Better art, Ham art, pork art, chicken art, tomato art, banana art, apple art, turkey art, cake art, cookie art.

I'm for an art that is combed down, that is hung from each ear, that is laid on the lips and under the eyes, that is shaved from the legs, that is brushed on the teeth, that is fixed on the thighs, that is slipped on the foot.

square which becomes blobby

From Store Days *by Claes Oldenburg. The Something Else Press, Inc. New York, 1967*

Eduardo Paolozzi

Metal Fables - Metropolitan Sentiments 1

Fifty-Second Street is an eastbound Manhattan thoroughfare that begins at Pier 92, North River, and dead ends on the other side of town in a bulbous U near the East River. It is at the end of 52nd Street that Garbo-watching begins.

Outside the wind is wet and cold. At the approaches to the bridge and at nearby street corners several shadowy figures in leather jackets come to life: pimps ready to escort their girls. Across the canal two display windows are lighted. Business is going on as usual.

That night's performance was sold up to the last minute, presumably on the assumption that the tradition of 'The show must go on' would win over the large wage cut. The big top was packed and the kids squealed with delight while they munched peanuts, ate hot dogs, drank soda pop and tried very hard to work up a bellyache at least equal to the one they had had when they last stole some green apples off a neighbour's tree.

Through the streets, parents come searching for their children. Often the most direct means of locating the runaways clustered together. Many sleep in crowded communal 'crash pads' (*below*), whose owners let them stay for nothing. They can eat and pick up their clothing free at stores, subsisting on a diet of hot dogs, pizza, cookies, pop and ice cream. By night traffic arteries are blocked off to divert streams around some vast new army installation. Parks, playgrounds, and open fields turn into ammunition dumps, fuel-oil bases, airfields, sites for radio stations, training-schools, or hospitals, or into areas marked off with red flags for artillery, machine-gun, or bombing practice.

This is the land of the unpredictable and unexpected. It is in a peculiar sense in the lap of the gods. And they are nervous gods, trembling, stormy, explosive. Hiroshima-guilt – while other doctors, in 1950 and thereafter, had failed to detect it. The fruit of their messages and of their death will be new, better equipped, better prepared to withstand the physical difficulties of a style developed solely on aesthetic principles, and irrespective of roach-ridden tenements where hippies sleep 10 to a room, and where there is seldom a place to wash.

These high buildings, that visitors from all over the world stare at with such astonishment make New York what it is.

Excerpts from September catalogue of the Jewish Museum, New York, March 20–May 12, 1968

Peter Phillips
Richard Smith

Phillips' hard paintings manipulate contemporary iconography in game formats. The game is unwinnable, the puzzle unsolvable, but the playing has a point. The jackpot may not be hit, but the spectator is enriched. The paintings are concerned with the tough or pseudo-tough pop-world, the erotic stakes are high, one might even make it with BB and MM. The love war danger thrill fear substitutes strippers horror movies motorcycle gang finery are riveted in dark bright hard edged paintings. The paintings are made with the precision of an exact register, nothing is off-printed. Phillips adds darkness to brightness; there is no blurring or shading, the paintings push forward for attention with an oppressive, juke-box amplification.

There is a dark side of popular art – Ray Charles rather than Bobby Vee; the Tingler rather than the Pirates of Tortuga, leather jackets rather than après-ski. The skill with which this side is presented is the same as in other products but the bright package (or plain wrapper) is a Pandora's box. The promise of illegitimate sensations in 'X' movies, paperback pseudo-pornography, stag-party records et cetera is a big part of the entertainment industry and they fulfil necessary functions in our mostly cleaned-up, well-lit urban scene. They may be substitutes but the emotions involved are the real thing. Along with this is the

line-up of dark heroes like Brando in One-Eyed Jacks, who shoots the villain in the back; like the monsters who are really the heroes. These elements are displayed not in the dog-eared environment of 'specialist' bookstores but in the framework of a child's gameboard or a pin-ball machine.

A most complete visual equivalent of Phillips' paintings is 42nd Street in the neon-bright block west of 6th Avenue with its six or seven cinemas with marquees ablaze with light, each with its corner of the movie market, double-feature western or horrors or war epics or 'art' films; its fluorescent bookstores; its pin-ball alleys with a shooting gallery and a freak show in the back: there are equivalent environments in most large cities. At the corner of 42nd Street there is a litter basket with the notice 'Cast your vote here for a cleaner New York.' Phillips I think would not throw anything in but he might neaten it up.

Ark 32, Journal of the Royal College of Art, Summer 1962

Robert Rauschenberg

NOTE ON PAINTING OCT 31 - NOV 2, 1963

I FIND IT NEARLY IMPOSSIBLE FREE ICE TO WRITE ABOUT JEEPAXLE MY WORK. THE CONCEPT I PLANTATARIUM STRUGGLE TO DEAL WITH KETCHUP IS OPPOED TO THE LOGICAL CONTINUITY LIFT TAB INHERENT IN LAGUAGE HORSES AND COMMUNICATION. MY FASCINATION WITH IMAGES OPEN 24 HRS. IS BASED ON THE COMPLEX INTERLOCKING OF DISPARATE VISUAL FACTS HEATED POOL THAT HAVE NO RESPECT FOR GRAMMAR. THE FORM THEN DENVER 39 IS SECOND HAND TO NOTHING. THE WORK THEN HAS A CHANCE TO ELECTRIC SERVICE BECOME ITS OWN CLICHÉ. LUGGAGE, THIS IS THE INEVITABLE FATE FAIR GROUND OF ANY INANIMATE OBJECT FREIGHTWAYS BY THIS I MEAN ANYTHING THAT DOESNOT HAVE INCONSISTENCY AS A POSSIBILITY

BUILT-IN..
THE OUTCOME OF A WORK IS BASED ICX
ICE ON AMOUNT OF INTENSITY ~~~~~~
CONCENTRATION AND JOY THAT IS
PURSUED ROADCROSSING IN THE ACT
OF WORK. THE CHARACTER OF THE
ARTIST HAS TOBE RESONSIVE AND
LUCKY. PERSONALLY I HAVE NEVER
BEEN INTERESTED IN A DEFENSIBLE
REASON POST CARD FOR WORKING
ACHIEVMENT FUNCTIONALLY IS A
~~~~~~ DELUSION. TO DO A NEEDED
WORK SHORT CHANGES ART. IT SEEMS
TO ME THAT A GREAT PART INDIAN
MOCCASINS OF URGENCY IN WORKING
LIES IN THE FACT THAT ONE ACTS
FREELY FRIENDS AND ASSOCIATES
MAY BECOME MORE CLOSELY ALLIED
WITH YOU REAL SOON. U.S. POSTAGE
STAMPS - SANITARILY PACKAGED -
SAVE A TRIP TO POST OFFICE
~~~~~~ SHAPES .. FILES .. CLEANS WITH
KEY CHAIN FORGET TO BRING IT
WITH YOU ... TO MAKE SOMETHING
THE NEED OF WHICH CAN ONLY
FISHING 7 SPRINGS BE DETERMINED
AFTER ITS EXISTENCE AND THAT
JUDGMENT SUBJECT TO CHANGE AT
ANY MOMENT. 15'18". IT ~~~~~~
IS EXTREMELY IMPORTANT THAT
ART BE UNJUSTIFIABLE.

ROBERT RAUSCHENBERG

Larry Rivers

statement

Because I move into some of my work things you recognize as portions of Camel
Cigarette packs, the front grill of a 1960 Buick, French Money, Rembrandt's
Syndics of the Drapery Guild from Dutchmasters Cigars, Vocabulary Lessons,
A Menu, Playing Cards, etc. it doesn't mean I love what they look like in the
original or that as an artist I'm agitated to introduce these images of Mass
Production as some socially significant statement. I have a bad arm and am
not interested in the art of holding up mirrors. Perhaps you will see Camel
Cigarettes or French Money differently after looking at my paintings. But what's
so marvelous about that. I hope you feel a thrill and think about something
different and then maybe think about Art and Me. I find the energy and inven-
tion and organization and the scale of industry that produces these things
thrilling enough. The business section of the *N.Y. Times* is much more exciting
to me than all the opinions on this & that show or dance or whatever. But unlike
a great many snobs who spend their time educating I don't think there is some
super visual strength and mystery in the products of Mass Culture: That Mass
Culture=Vulgarity which somehow equals the Good & The Beautiful. This
slumming is really just a dopey extension of eighteenth-century sentimentality
about the Noble Savage. Remember todays Noble Savages who sit down to
create the images for these products went to art schools, traditional & bohemian
& were exposed to everything that tends to civilize. They admired the Old
Masters & still tell you all about Picasso or perhaps Klee & they made lots of
drawings. They really tried. When you meet them you are not in the presence
of a brute. I'm not original when I tell you what adorns these products is the
remnants of a form 'Tried & True' watered down further by fifty-five committee
meetings. It's not vulgar. It's just inoffensive and clear. I'm not calling for
quality or what I think is quality. The world is beautiful enough & of course
ugly enough to service the range of human imagination. After all if everyone
were as full of quality as you & I there would be no one to serve us a frankfurter
at Nedicks. So I don't hate the Camel rendered on the cigarette pack. It
doesn't matter. I like a lot of things I see that I never use. I used to see Mass
Products in a more relaxed way. Their use in 'Art' has made them a bit of a
problem. But that's Life. If I am moved to work from these products it's for
what I can take from them for my ideas of a work of Art. Excuse the tone. In
order to paint I must look at something & I must think that in some way it is
about the thing I'm looking at. I think what I choose to look at is based primarily
on, 'what out there will allow me to use what's in my bag of tricks'. I'm quite a
one-eyed face maker and probably think my drawing is greater than anyone's
around. Letters of the alphabet & home-made stencils found there in great
abundance, because of their manufactured look, set off the artiness of my
rendering. There are smudges. The right amount of laziness, etc. Outside of
these personal conventions, bulging and changing in my bag, a combination of
factors influence my choosing objects from Mass Production. At least they pass
through my mind. Availability . . . a cheap easily gotten model, any store almost
any time. Flatness . . . the reduced conflict between what you are looking at and

what you end up with on your canvas. Ten years of abstract art adoration leading to neglect and then hunger for something you delude yourself into thinking you can call your own. In certain instances the way in which you want to go down in history. Embarrassment with seriousness, quote 'straight painting'. Perhaps accident, innocence and of course fun & the various reliefs experienced in the presence of absurdity. It is these things I think which account for much more in my choosing portions of Mass Culture than the obvious everyday humanistic or politically responsible overtones.

A statement read to the International Association of Plastic Arts by Larry Rivers at the Museum of Modern Art Symposium on 'Mass Culture and the Artist', New York, 8. October 1963

James Rosenquist
What is the F-111? (interview with G. R. Swenson)

SWENSON: What is the F-111?
ROSENQUIST: It is the newest, latest fighter-bomber at this time, 1965. This first of its type cost many million dollars. People are planning their lives through work on this bomber, in Texas or Long Island. A man has a contract from the company making the bomber, and he plans his third automobile and his fifth child because he is a technician and has work for the next couple of years. Then the original idea is expanded, another thing is invented; and the plane already seems obsolete. The prime force of this thing has been to keep people working, an economic tool; but behind it, this is a war machine.
SWENSON: What about the man who makes the F-111?
ROSENQUIST: He is just misguided. Masses of people are being snagged into a life and then continue that life, being enticed a little bit more and a little bit more in the wrong direction.
SWENSON: What have you tried to do in this painting?
ROSENQUIST: I think of it like a beam at the airport. A man in an airplane approaching a beam at the airport, he may fly twenty or thirty miles laterally, out of the exact way, but he continues to be on the beam. As he approaches closer to what he wants, or to the airport, he can be less divergent because the beam is a little narrower, maybe only one or two miles out of the way, and less and less until when he gets right on it; then he'll be there.

The ambience of the painting is involved with people who are all going toward a similar thing. All the ideas in the whole picture are very divergent, but I think they all seem to go toward some basic meaning. They're divergent so it's allowable to have orange spaghetti, cake, light bulbs, flowers. . . .
SWENSON: Going toward what?
ROSENQUIST: Some blinding light, like a bug hitting a light bulb.

I think of the picture as being shoveled into a boiler. The picture is my personal reaction as an individual to the heavy ideas of mass media and communication and to other ideas that affect artists. I gather myself up to do something in a specific time, to produce something that could be exposed as a human idea of the extreme acceleration of feelings. The way technology appears to me

now is that to take a stance – in a painting, for example – on some human qualities seems to be taking a stance on a conveyor belt: the minute you take a position on a question or on an idea, then the acceleration of technology, plus other things, will in a short time already have moved you down the conveyor belt. The painting is like a sacrifice from my side of the idea to the other side of society.

I can only hope to grasp things with the aid of a companion like an IBM machine. I would try to inject the humanity into the IBM machine; and myself and it, this extreme tool, would go forward.

I hope to do things in spite of my own fallacies.

If a company or institution is using people like digits and massing them in schools of learning toward appreciating new ideas and new inventions, I react to that and try to pose a problem to think in terms of humanity again. So this picture is partial, incomplete maybe, but a fragment I am expending into the boiler.

SWENSON: In 1961 it seemed that you were adopting techniques and styles that were not your own but those of sign painters, professional and almost objective techniques. That had the aspect of anti-style; yet *Time* magazine recently referred to 'Rosenquist's precise, realistic style'.

ROSENQUIST: Well, the style I use was gained by doing outdoor commercial work as hard and as fast as I could. My techniques for me are still anti-style. I have an idea what I want to do, what it will look like when I want it finished – in between is just a hell of a lot of work.

When they say the Rosenquist style is very precise, maybe they just know that painting style as they know it is going out of style. Ways of accomplishing things are extended to different generations in oblique places. Billboard painting techniques are much like Mexican muralist techniques. Few people extend themselves in it at the time because it is not very much considered.

SWENSON: You worried some about the painting for the New York State pavilion at the World's Fair, that it would be dwarfed by some hundred-foot bride on the Kodak building. Is there any relationship between that painting and the size of the 'F-111'?

ROSENQUIST: The picture at the World's Fair had a relation to the rest of the landscape, the huge buildings, huge pink Kodacolor photographs. That painting was exposed to other things of large scale and had to exist on some other terms than those I usually deal with.

The 'F-111' was enclosed – four walls of a room in a gallery. My idea was to make an extension of ways of showing art in a gallery, instead of showing single pictures with wall space that usually gives your eye a relief. In this picture, because it did seal up all the walls, I could set the dial and put in the stops and rests for the person's eye in the whole room instead of allowing the eye to wander and think in an empty space. You couldn't shut it out, so I could set the rests.

SWENSON: Put in relief?

ROSENQUIST: Such as a light sky-blue area, which I've always felt as a relief. Or the one empty wall space with the missing canvas.

At first the missing panel was just to expose nature, that is, the wall wherever it was hung; and from there of course would be extended the rest of the space wherever it was exhibited. In the gallery the painting was a cube or a box

where the only area left on the walls was the 'missing' panel. At one time I planned to hang a plexiglass panel over it: you would look through it and still be exposed to the wall.

SWENSON: Would you fill in some background on each of the images, beginning at the left?

ROSENQUIST: I used those same wallpaper roller patterns in 1962 on a painting called 'Silver Skies'. I saw the pattern in an elevator lobby and thought of a solid atmosphere; you walk outside of your apartment into what used to be open air and all of a sudden feel that it has become solid with radioactivity and other undesirable elements. So I used a wallpaper roller with hard artificial flowers to hang in the atmosphere like a veil. In the panel at the other end, at the right side of the painting, I tried aluminum flowers on an aluminum panel to give a softer visual effect.

SWENSON: What about the aluminum panels on either end?

ROSENQUIST: People came into the gallery and immediately they'd say, 'It's a picture of a jet plane painted on aluminum panels'. People thought the ends were simply panels that hadn't been painted, and that the rest of the picture was on aluminum. The physical feeling that gave, the feeling of metal, is something different from canvas, a brittle feeling. The picture is mostly painted on canvas, but I think I achieved that brittle feeling with an economy – at least for a few people.

Originally the picture was an idea of fragments of vision being sold, incompleted fragments; there were about fifty-one panels in the picture. With one of them on your wall, you could feel something of a nostalgia, that it was incomplete and therefore romantic. That has to do with the idea of the man now collecting, a person buying a recording of the time or history. He could collect it like a fragment of architecture from a building on Sixth Avenue and Fifty-second Street; the fragment even now or at least in the near future may be just a vacant aluminum panel whereas in an earlier period it might have been a fancy cornice or something seemingly more human.

Years ago when a man watched traffic going up and down Sixth Avenue, the traffic would be horses and there would be a pulsing, muscular motion to the speed on the avenue. Now what he sees may be just a glimmer, a flash of static movement; and that idea of nature brings a strange, for me even now, a strange idea of what art may become, like a fragment of this painting which is just an aluminum panel.

SWENSON: It might have been better, closer to your intention, if it had been sold piece by piece.

ROSENQUIST: Yes.

SWENSON: Then what would have happened to the picture?

ROSENQUIST: I don't know exactly. I wanted to relate the idea of the new man, the new person who appreciates things, to this painting. It would be to give the idea to people of collecting fragments of vision. One piece of this painting would have been a fragment of a machine the collector was already mixed up with, involved in whether he knew it or not. The person has already bought these airplanes by paying income taxes or being part of the community and the economy. Men participate in the world whether it's good or not and they may physically have bought parts of what this image represents many times.

Then anyone interested in buying a blank part of this, knowingly or unknowingly – that's the joke – he would think he is buying art and, after all, he would just be buying a thing that paralleled part of the life he lives. Even though this picture was sold in one chunk, I think the original intention is still clear. The picture is in parts.

SWENSON: If someone bought one of these panels, he would be buying a souvenir, of the painting, of the F-111, of the time?

ROSENQUIST: Yes.

SWENSON: To get back to the images, what about the runner's hurdle?

ROSENQUIST: At the gallery the hurdle was presented in two perpendicular halves because it came at the corner of the room. The hurdle was broken right down the center. On the left are a couple of aluminum panels so that the right side, which is superimposed on painted areas, reflected around the corner into the aluminum and it appeared that there was another piece of the hurdle. In the gallery it looked as if a runner would have to jump a triangular hurdle, or one with several alternatives, but they were blind alternatives because the hurdle was in a corner. The runner seemed to hurdle himself into a corner.

SWENSON: The angel food cake?

ROSENQUIST: It's foodstuff. The small flags planted on it show the elements in the cake, like protein and iron and riboflavin – food energy. There is also a shaft that goes in the middle of the cake that is from the core or mold used to bake those cakes. I always remember it as some kind of abyss, this big hole in the middle of the cake. The flags also mean flaming candles, like on a birthday cake, of age and time, and flags being planted and staking out areas in life, like food, being eaten for energy. Actually the F-111, the plane itself, could be a giant birthday cake lying on a truck for a parade or something—it has even been used like that – but it was developed as a horrible killer.

SWENSON: And the tire?

ROSENQUIST: The tire is a crown, a celebration of the town and country winter tire. The design, magnified, appears regal. I'd never thought of what rubber tires or wheels meant to me, and I looked at the tire tread and it seemed very strong and cruel or at least very, very visual. It also looked like it was rising up, like a crown, and so I used the image on top of the cake that way. And of course the two images have similar shapes.

SWENSON: And those three light bulbs?

ROSENQUIST: Yes, in pink, yellow and blue, which are the three basic colors of the spectrum. In that area of the picture they allowed me to try experiments in color and scale that I could not have tried in another painting in a smaller size. That huge area allowed me to paint with regular artist's oil paint, the pink-grey and yellow-grey and blue-grey, on top of a fluorescent background. The dark red fluorescent paint appears to be lighter than the three light bulbs but the paint in the three light bulbs lets you get the idea that the bulbs are glowing, but not that they are turned on. It seemed to be like force against force.

The broken one is not broken the way a light bulb would break, but more like an egg would crack.

The spaghetti just on the right, with the fork, has been painted orange with artist's oil color; then a transparent fluorescent dark red color has been spread on top of the whole area, to give it a general tone change, like a glaze.

SWENSON: The girl under the hairdryer?

ROSENQUIST: In the gallery she seemed very crucial; everyone looked at her because they faced her when they went into the room. Here at the Jewish museum it isn't so prominent and I like it better. I thought of taking the face out many times, but then the whole painting would be closer to what is historically the look of abstract painting. I didn't think the face related to earlier painting.

The little girl is *the* female form in the picture. It is like someone having her hair dried out on the lawn, in Texas or Long Island. Painting the grass in Day-Glo green colors is like the change of nature in relation to the new look of the landscape.

SWENSON: Next there is an umbrella superimposed over an atom bomb blast. Is that about fallout?

ROSENQUIST: I suppose the umbrella could be something about fallout, but for me it's like someone raising his umbrella or raising his window in the morning, looking out the window and seeing a bright red and yellow atomic bomb blast, something like a cherry blossom, a beautiful view of an atomic blast.

When I was working in Times Square and painting signboards the workmen joked around and said the super center of the atomic target was around Canal Street and Broadway. That's where the rockets were aimed from Russia; and these guys, the old-timers would say, 'Well, I'm not worried. At least we'll have a nice view right up here against the wall.'

To me it's now a generation removed, the post-Beat young people. They're not afraid of an atomic war and think that sort of attitude is *passé*, that it won't occur. The Beat people, like Kerouac and Robert Frank, Dick Bellamy, Ginsberg and Corso, their first sensibility was of it being used immediately and they were hit by the idea of it, they were shocked and sort of threatened. Now the younger people are blasé and don't think it can happen. So this is a restatement of that Beat idea, but in full color.

The umbrella is friendlier than having to do with fallout. It's an aperture for a view. The rod holding up the umbrella goes right down the middle of the explosion like something being saved, the center of something else at the same time. The umbrella is realistic, it's a realistic vision, with frost or snow on top of it. The blue in the umbrella is its own color, not a Surrealistic piece of sky. It's a beach umbrella that was left up in the winter.

Then next, that's an underwater swimmer wearing a helmet with an air bubble above his head, an exhaust air bubble that's related to the breath of the atomic bomb. His 'gulp!' of breath is like the 'gulp!' of the explosion. It's an unnatural force, man-made.

I heard a story that when a huge number of bombers hit in Vietnam, and burned up many square miles of forest, then the exhaust of the heat and air pressure of the fire created an artificial storm and it started raining and helped put the fire out. The natives thought that something must be on their side; they thought it was a natural rain that put the fire out but it was actually a man-made change in the atmosphere.

SWENSON: What is the blanket-like form at the bottom of the picture?

ROSENQUIST: It is a huge arabesque, a huge fold. I painted it as a fold of aluminum material, an image of aluminum cloth. It appears soft, like a blanket.

It reminds me of a painter's drop cloth, finishing up the bottom of the

painting, hanging under the painting out onto the floor, catching the drops and residue of his paint. That's the nature from the artist's brush. The idea – his art – is on the wall; the junk or stuff of paint on the floor is nature, and something else. The artist is like a samurai; he selects something, and his art is what the artist says it is, it's not something else. The shiny grey arabesque is an extension of the relation between the painter and nature which could be a drop cloth or paint quality.

Then the arabesque changes into foodstuff, into spaghetti, and from its grey color into orange. The painting has its ending in an orange field, the image of spaghetti.

SWENSON: You were quoted in the *Times* as saying that you wanted this painting to be an antidote to the new devices that affect the ethics of the human being. . . .

ROSENQUIST: Yes. I hope this picture is a quantity that will release the idea of the new devices; my idea is that a man will turn to subversion if he even hears a rumor that a lie detector will be used on him in the normal course of business. What would happen if a major corporation decided to use all the new devices available to them? I'm sure the hint of this is starting to change people's ethics.

I said this picture was an antidote. To accumulate an antidote is to shift gears, to get to an area where an artist can be an effect. To get to another strata – anti-style could be a lever.

SWENSON: You once said to me that in your paintings you were trying to get at a quality, even more mysterious than death.

ROSENQUIST: Yes. What I meant was that ideas can have more of a mysterious effect than someone simply being eradicated. The effect on someone, the reality of something, can be more horrible and more mysterious than someone being totally destroyed. Having every memory obliterated – that can be more horrible than being shot.

SWENSON: But you're not saying that you are anti-machine because you are anti-style, or are you?

ROSENQUIST: Machines are exciting. I'm not anti-machine, but some machines seemingly can't be dealt with, they're so sophisticated. I feel we can be tripped up by the need to make a new ethic, instead of being very careful. We think we have solved something with the machine and actually we've tripped up human nature.

SWENSON: You were also quoted as saying that you were involved with the United States and the position of a person trying to be an artist. Were you suggesting by this that people ought to learn painting rather than how to run IBM machines or make F-111s?

ROSENQUIST: No. I'm amazed by – when I think of technology, I think of it being fantastic. I *would* want them to stop making F-111s because it's a war industry; but I wouldn't try to get a technologist to become an artist.

SWENSON: You don't see any war between technology and art?

ROSENQUIST: No. I see a closer tie with technology and art and a new curiosity about new methods of communication coming from all sides. The present position of an artist seems to be a person who offers up a gift, an antidote to something, a small relief to a heavy atmosphere. A person looking at it may say, 'That's beautiful, amazing, fantastic, a nice thing.' Artists seem to offer up their

things with very much humility and graciousness while society now and the economy seem to be very rambunctious. The stance of the artists now, compared with the world and the ideas in society, does not seem to equate; they don't relate except as an artist offering up something as a small gift. So the idea of this picture was to do an extravagance, something that wouldn't simply be offered as a relief.

Partisan Review, *Autumn 1965*

James Rosenquist
interview with G. R. Swenson

I think critics are hot-blooded. They don't take very much time to analyze what's in the painting. . . .

O.K., the critics can say [that Pop artists accept the mechanization of the soul]. I think it's very enlightening that *if* we do, we realize it instead of protesting too much. It hasn't been my reason. I have some reasons for using commercial images that these people probably haven't thought about. If I use anonymous images – it's true my images have not been hot-blooded images – they've been anonymous images of recent history, In 1960 and 1961 I painted the front of a 1950 Ford. I felt it was an anonymous image. I wasn't angry about that, and it wasn't a nostalgic image either. Just an image. I use images from old magazines – when I say old, I mean 1945 to 1955 – a time we haven't started to ferret out as history yet. If it was the front end of a new car there would be people who would be passionate about it, and the front end of an old car might make some people nostalgic. The images are like no-images. There is a freedom there. If it were abstract, people might make it into something. If you paint Franco-American spaghetti, they won't make a crucifixion out of it, and also who could be nostalgic about canned spaghetti? They'll bring their reactions but, probably, they won't have as many irrelevant ones. . . .

The images are now, already, on the canvas and the time I painted it is on the canvas. That will always be seen. That time span, people will look at it and say, 'why did he paint a '50 Ford in 1960, why didn't he paint a '60 Ford?' That relationship is one of the important things we have as painters. The immediacy may be lost in a hundred years, but don't forget that by that time it will be like collecting a stamp; this thing might have ivy growing around it. If it bothers to stand up – I don't know – it will belong to a stamp collector, it will have nostalgia then. But still that time reference will mean something. . . .

I have a feeling, as soon as I do something, or as I do something, nature comes along and lays some dust on it. There's a relationship between nature – nature's nature – and time, the day and the hour and the minute. If you do an iron sculpture, in time it becomes rusty, it gains a patina and that patina can only get to be beautiful. A painter searches for a brutality that hasn't been assimilated by nature. I believe there is a heavy hand of nature on the artist. My studio floor could be, some people would say that is, part of me and part of my painting

because that is the way I arranged it, the way things are. But it's not, because it's an accidental arrangement; it *is* nature, like flowers or other things. . . .

[Paint and paint quality] are natural things before you touch them, before they're arranged. As time goes by the brutality of what art is, the idea of what art can be, changes; different feelings about things become at home, become accepted, natural. . . . [Brutality is] a new vision or method to express something, its value geared right to the present time. . . .

When I was a student, I explored paint quality. Then I started working, doing commercial painting and I got all of the paint quality I ever wanted. I had paint running down my armpits. I kept looking at everything I was doing – a wall, a gasoline tank, I kept looking to see what happened, looking at a rusty surface, at the nature, at changing color. I've seen a lot of different ways paint takes form and what it does, and what excited me and what didn't. After some Abstract-Expressionist painting I did then, I felt I had to slice through all that, because I had a lot of residue, things I didn't want. I thought that I would be a stronger painter if I made most of my decisions before I approached the canvas; that way I hoped for a vision that would be more simple and direct. I don't know what the rules for Abstract-Expressionism are, but I think one is that you make a connection with the canvas and then you discover; that's what you paint – and eliminate what you don't want. I felt my canvases were jammed with stuff I didn't want. . . .

I'm amazed and excited and fascinated about the way things are thrust at us, the way this invisible screen that's a couple of feet in front of our mind and our senses is attacked by radio and television and visual communications, through things larger than life, the impact of things thrown at us, at such a speed and with such a force that painting and the attitudes toward painting and communication through doing a painting now seem very old-fashioned. . . .

I think we have a free society, and the action that goes on in this free society allows encroachments, as a commercial society. So I geared myself, like an advertiser or a large company, to this visual inflation – in commercial advertising which is one of the foundations of our society. I'm living in it, and it has such impact and excitement in its means of imagery. Painting is probably more exciting than advertising – so why shouldn't it be done with that power and gusto, with that impact. I see very few paintings with the impact that I've felt, that I feel and try to do in my work. . . . My metaphor, if that is what you can call it, is my relations to the power of commercial advertising which is in turn related to our free society, the visual inflation which accompanies the money that produces box tops and space cadets. . . .

When I use a combination of fragments of things, the fragments or objects or real things are caustic to one another, and the title is also caustic to the fragments. . . . The images are expendable, and the images are in the painting and therefore the painting is also expendable. I only hope for a colorful shoe-horn to get the person off, to turn him on to his own feelings. . . .

The more we explore, the more we dig through, the more we learn the more mystery there is. For instance, how can I justify myself, how can I make my mark, my 'X' on the wall in my studio, or in my experience, when somebody is jumping in a rocket ship and exploring outer space? Like, he begins to explore space, the deeper he goes in space the more there is of nature, the more mystery

there is. You may make a discovery, but you get to a certain point and that point opens up a whole new area that's never even been touched. . . .

I treat the billboard image as it is, so apart from nature. I paint it as a reproduction of other things; I try to get as far away from the nature as possible. . . .

An empty canvas is full, as Bob [Rauschenberg] said. Things are always gorgeous and juicy – an empty canvas is – so I put something in to dry it up. Just the canvas and paint – that would be nature. I see all this stuff [pointing to the texture of a canvas] – that's a whole other school of painting. All that very beautiful canvas can be wonderful, but it's another thing. The image – certainly it's juicy, too – but it throws your mind to something else, into art. From having an empty canvas, you have a painted canvas. It may have more action; but the action is like a confrontation, like a blow that cancels out a lot of other stuff, numbing your appreciation for a lot of juicy things. Then, too, somebody will ask, why do I want that image there? I don't want that image, but it's there. To put an image in, or a combination of images, is an attempt to make it at least not nature, cancel it from nature, wrest it away. Look at that fabric, there, the canvas, and the paint – those are like nature. . . .

I learned a lot more about painting paint when I painted signs. I painted things from photos and I had quite a bit of freedom in the interpretation, but still, after I did it, it felt cold to me, it felt like I hadn't done it, that it had been done by a machine. The photograph was a machine-produced image. I threw myself at it. I reproduced it as photographically and stark as I could. They're still done the same way; I like to paint them as stark as I can. . . .

I thought for a while I would like to use machine-made images, silk-screens, maybe. But by the time I could get them – I have specifics in my mind – it would take longer or as long, and it would be in a limited size, than if I did them as detached as I could by hand, in the detached method I learned as a commercial painter. . . .

When I first started thinking like this, feeling like this, from my outdoor painting, painting commercial advertising, I would bring home colors that I liked, associations that I liked using in my abstract painting, and I would remember specifics by saying this was a dirty bacon can, this was a yellow T-shirt yellow, this wos a Man-Tan suntan orange. I remember these like I was remembering an alphahet, a specific color. So then I started painting Man-Tan orange and – I always remember Franco-American spaghetti orange, I can't forget it – so I felt it as a remembrance of things, like a color chart, like learning an alphabet. Other people talk about painting nothing. You just can't do it. I paint something as detached as I can and as well as I can; then I have one image, that's it. But in a sense the image is expendable; I have to keep the image so that the thing doesn't become an attempt at a grand illusion, an elegance. . . .

If I use a lamp or a chair, that isn't the subject, it isn't the subject matter. The relationships may be the subject matter, the relationships of the fragments I do. The content will be something more, gained from the relationships. If I have three things, their relationship will be the subject matter; but the content will, hopefully, be fatter, balloon to more than the subject matter. One thing, though, the subject matter isn't popular images, it isn't that at all.

From 'What is Pop Art?' Interviews with eight painters (Part II). Gene Swenson, Art News, *February 1964*

Colin Self

statement

I am interested in upheavals, displacement and transference of emotion. Spiritual osmosis of sensation, thought, love or aggressive drives into new behaviour. The play on this spiritual osmosis in industrialized society or in wartime.

Suppression of love, sexual force or whatever and its new (sometimes unconscious) emergence into new forms. Be it furniture or car design, new art or love. People starved of their natural environments. Adjusting to new environments and situations.

[Soldier in *All Quiet on the Western Front* had been starved of mental food for so long that the sight of a butterfly made him utterly forget his situation, resulting in death from sniper fire. (The butterfly became deadlier than the enemy.)]

How people have adjusted to the raw truth of the thought of atomic warfare. The new culture incorporates the crisis into its new behaviour patterns.

Development of the aeroplane as a weapon affects me like an ever increasing, vibrating agony pain.

Art to me is a parasite. All the greatest art is firmly attached to and reflective of all the great religious, political or scientific developments (or misemployment of development).

Like the parasite sucker fish beneath the shark. It must travel with the shark in order to exist. Swimming on its own it becomes nothing.

Art must continually mirror something outside itself to have standards.

Sensual body in the photograph I have of 1st world war pinup. High nippled, firm breasts. Only the photo is real now. In time our records become us. Like being left holding the high tide mark on the sand after the tide has gone out.

$$\text{Effects of continual} \begin{cases} \text{noise} \\ \text{travel} \\ \text{the clock} \\ \text{war, etc.} \end{cases} \text{on society and art.}$$

I like snapshots of amazing or mysterious events, like that Japanese mountaineer's photos of the airliner breaking up and crashing into Mount Fuji. It's the witnessing. To witness.

Displacement and upheaval of peoples, animals and minerals from their natural haunts and formations (Zoos, Belsen, etc.). Chain reaction caused by this.

Awful ugliness in the photo I have of the blue whale which has been dragged from the sea, where it fits, functions (and looks beautiful) to the factory. The great gaping mess of flesh whose collapsing rib cage causes its suffocation by the extra gravitational pull in the air.

Its colouring is now wrong, shape – everything is wrong. I enjoy the way museums present peoples. Antique trivia on velvet backgrounds, broken fragments of pots displayed and guarded. Most important thing (the People) being missing. In time our records become us. The hot-dogs were created incorporating that 'museum' vision (Ephemeral).

The immediacy of machinery, whose forms, created for their functional value, have brought with them new beauty and rhythm.

Many purely functional objects are manufactured which have an extremely potent purely visual force. It is a logical step to borrow (foster) these objects for use as I personally see them. To arrange them. My view of them is my own. Priority of one image over another, in my mind, is something personal. The act of fostering rather than conceiving.

Oriental art forms. Their difference to Western art – and their validity. (Moon gazing parties, asymmetrical raku pottery, Noh plays, etc.)

[*Notes from Nov 1965 to Jan 1967*]

Studio International, *September 1967*

Richard Smith

statement

Instant Archaeology
Decisions in the earlier (to 1963) paintings were made to bring outside images into the paintings, the image references for the most part were obtuse but have become more visible with time. These references conditioned a number of factors in the paintings; colour, format and figuration were all affected in various degrees.

The aim of this inclusion of outside images was an effort to bring a fresh sensibility to making paintings and an extended sensibility in looking at paintings. From the vantage point of 1968 the effort seems to have proved at least a partial success. With pop-art saturation, the spectator becomes very conscious of images and objects taken from the mass media and made special, so much so that certain favoured objects are difficult to see in other than a fine art context. We are all archaeologists, though for the most part we are digging up things we ourselves buried or are only dusty.

There seemed a time when a variety of visual phenomena from various disciplines (print, film, photography) shared a sensibility (more than style), and by trying to refer to and incorporate this sensibility into paintings I felt I could use a visual octave outside the range of fine art. This would be possible I thought through paintings that shared scale, colour, texture, almost a shared *matière* with an aspect of the mass media.

This attitude no longer seems possible as the quality of the source material has changed. With graphics' total involvement and films' increasing involvement in the recent past there is now no present.

The Present
Though the source material becomes dated there is no reason why the paintings should date at the same rate or in a similar way.

I am seldom conscious of the moments of change at the time of change; paintings slipped from 2D to 3D without my being aware of a crucial change, 2D paintings did not stop immediately. In the first 3D paintings the actual physical shape was another layer in my concern with a complex of illusion and allusion,

it was an adding of an aspect of 'real', a solid space-occupying aspect. This 'real' bulk was constructed technically as a flat canvas plus being always connected with a flat rectangular canvas.

The shift in emphasis to where the 3D property of the painting became more the subject happened gradually. A growing disinterest in my previous source material was one factor, an apparent potential in the forms I was making was a second. The making of paintings has always been a subject in my work and with the shaping of the canvas this subject became more obvious and in some ways primary.

The earlier references to print and packaging were not as obvious as they now look and there are references built into the current painting which have a less particular range and which remain buried. These references act mainly as a kind of associative mnemonic enabling an idea around a colour or a form to be sustained.

I am in a situation now where decisions and concerns are in areas foreign to the most visible elements of the earlier paintings. In a retrospective considera-tion one can make convenient conclusions and though I see a relatively constant core in my work this core was not always my most pressing concern. A visual crusade on the level of 'dig this' was not what I wanted but I sense that it has somewhat turned out that way.

The newer paintings I want to be new entries in a lexicon not new definitions of forms already there.

Andy Warhol

Larry Bell

It is quite unique to these past few years that a generation of artists should have its influence on a second generation before it has even resolved its own philosophy. Modern means of communication and Pop Art are a romance that must have been made in heaven. It is my opinion that Andy Warhol is an incredibly important artist; he has been able to take painting as we know it, and completely change the frame of reference of painting as we know it, and do it successfully in his own terms. These terms are also terms that we may not understand.

Warhol has successfully been able to remove the artist's touch from the art. He has not tried to make a science out of it as Seurat did, but made an anti-science, anti-aesthetic, anti-'artistic', art totally devoid of all considerations that we may have thought of as necessary. He has taken a super-sophisticated attitude and made it the art, and made the paintings an expression of complete boredom for aesthetics as we know it.

It has always been my opinion that the only art that is really important is the art that changes. Warhol is important and his paintings are art. In the past artists have been involved with making art as an object, alone, relating only to

itself; these paintings are objects without reference and without relationship even to themselves. They even have very little to do with Andy Warhol, maybe nothing, because it is dubious whether he had anything to do with the act of painting them. It is painting in the most absolute and abstract sense; it is Pop Art and probably the first true, pure honest example of it. The paintings are visual proof that the 'thought' is sincere, considered and deliberate, with absolutely no guesswork, second guessing, or naïve accidents. It is absolute, it is painting, most of all, it is art. In any event, and no matter what is finally decided about it, nothing can take away from it the important changes that the work itself has made in the considerations of other artists.

From a statement written by Larry Bell in September, 1963, upon first seeing an exhibition of Warhol's work.

<p align="right">Artforum, February 1965</p>

Andy Warhol

interview with G. R. Swenson

Someone said that Brecht wanted everybody to think alike. I want everybody to think alike. But Brecht wanted to do it through Communism, in a way. Russia is doing it under government. It's happening here all by itself without being under a strict government; so if it's working without trying, why can't it work without being Communist? Everybody looks alike and acts alike, and we're getting more and more that way.

I think everybody should be a machine.

I think everybody should like everybody.

Is that what Pop Art is all about?

Yes. It's liking things.

And liking things is like being a machine?

Yes, because you do the same thing every time. You do it over and over again.

And you approve of that?

Yes, because it's all fantasy. It's hard to be creative and it's also hard not to think what you do is creative or hard not to be called creative because everybody is always talking about that and individuality. Everybody's always being creative. And it's so funny when you say things aren't, like the shoe I would draw for an advertisement was called a 'creation' but the drawing of it was not. But I guess I believe in both ways. All these people who aren't very good should be really good. Everybody is too good now, really. Like, how many actors are there? There are millions of actors. They're all pretty good. And how many painters are there? Millions of painters and all pretty good. How can you say one style is better than another? You ought to be able to be an Abstract-Expressionist next week, or a Pop artist, or a realist, without feeling you've given up something. I think the artists who aren't very good should become like everybody else so that people would like things that aren't very good. It's already happening. All you have to do is read the magazines and the catalogues.

It's this style or that style, this or that image of man – but that really doesn't make any difference. Some artists get left out that way, and why should they?
Is Pop Art a fad?
Yes, it's a fad, but I don't see what difference it makes. I just heard a rumor that G. quit working, that she's given up art altogether. And everyone is saying how awful it is that A. gave up his style and is doing it in a different way. I don't think so at all. If an artist can't do any more, then he should just quit; and an artist ought to be able to change his style without feeling bad. I heard that Lichtenstein said he might not be painting comic strips a year or two from now – I think that would be so great, to be able to change styles. And I think that's what's going to happen, that's going to be the whole new scene. That's probably one reason I'm using silk screens now. I think somebody should be able to do all my paintings for me. I haven't been able to make every image clear and simple and the same as the first one. I think it would be so great if more people took up silk screens so that no one would know whether my picture was mine or somebody else's.
It would turn art history upside down?
Yes.
Is that your aim?
No. The reason I'm painting this way is that I want to be a machine, and I feel that whatever I do and do machine-like is what I want to do.
Was commercial art more machine-like?
No, it wasn't. I was getting paid for it, and did anything they told me to do. If they told me to draw a shoe, I'd do it, and if they told me to correct it, I would – I'd do anything they told me to do, correct it and do it right. I'd have to invent and now I don't; after all that 'correction', those commercial drawings would have feelings, they would have a style. The attitude of those who hired me had feeling or something to it; they knew what they wanted, they insisted; sometimes they got very emotional. The process of doing work in commercial art was machine-like, but the attitude had feeling to it.
Why did you start painting soup cans?
Because I used to drink it. I used to have the same lunch every day, for twenty years, I guess, the same thing over and over again. Someone said my life has dominated me; I liked that idea. I used to want to live at the Waldorf Towers and have soup and a sandwich, like that scene in the restaurant in *Naked Lunch*. . . .

We went to see *Dr No* at Forty-second Street. It's a fantastic movie, so cool. We walked outside and somebody threw a cherry bomb right in front of us, in this big crowd. And there was blood. I saw blood on people and all over. I felt like I was bleeding all over. I saw in the paper last week that there are more people throwing them – it's just part of the scene – and hurting people. My show in Paris is going to be called 'Death in America'. I'll show the electric-chair pictures and the dogs in Birmingham and car wrecks and some suicide pictures.
Why did you start these 'Death' pictures?
I believe in it. Did you see the *Enquirer* this week? It had 'The Wreck that Made Cops Cry' – a head cut in half, the arms and hands just lying there. It's sick, but I'm sure it happens all the time. I've met a lot of cops recently. They take pictures of everything, only it's almost impossible to get pictures from them.

When did you start with the 'Death' series?

I guess it was the big plane crash picture, the front page of a newspaper: 129 DIE. I was also painting the *Marilyns*. I realized that everything I was doing must have been Death. It was Christmas or Labor Day – a holiday – and every time you turned on the radio they said something like, '4 million are going to die'. That started it. But when you see a gruesome picture over and over again, it doesn't really have any effect.

But you're still doing 'Elizabeth Taylor' pictures.

I started those a long time ago, when she was so sick and everybody said she was going to die. Now I'm doing them all over, putting bright colors on her lips and eyes.

My next series will be pornographic pictures. They will look blank; when you turn on the black lights, then you see them – big breasts and. . . . If a cop came in, you could just flick out the lights or turn to the regular lights – how could you say that was pornography? But I'm still just practising with these yet. Segal did a sculpture of two people making love, but he cut it all up, I guess because he thought it was too pornographic to be art. Actually it was very beautiful, perhaps a little too good, or he may feel a little protective about art. When you read Gênet you get all hot, and that makes some people say this is not art. The thing I like about it is that it makes you forget about style and that sort of thing; style isn't really important.

Is 'Pop' a bad name?

The name sounds so awful. Dada must have something to do with Pop – it's so funny, the names are really synonyms. Does anyone know what they're supposed to mean or have to do with, those names? Johns and Rauschenberg – Neo-Dada for all these years, and everyone calling them derivative and unable to transform the things they use – are now called progenitors of Pop. It's funny the way things change. I think John Cage has been very influential, and Merce Cunningham, too, maybe. Did you see that article in the *Hudson Review* ['The End of the Renaissance?', Summer, 1963]? It was about Cage and that whole crowd, but with a lot of big words like radical empiricism and teleology. Who knows? Maybe Jap and Bob were Neo-Dada and aren't any more. History books are being rewritten all the time. It doesn't matter what you do. Everybody just goes on thinking the same thing, and every year it gets more and more alike. Those who talk about individuality the most are the ones who most object to deviation, and in a few years it may be the other way around. Some day everybody will think just what they want to think, and then everybody will probably be thinking alike; that seems to be what is happening.

Is Pop Art a counter-revolution?

I don't think so. As for me, I got my subject matter from Hans Memling (I started with 'Portrait Collages') and de Kooning gave me content and motivation. My work evolves from that.

What influences have you felt in your work from, say, Dada?

When I first came across it, I respected it and thought it was pretty good; but it didn't have anything to do with me. As my work began to evolve I realized – not consciously, it was like a surprise – that maybe it had something to do with my work.

It was the same with Rauschenberg. When I saw his painting with the radios

in it I thought it was fine, O.K., but it had no effect on me. It ceased to exist for me except in Rauschenberg's world. Much later I got interested in the addition of movement to painting, so a part of the painting was attached to a motor. An interest in using light and sound followed – I put in a television. But not only for the television image – who cares about television images? – but because I cared about the dimension it gave to painting, something that moved, and gave off light and sound. I used a radio and when I did I felt as if I were the first who'd ever used a radio. It's not that I think of that as an accomplishment – it's just that Rauschenberg didn't seem an immediate factor in it. He was, of course; his use of objects in paintings made it somehow legitimate; but I used a radio for my own reasons. . . .

I've been painting more, lately, in these big works. I'm more and more aware of how audacious the act of painting is. One of the reasons I got started making collages was that I lacked involvement with the thing I was painting; I didn't have enough interest in a rose to paint it. Some of this, I think, comes from the painting of the fifties – I mean, for a painter the love of flowers was gone. I don't love roses or bottles or anything like that enough to want to sit down and paint them lovingly and patiently. Now with these big pictures, well, there aren't enough billboards around and I have to paint a bowl – and I don't have any feelings about bowls or how a bowl should be. I only know I have to have a bowl in that painting. Here, in this picture I'm working on, I made this plain blue bowl and then I realized it had to have something on it. I had to invent a bowl and – god! – I couldn't believe how audacious it was. And it's threatening too – painting something without any conviction about what it should be.

Do you mean that collage materials permit you to use an image and still be neutral toward the object represented?

I think painting is essentially the same as it has always been. It confuses me that people expect Pop Art to make a comment or say that its adherents merely accept their environment. I've viewed most of the paintings I've loved – Mondrians, Matisses, Pollocks – as being rather dead-pan in that sense. All painting is fact, and that is enough; the paintings are charged with their very presence. The situation, physical ideas, physical presence – I feel that is the comment.

From 'What is Pop Art?' Interviews with eight painters (Part I). Gene Swenson, Art News, November 1963

Tom Wesselmann
interview with G. R. Swenson

What is Pop Art?
I dislike labels in general and Pop in particular, especially because it over-emphasizes the material used. There does seem to be a tendency to use similar materials and images, but the different ways they are used denies any kind of group intention.

When I first came to painting there was only de Kooning – that was what I wanted to be, with all its self-dramatization. But it didn't work for me. I did one sort of non-objective collage that I liked, but when I tried to do it again I had a kind of artistic nervous breakdown. I didn't know where I was. I couldn't stand

the insecurity and frustration involved in trying to come to grips with something that just wasn't right, that wasn't me at any rate.

Have you banished the brushstroke from your work?

I'm painting now more than I used to because I'm working so big; there's a shortage of collage material. So brushstrokes can occur, but they are often present as a collage element; for example, in one big still-life I just did there's a tablecloth section painted as if it were a fragment from an Abstract-Expressionist painting inserted into my picture. I use de Kooning's brush knowing it is his brush.

One thing I like about collage is that you can use anything, which gives you that kind of variety; it sets up reverberations in a picture from one kind of reality to another. I don't attach any kind of value to brushstrokes, I just use them as another thing from the world of existence. My first interest is the painting which is the whole, final product. I'm interested in assembling a situation resembling painting, rather than painting; I like the use of painting because it has a constant resemblance to painting.

What is the purpose of juxtaposing different kinds of representations?

If there was any single aspect of my work that excited me, it was that possibility – not just the differences between what they were, but the aura each had with it. They each had such a fulfilled reality; the reverberations seemed a way of making the picture more intense. A painted pack of cigarettes next to a painted apple wasn't enough for me. They were both the same kind of thing. But if one is from a cigarette ad and the other a painted apple, they are two different realities and they trade on each other; lots of things – bright strong colors, the qualities of materials, images from art history or advertising – trade on each other. This kind of relationship helps establish a momentum throughout the picture – all the elements are in some way very intense. Therefore throughout the picture all the elements compete with each other.

What does aesthetics mean to you and your work?

Aesthetics is very important to me, but it doesn't deal with beauty or ugliness – they aren't values in painting for me, they're beside the point. Painting relates to both beauty and ugliness. Neither can be made. (I try to work in the gap between the two.) I've been thinking about that, as you can see. Perhaps 'intensity' would be a better emphasis. I always liked Marsicano's quote – from ARTNEWS – 'Truth can be defined as the intensity with which a picture forces one to participate in its illusion.'

Some of the worst things I've read about Pop Art have come from its admirers. They begin to sound like some nostalgia cult – they really worship Marilyn Monroe or Coca-Cola. The importance people attach to things the artist uses is irrelevant. My use of elements from advertising came about gradually. One day I used a tiny bottle picture on a table in one of my little nude collages. It was a logical extension of what I was doing. I use a billboard picture because it is a real, special representation of something, not because it is from a billboard. Advertising images excite me mainly because of what I can make from them. Also I use real objects because I need to use objects, not because objects need to be used. But the objects remain part of a painting because I don't make environments. My rug is not to be walked on.

From 'What is Pop Art?' Interviews with eight painters (Part II). Gene Swenson, Art News, February 1964

I EDWARD RUSCHA *Noise, Pencil, Broken Pencil, Cheap Western* 1963
Oil on canvas, 77 × 66½ ins (124)

Numbers in brackets () refer to catalogue entries
 *not in exhibition
**original version; 2nd version in
 exhibition not illustrated

II JANN HAWORTH *L.A. Times Bedspread* 1965
 Fabric, 78×100 ins (44)

III OYVIND FAHLSTRÖM *Performing Krazy Kat No. 2, Sunday Edition* 1963–64 ▶
 Tempera on paper on canvas, 52×34 ins (34)

IV PETER BLAKE *Got a Girl* 1960-61
Oil on hardboard with collage,
27×61 ins (12)

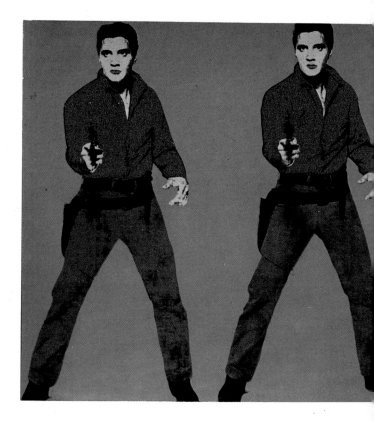

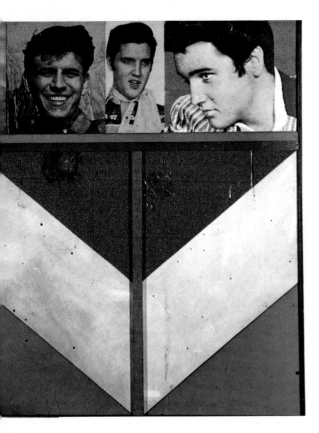

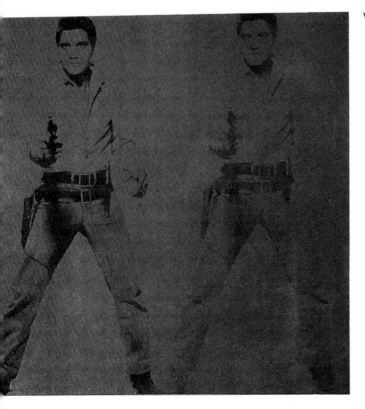

V ANDY WARHOL *Elvis I and II* 1964
Silk screen on acrylic and
aluminium on canvas,
2 panels, 82×82 ins each (154)

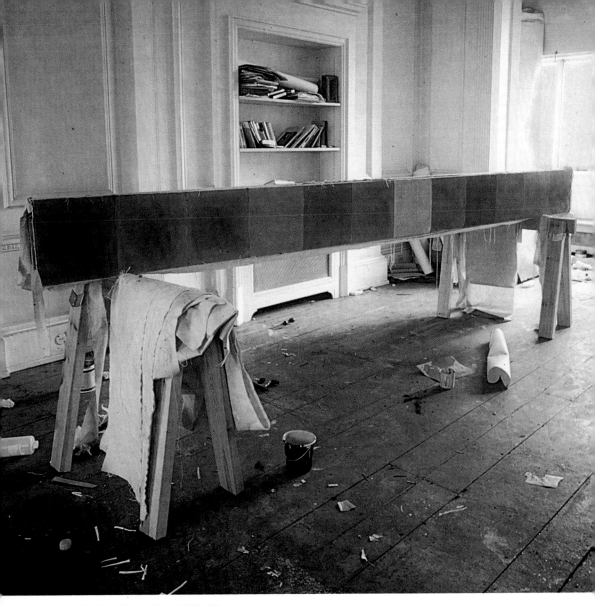

VI JIM DINE *Saw Horse Piece* 1968-69
Paint, canvas, wood, 44×144×43 ins (32)

VII ROY LICHTENSTEIN *Cathedral* 1969 ▶
One of six screen prints after Monet, 47×33 ins (89)

VIII ROBERT INDIANA *The Demuth Five* 1963
Oil on canvas, 64×64 ins (52)

**1 CLAES OLDENBURG *Bedroom Ensemble I* 1963 Mixed media construction, 10×17×20 ft

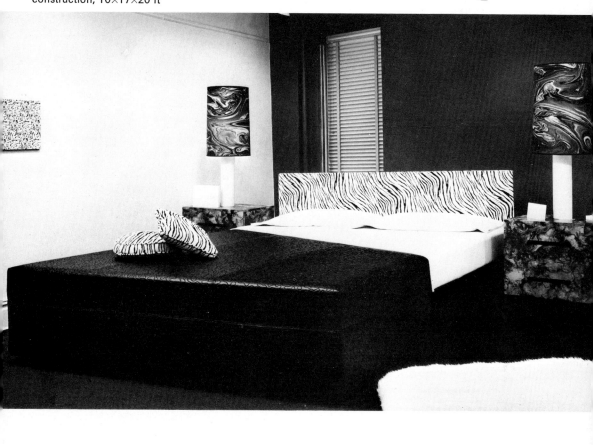

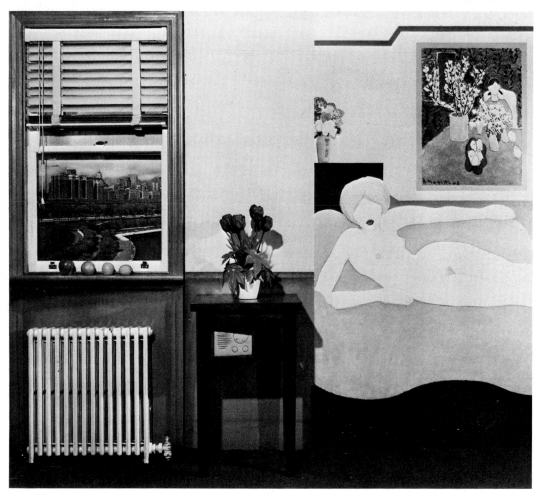

2 TOM WESSELMANN *Great American Nude No. 48* 1963 Construction and mixed media, 84×108 ×36 ins (160)

3 RICHARD HAMILTON *Just What Is It that Makes Today's Homes so Different, so Appealing?* 1956 Collage, 10¼×9¾ ins (38)

*4 JAMES ROSENQUIST *Untitled* 1963 Oil on canvas with projections, 78×78 ins

5 JIM DINE *Four Rooms* 1962 Oil on canvas, with chair, 72×180 ins (28)

6 WAYNE THIEBAUD *Woman in Tub* 1965 Oil on canvas, 36×60 ins (143)

black bathroom #2

7 JIM DINE *Black Bathroom No. 2*
1962 Oil on canvas with china
wash-basin, 72×72 ins (29)

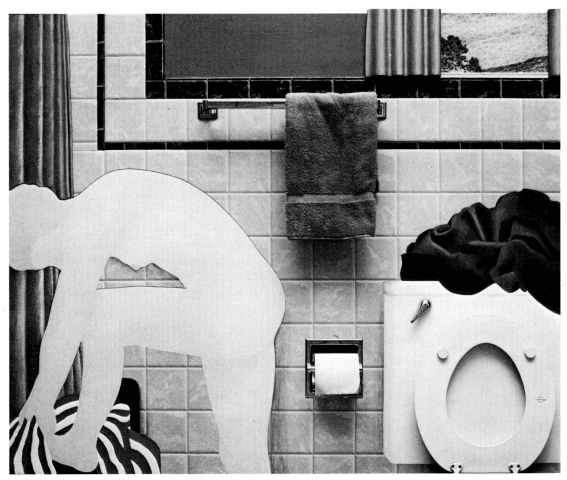

*8 TOM WESSELMANN *Bathtub Collage No. 1* 1963 Construction and mixed media, 48×60 ins

*9 GEORGE SEGAL *Woman Shaving her Leg* 1963 Plaster figure and bathroom, 63×65×30 ins ▶

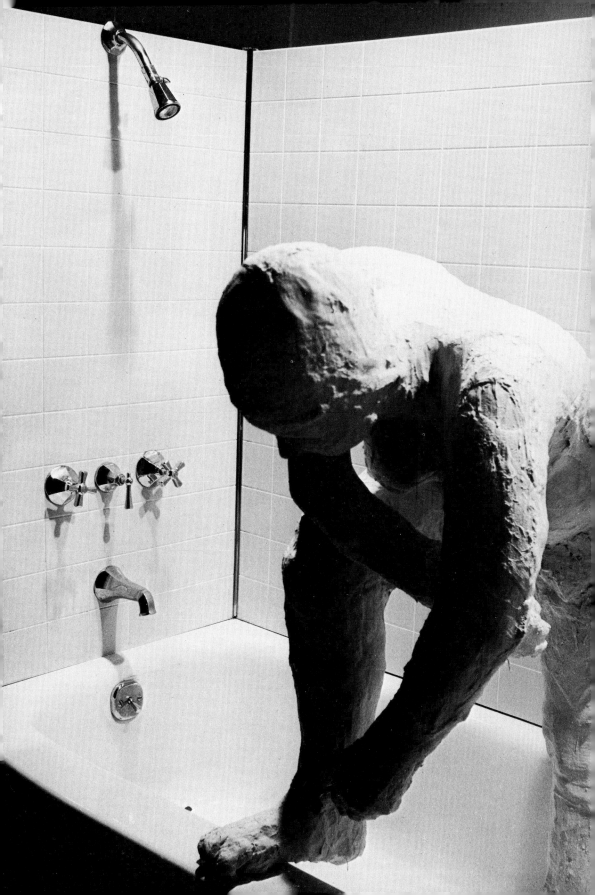

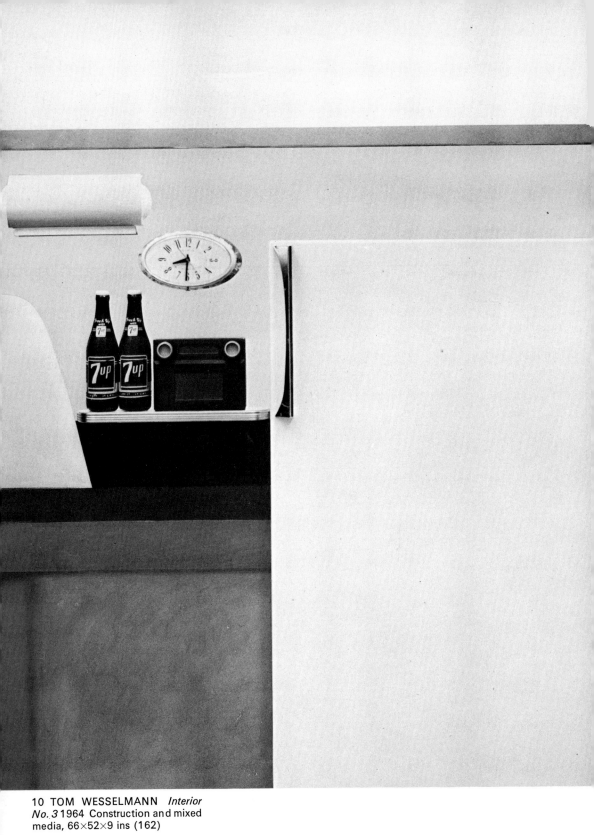

10 TOM WESSELMANN *Interior No. 3* 1964 Construction and mixed media, 66×52×9 ins (162)

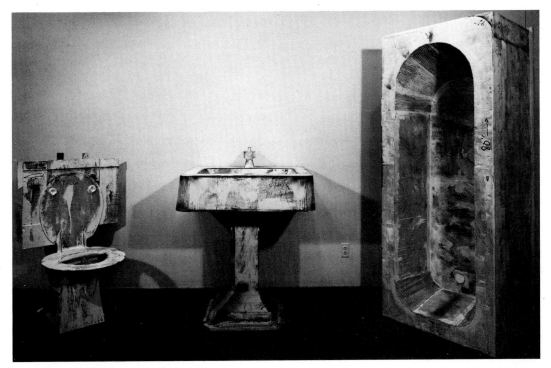

*11 CLAES OLDENBURG *Model for Bathroom* 1966 Corrugated paper and enamel

*12 ROY LICHTENSTEIN *Bathroom* 1961 Oil on canvas, *c.* 40×65 ins

13 CHRISTO *Packed Armchair*
1964–65 Armchair, plastic, cloth,
polyethylene, ropes, $38 \times 31\frac{1}{4} \times 32$
ins (24)

14 GEORGE BRECHT *Chair
Event* 1969 realization of 1961
event-score. Chair with objects,
36×24×21 ins (20)

15 RICHARD ARTSCHWAGER
Executive Table and Chair Formica
on wood, 44×44×25 ins (4)

16 ALEX HAY *Label* 1967 Spray lacquer and stencil on canvas, 37× 60 ins (46)

17 CLAES OLDENBURG *Soft Typewriter* 1963-64 Vinyl, kapok, cloth, plexiglass, 9×27½×26 ins (104)

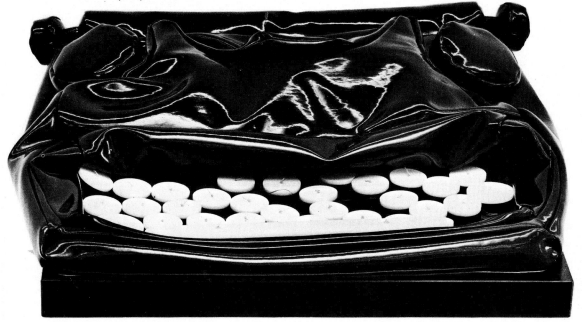

18 RICHARD SMITH *Cash Register* 1965 Oil on canvas, $48\frac{1}{2} \times 49\frac{1}{4} \times 14\frac{1}{2}$ ins (139)

19 RICHARD SMITH *Cash Register* 1965 Oil on canvas, $48\frac{1}{2}\times$ $49\frac{1}{4}\times15\frac{1}{4}$ ins (140)

20 DEREK BOSHIER *Airmail Letter*
1961 Oil on canvas, 60×60 ins (14)

21 ROY LICHTENSTEIN *Composition II* 1964 Magna on canvas, 56×48 ins (88)

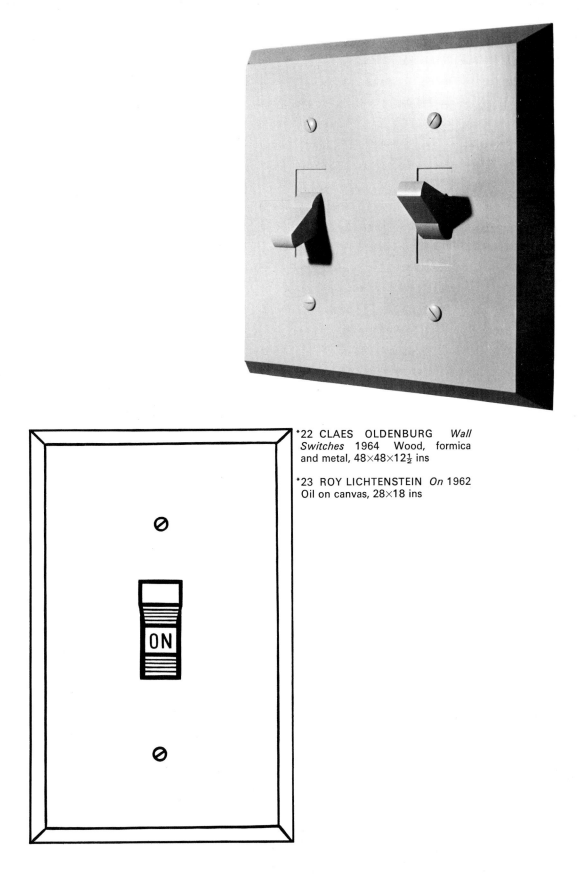

*22 CLAES OLDENBURG *Wall Switches* 1964 Wood, formica and metal, 48×48×12½ ins

*23 ROY LICHTENSTEIN *On* 1962 Oil on canvas, 28×18 ins

24 ALEX HAY *Toaster* 1964 Oil
on canvas, 92×73 ins (overall) (45)

25 RICHARD HAMILTON *Toaster*
1967 Aluminium and perspex
relief on photo on panel, 36×36 ins
(40)

26 JIM DINE *Toaster* 1962 Oil ▶
on canvas and toaster, 100×80×7
ins (30)

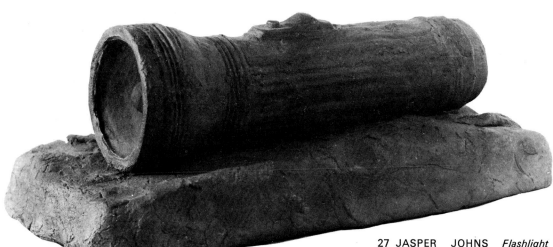

27 JASPER JOHNS *Flashlight*
1958 Papier-mâché and glass,
8×3½×3 ins (54)

28 JASPER JOHNS *Lightbulb*
1960 Painted bronze, 4¼×6×4 ins
(56)

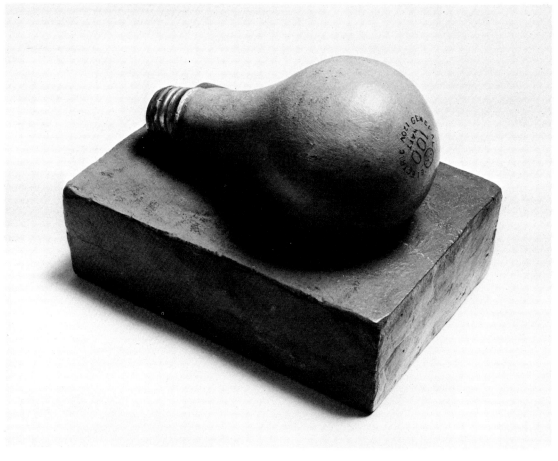

29 ROBERT MORRIS *Untitled sculpture* 1963 Wood and rope. $5\frac{3}{8}\times15\frac{3}{4}\times3\frac{1}{2}$ ins (96)

30 ROBERT RAUSCHENBERG *Pail for Ganymede* 1959 Construction, $13\times6\times5$ ins (116)

31 TOM WESSELMANN *Still life
No. 54* 1965 Plastic (illuminated),
48×60 ins (163)

32 ALEX HAY *Paper Bag* 1968
Paper, epoxy, fibreglass, paint, 60×
29×17¾ ins (49)

33 PETER BLAKE *Pub Door* 1962
Collage construction, 56½×37×
10¾ ins (13)

34 ROBERT RAUSCHENBERG ▶
Winter Pool 1959 Combine
painting, 88½×58½ ins (115)

◀ 35 GEORGE SEGAL *Cinema* 1963
Plaster figure and illuminated plexi-
glass, 118×96×39 ins (131)

36 WAYNE THIEBAUD *Booth
Girl* 1964 Oil on canvas, 72×48 ins
(142)

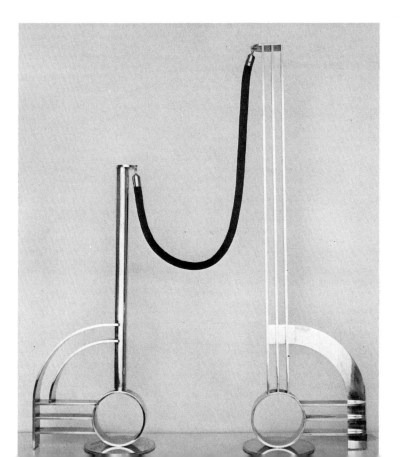

37 EDWARD RUSCHA *Hollywood*
1968 Lithograph, 40¾×12½ ins
(130)

◀ 38 ROY LICHTENSTEIN *Modern
Sculpture with Velvet Rope* 1968
Brass and velvet rope, 2 parts: 83¼×
26×15 ins; 59×26×15 ins (88a)

39 COLIN SELF *Cinema 3* 1964
Pencil and collage, 15×22 ins (133)

40 COLIN SELF *Cinema SI* 1964
Wood, upholstery, paper and lac-
quers, 24×24 ins (135)

41 COLIN SELF *Cinema 11* 1965
Pencil and collage, 15×22¼ ins
(134)

42 COLIN SELF *Empty Cinema*
1966 Pencil, pen and ink, 22×29½
ins (136)

43 JANN HAWORTH *Mae West*
1965 Mixed media, 28¼×22½ ×25
ins (42)

44 JAMES ROSENQUIST *Untitled* 1964 Oil on canvas, 92×78 ins (122)

45 ANDY WARHOL *Gold Marilyn Monroe* 1962 Synthetic polymer paint silk-screened, and oil on canvas, 83¼×57 ins (151)

46 PETER PHILLIPS *Star/Card/Table* 1962 Oil on canvas, 30×33 ins (112)

47 RAY JOHNSON *Shirley Temple II* 1967 Collage, 18×20½ ins (72)

48 RAY JOHNSON *Guess Who's Coming to Dinner?* 1968 Collage, 17×20½ ins (73)

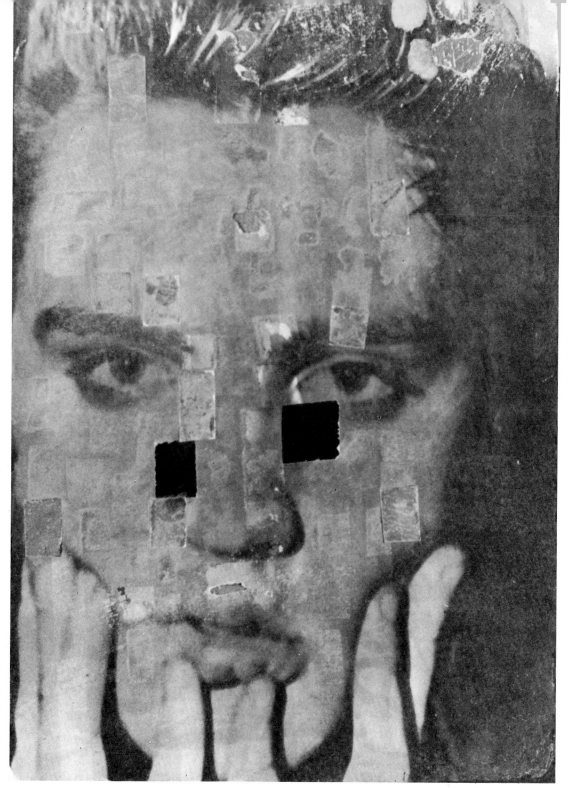

49 RAY JOHNSON *Elvis Presley*
No. 2 1955 Collage, $15\frac{3}{8} \times 11\frac{1}{2}$ ins
(65)

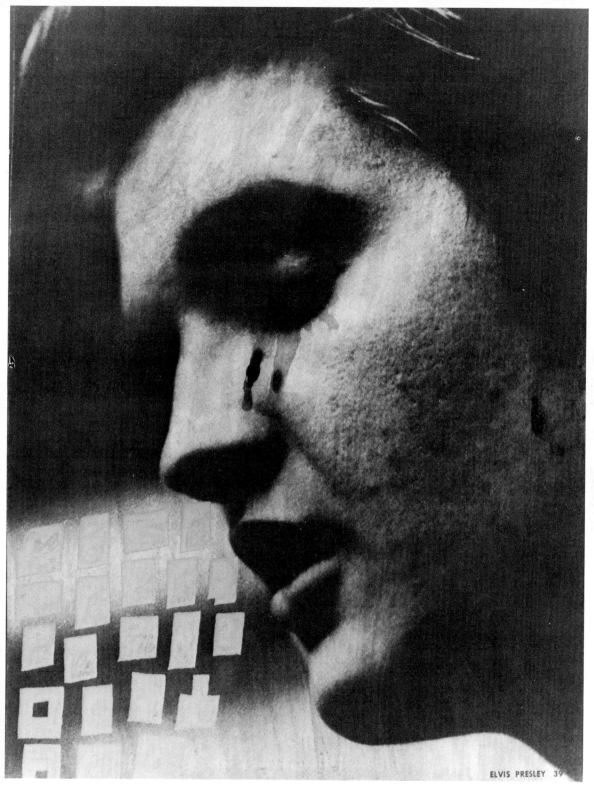

ELVIS PRESLEY 39

50 RAY JOHNSON *Elvis Presley
No. 1* 1955 Collage, 15×11½ ins
(64)

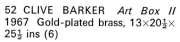

51 ROY LICHTENSTEIN *Art* 1962
Oil on canvas, 36×68 ins (85)

52 CLIVE BARKER *Art Box II*
1967 Gold-plated brass, 13×20½×
25½ ins (6)

QUALITY MATERIAL ---

CAREFUL INSPECTION --

GOOD WORKMANSHIP.

ALL COMBINED IN AN EFFORT TO GIVE YOU A PERFECT PAINTING.

53 JOHN BALDESSARI *Quality Material* 1967 Oil and acrylic on canvas, $67\frac{3}{4} \times 56\frac{1}{2}$ ins (5)

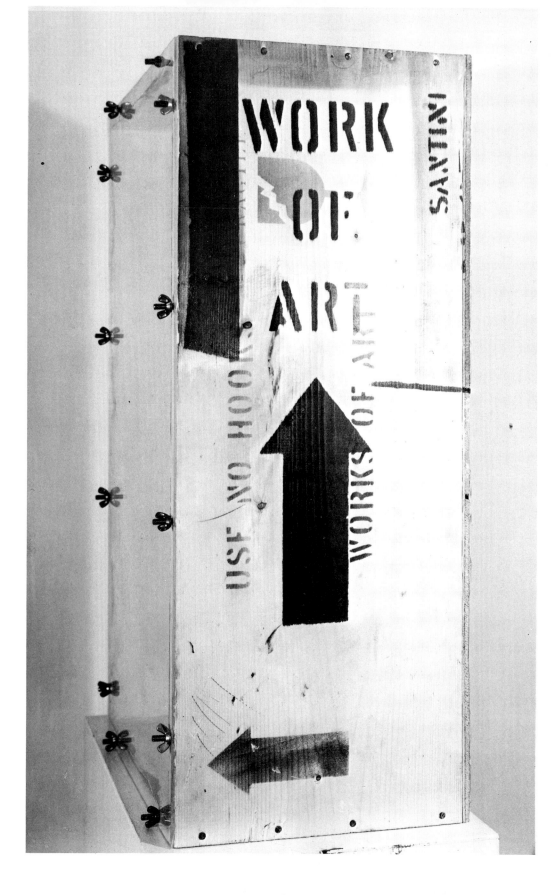

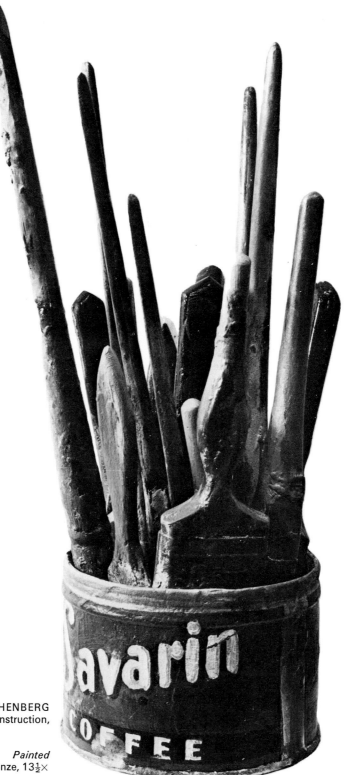

54 ROBERT RAUSCHENBERG
Art Box 1962–63 Construction,
30×16×12 ins (117)

55 JASPER JOHNS *Painted
Bronze* 1960 Painted bronze, 13½×
8 ins diameter (57)

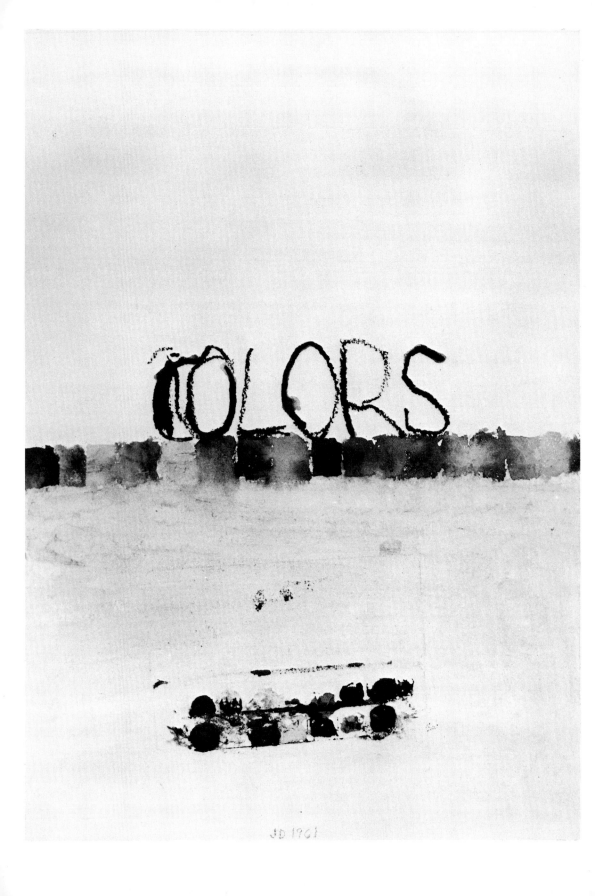

◀ 56 JIM DINE *Paint Box No. 1* 1961
Watercolour, $14\frac{1}{8}\times10\frac{5}{8}$ ins (27)

57 JOE TILSON *Colour Chart A*
1967–68 Polyurethane on wood
relief, 24×33×2 ins (145)

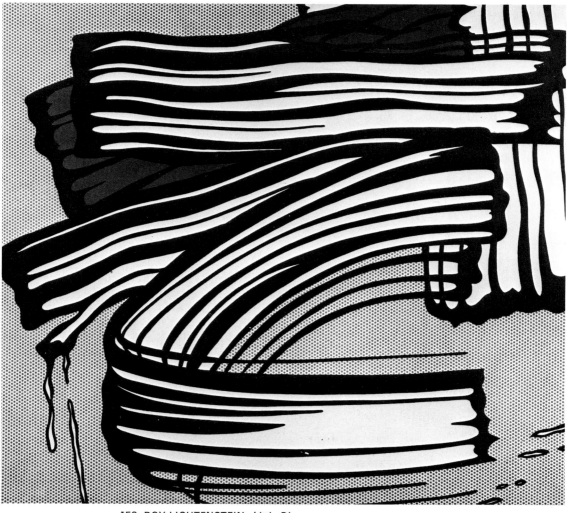

*58 ROY LICHTENSTEIN *Little Big Painting* 1965 Oil on canvas, 68×80 ins

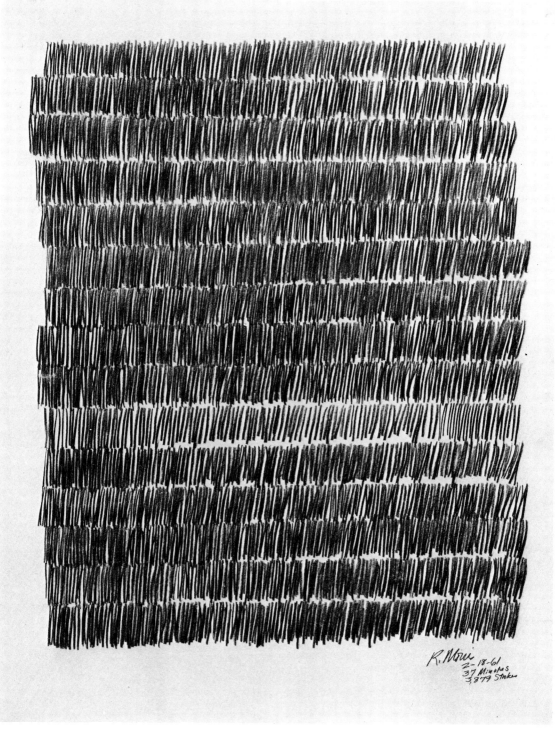

59 ROBERT MORRIS *37 Minutes*
3879 Strokes 1961 Pencil on paper,
24¾×19½ ins (95)

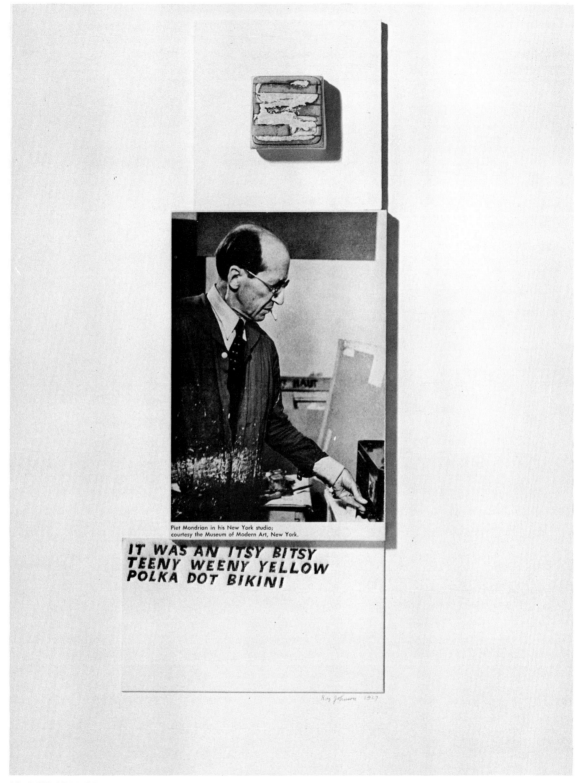

Piet Mondrian in his New York studio;
courtesy the Museum of Modern Art, New York.

IT WAS AN ITSY BITSY
TEENY WEENY YELLOW
POLKA DOT BIKINI

60 RAY JOHNSON *Bridget Riley's
Comb* 1966 Collage, 24½×13⅛ ins
(68)

61 RAY JOHNSON *Mondrian*
1967 Collage, 18½×14 ins (69)

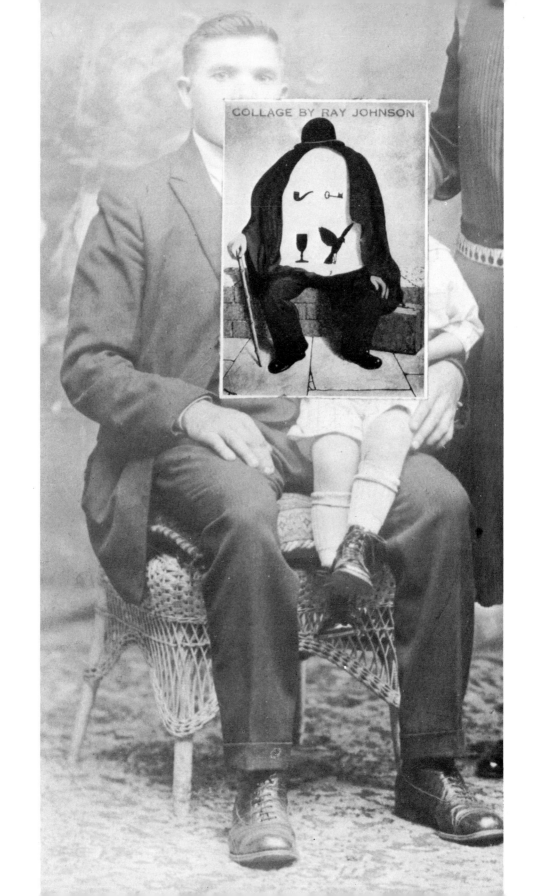

◄ 62 RAY JOHNSON *Homage to Magritte* 1962 Collage, $13\frac{1}{4}\times6\frac{1}{2}$ ins (66)

63 CLIVE BARKER *Homage to Magritte* 1969 Chrome-plated bronze, $8\times9\frac{1}{2}$ ins (8)

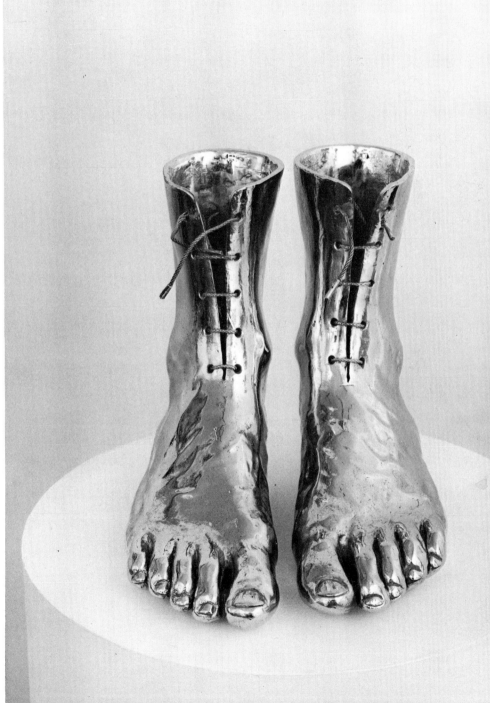

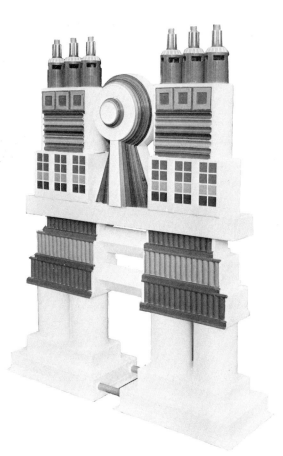

64 EDUARDO PAOLOZZI *Tower for Mondrian* 1963–64 Painted aluminium, 95¾×71¼×16⅛ ins (110)

65 PATRICK CAULFIELD *Sculpture in a Landscape* 1966 Oil on hardboard, 48×84 ins (23)

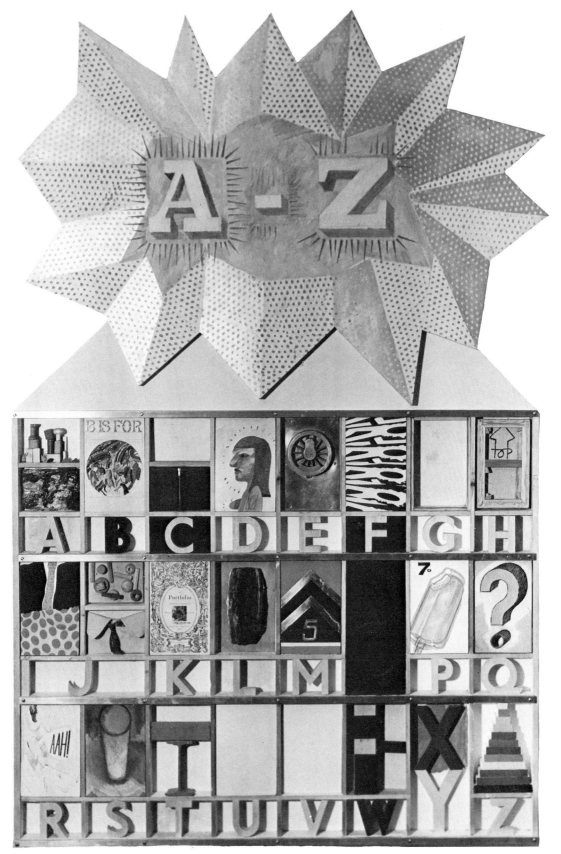

66 JOE TILSON *A–Z, A Contributive Picture* 1963 Construction, 92×60×4 ins (144)

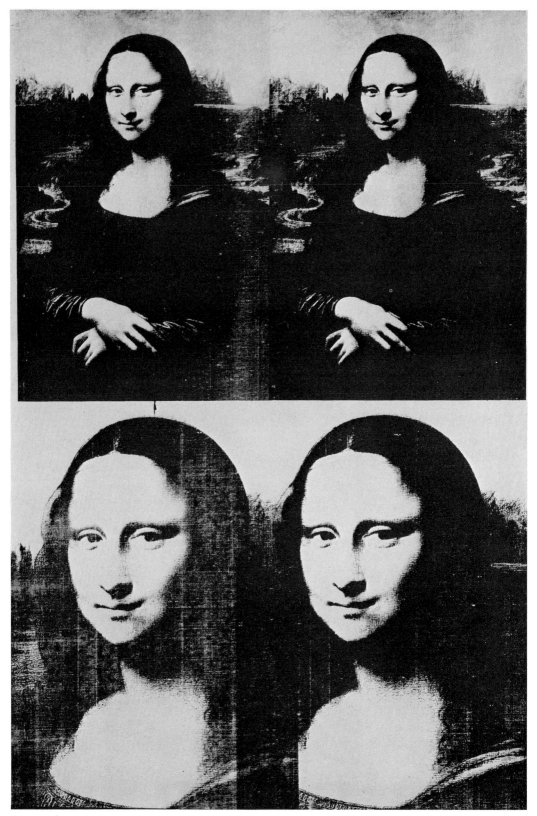

67 ANDY WARHOL *Mona Lisa* 1963 Silk-screen on canvas, 43¾×29⅛ ins (157)

68 ROY LICHTENSTEIN *Woman in Armchair* 1963 Magna on canvas, 68×48 ins (86)

69 JOHN CLEM CLARKE *Liberty
Leading the People* (after Dela-
croix) 1968 Oil on canvas, 60×48
ins (25)

70 PATRICK CAULFIELD *Greece Expiring on the Ruins of Missolonghi* (after Delacroix) 1963 Oil on hardboard, 60×48 ins (22)

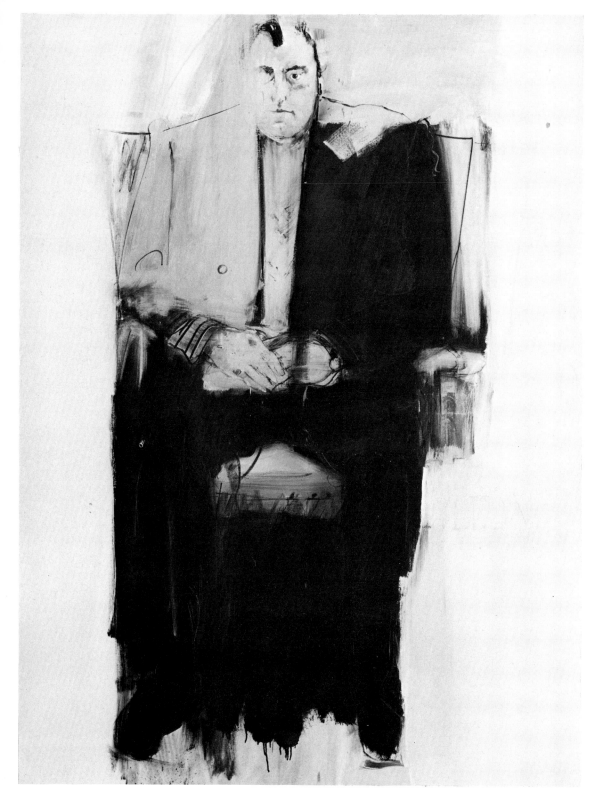

71 LARRY RIVERS *Mr Art* (Portrait of David Sylvester) 1962 Oil on canvas, 72×52 ins (118)

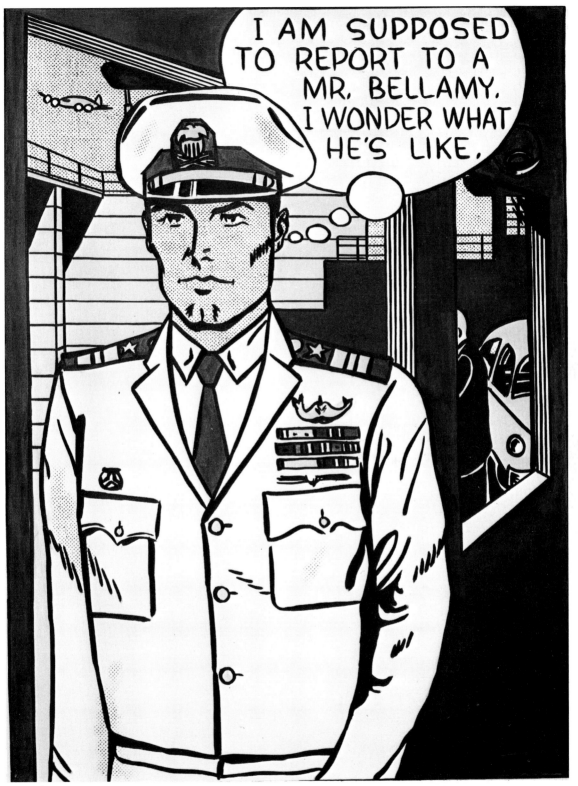

72 ROY LICHTENSTEIN *Mr Bellamy* 1961 Oil on canvas, 56×42 ins (81)

73 LARRY RIVERS *OK Robert OK Negro* 1966 Spray paint, pencil, collage, 23½×19¾ ins (120)

74 MARISOL *Henry* 1965 Construction, 67×31×16½ ins (93)

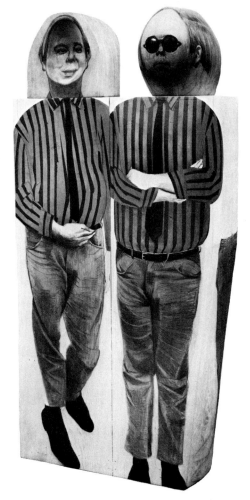

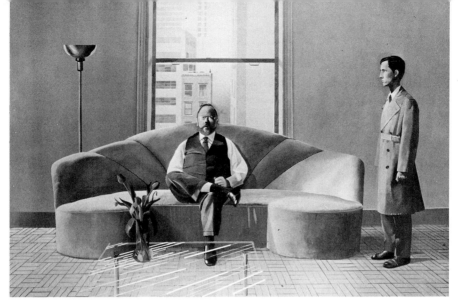

75 DAVID HOCKNEY *Henry Geld-zahler and Christopher Scott* 1969 Acrylic on canvas, 84×120 ins (51)

76 EDWARD KIENHOLZ *Walter Hopps, Hopps, Hopps* 1959 Construction, 78×34 ins (76)

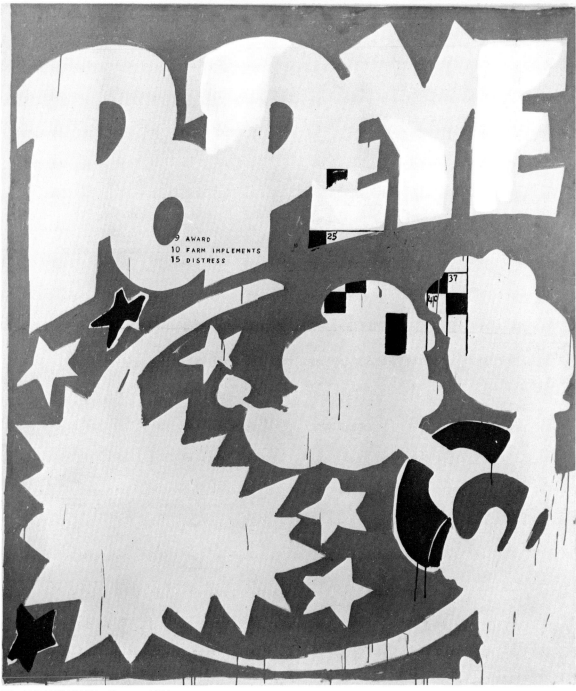

77 ANDY WARHOL *Popeye* 1961
Casein on canvas, $68\frac{1}{4} \times 58\frac{1}{2}$ ins
(147)

78 JESS COLLINS *Tricky Cad*
1959 Newspaper collage, 19×7
ins (26)

79 OYVIND FAHLSTRÖM *Green Pool* 1968–69 Variable structure in plexiglass pool with dyed water, 6×21×42 ins (36)

80 ROY LICHTENSTEIN *Eddie Diptych* 1962 Oil on canvas, 44×52 ins (2 panels) (83)

81 OYVIND FAHLSTRÖM *Performing Krazy Kat III* 1965 Variable painting, tempera on canvas and metal with movable magnetic elements, 54½×36½ ins (35) ►

"JAIL"

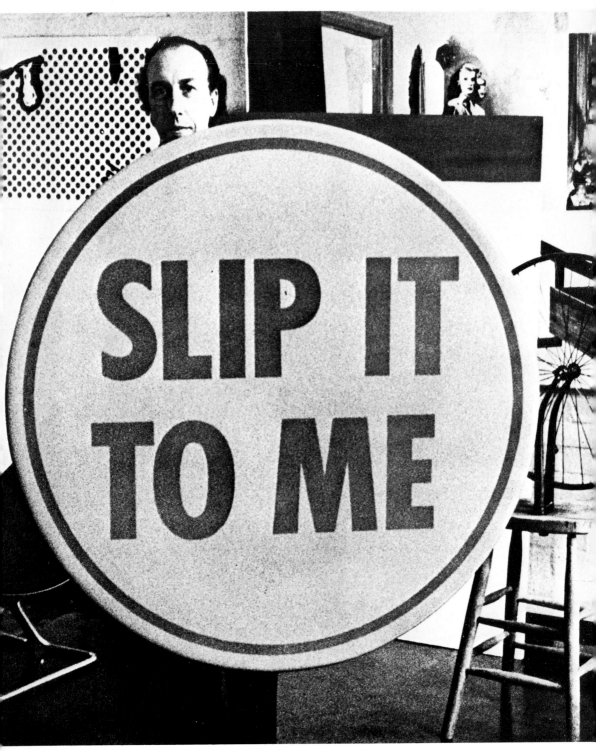

82 RICHARD HAMILTON *Epiphany* 1964 Cellulose on panel, 48 ins diameter (39)

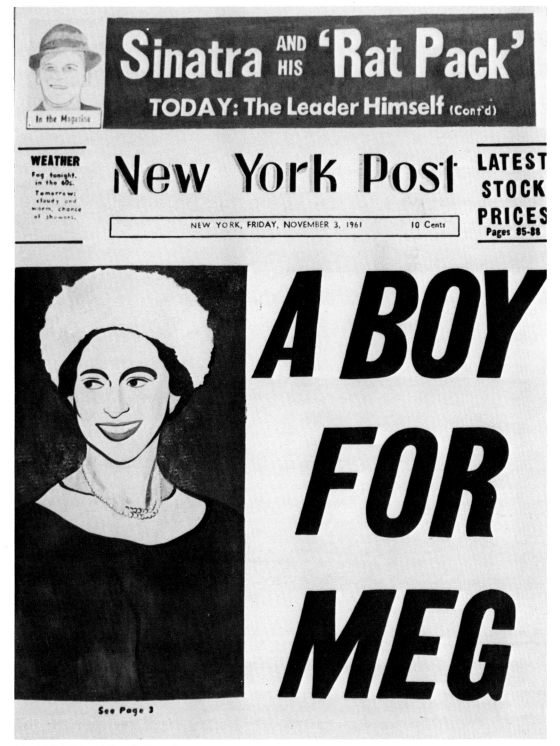

83 ANDY WARHOL *A Boy for Meg* 1961 Oil on canvas, 72⅝×52⅝ ins (148)

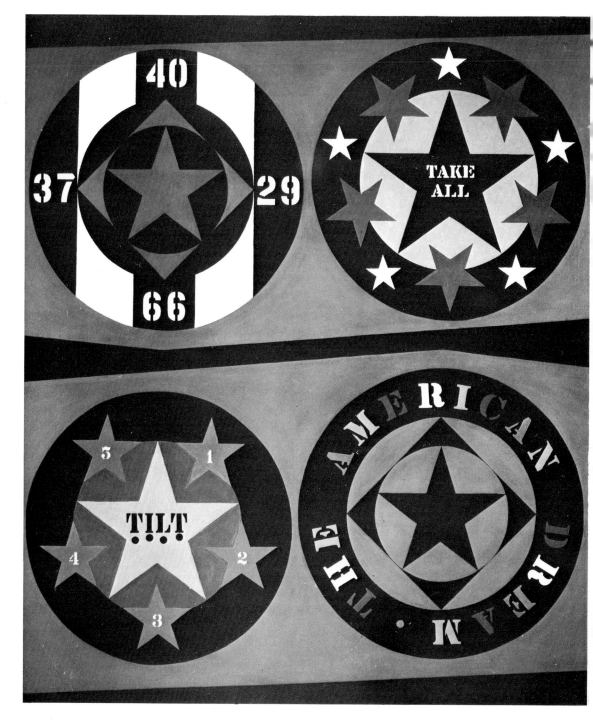

*84 ROBERT INDIANA *The American Dream I* 1961 Oil on canvas, $72\frac{1}{8}\times60\frac{1}{8}$ ins

*85 JOE TILSON *Nine Elements* 1963 Kandy, pearl and acrylic on wood relief, 102×72 ins

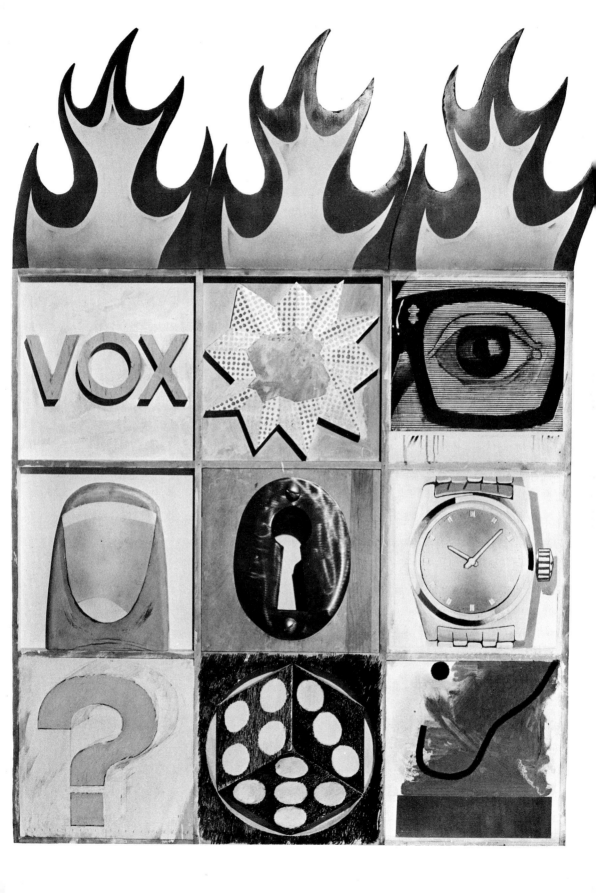

86 ARAKAWA *Webster's Dictionary, Page 1* 1965 Pencil and ink on canvas, 30×40 ins (1)

87 R. B. KITAJ *In Our Time* series of fifty screen prints 1969 31 × 22 ins each
(a) *Four in America* by Gertrude Stein
(b) *Fighting the Traffic in Young Girls* (78)
(c) *Articles and Pamphlets* by Maxim Gorky

(a)

(b)

(c)

88 EDWARD RUSCHA *Business*
1964 Drawing, $10\frac{1}{4}\times12\frac{1}{2}$ ins (128)

89 EDWARD RUSCHA *Jelly* 1964
Drawing, $10\frac{1}{2}\times12$ ins (126)

JELLY

A U T O M A T I C

90 EDWARD RUSCHA *Automatic*
1964 Drawing, 12½×11 ins (127)

91 EDWARD RUSCHA *Dimple*
1964 Drawing, 10¼×12½ ins (125)

92 GEORGE BRECHT *Silence*
1966 Letters on canvas, 8¾×14 ins
(18)

93 GEORGE BRECHT *No smok-ing* 1966 Letters on canvas, 8¾×14
ins (19)

IX JASPER JOHNS *Painted Bronze* 1960
Painted bronze, 5½×8×4¾ ins (55)

X CLAES OLDENBURG *Ironing Board with Shirt and Iron*
1964 Vinyl, nylon, wood, $67\frac{1}{2} \times 80 \times 24$ ins (108)

XI CLAES OLDENBURG *Giant Gym Shoes* 1963
Painted plaster, wire and cloth, $14\frac{1}{2} \times 8\frac{1}{2} \times 32\frac{1}{8}$ ins (100)

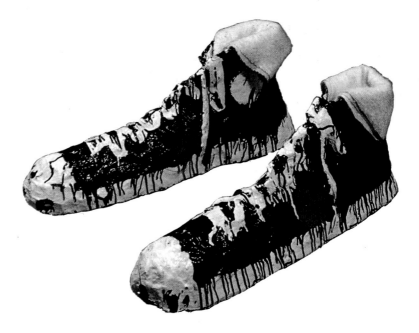

XII GEORGE BRECHT *Clothes Tree* 1969 realization of 1961 event-score
Clothes tree with objects, 77×29×29 ins (21)

XIII ALEX HAY *Graph Paper* 1967
 Spray lacquer and stencil on canvas, $87\frac{5}{8} \times 68$ ins (47)

XIV ANDY WARHOL *Green Coca-Cola Bottles* 1962 ▶
 Oil on canvas, $82\frac{1}{4} \times 57$ ins (152)

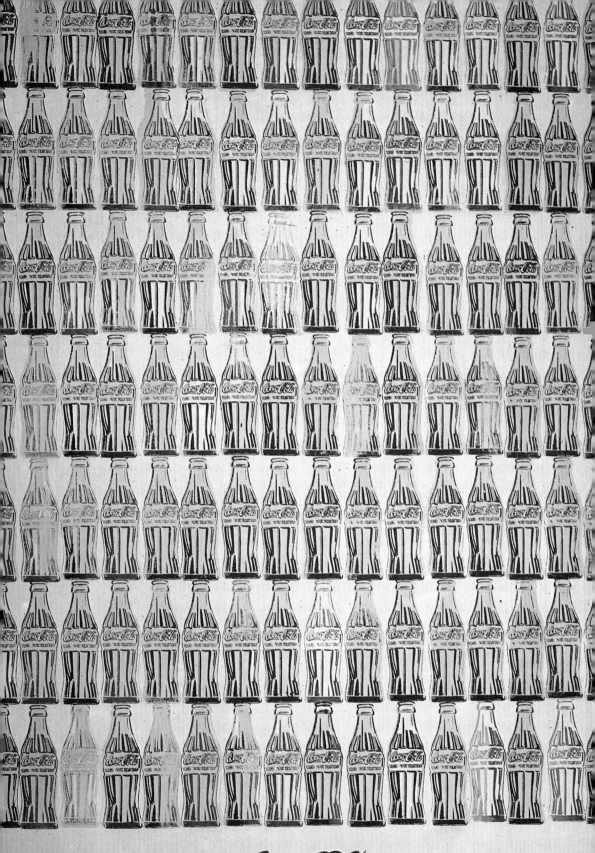

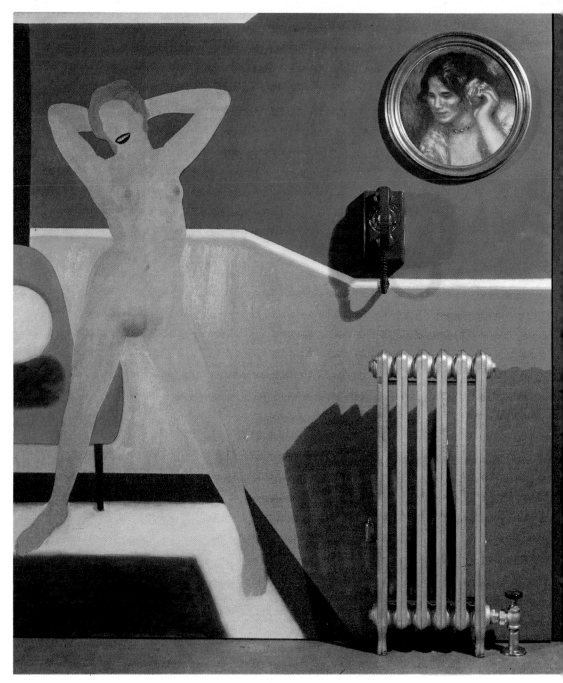

XV TOM WESSELMANN *Great American Nude No. 44* 1963
Collage painting with radiator and telephone, 81×96×10 ins (161)

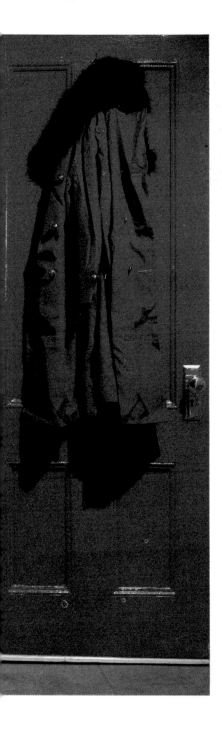

XVI DAVID HOCKNEY *Typhoo Tea* 1962
Oil on shaped canvas, 78×30 ins (50)

XVII RICHARD HAMILTON *I'm Dreaming of a
White Christmas* 1967-68
Oil on canvas, 42×63 ins (41)

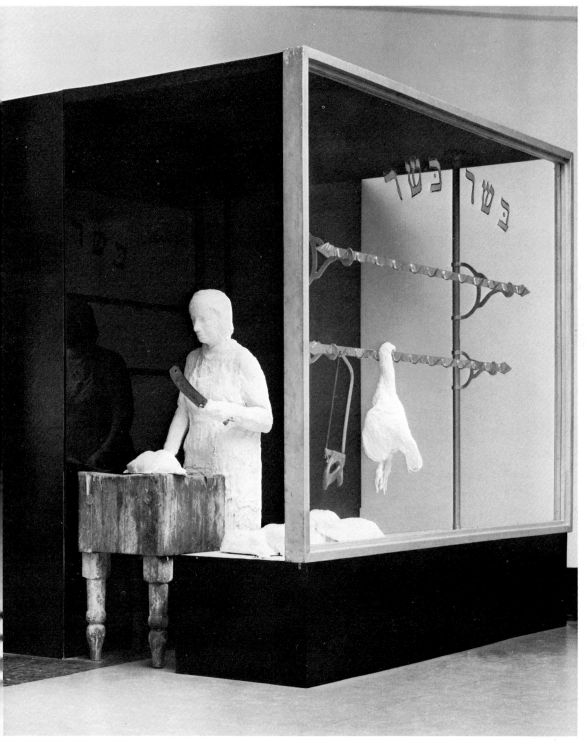

94 GEORGE SEGAL *The Butcher
Shop* 1965 Plaster figure in shop
environment, 94×99×48 ins (132)

95 EDWARD KIENHOLZ *The Portable War Memorial* 1968 Environmental construction with operating coke machine, 9½×8×32 ft (77)

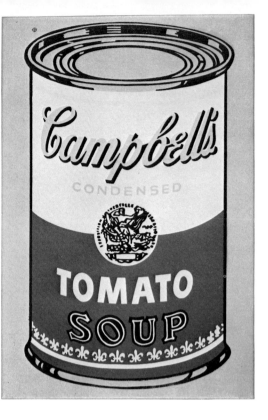

96 ANDY WARHOL *Campbell's Soup* 1965 Oil, silk-screened on canvas, $36\frac{1}{8}\times24$ ins (156)

97 ANDY WARHOL *4 Campbell's Soup Cans* 1962 Oil on canvas (150)

98 ANDY WARHOL *100 Soup Cans* 1962 Oil on canvas, 72×52 ins (149) ▶

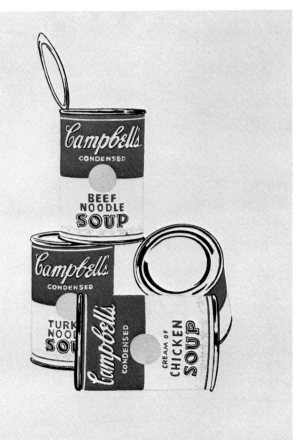

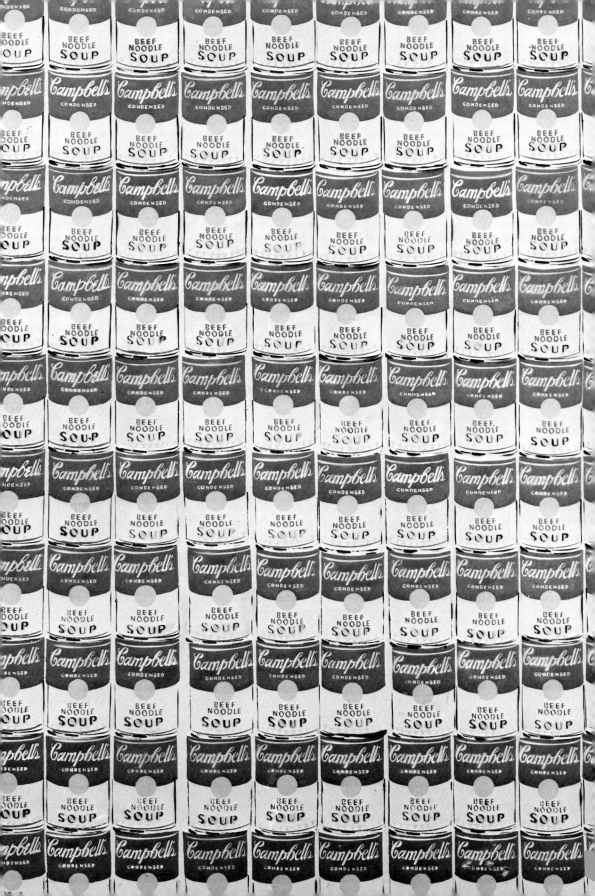

99 MEL RAMOS *The Pause that Refreshes* 1967 Oil on canvas, 48×48×48 ins (114)

100 MARISOL *Love* 1962 Plaster and Coca-Cola bottle, $8\frac{1}{4}\times6\frac{1}{4}\times4$ ins (92)

101 CHARLES FRAZIER *American
Nude* 1963 Bronze, ht 7¾ ins (37)

102 CLIVE BARKER *Three Cokes*
1969 Chrome-plated bronze, 11½×
6¾×6¾ ins (9)

103 JAMES ROSENQUIST
Silhouette II 1962 Oil on canvas
and masonite, 41×47 ins (121)

104 ROY LICHTENSTEIN
Mustard on White 1963 Magna
on plexiglass, 24×32 ins (87)

105 EDWARD RUSCHA *Glass of Milk Falling* 1967 Oil on canvas, 20×24 ins (129)

106 ROY LICHTENSTEIN *Ice Cream Soda* 1962 Oil on canvas, 64×32 ins

*107 MEL RAMOS *Val Veeta* 1965 Oil on canvas, 48×60 ins

108 KAY KURT *For All Their Innocent Airs, They Know Exactly Where They're Going* 1968 Oil on canvas, 60×144 ins (80)

109 CLAES OLDENBURG *Strawberry—Three Pies from Javatime* 1963 Painted plaster, metal and porcelain. Pie, $4\frac{1}{4} \times 6 \times 9$ ins, porcelain plate, $9\frac{3}{8}$ ins diameter, metal fork, $7\frac{1}{4}$ ins (101)

110 WAYNE THIEBAUD *Pie Counter* 1963 Oil on canvas, 30×36 ins (141)

111 LARRY RIVERS *Webster and Cigars* 1964–66 Construction, 13¼ ×16×13¼ ins (119)

112 CLAES OLDENBURG *Five Studies for Cigarette Butts* 1966 Plaster on plexiglass, 7½×18×18 ins (105)

113 RICHARD SMITH *Gift Wrap*
1963 Oil on shaped canvas, 80×
208×33 ins (138)

114 RICHARD SMITH *Flip Top*
1962 Oil on canvas, 84×68 ins
(137)

115 JIM DINE *A Nice Pair of Boots* 1965 Cast aluminium, painted, 16×11 ins each (31)

116 CLIVE BARKER *Rio – Homage to Marlon Brando* 1969 Chrome-plated bronze, 13¾×11¾×11¾ ins (7)

*117 ROY LICHTENSTEIN *Keds*
1961 Oil on canvas, 48½×34¾ ins

118 JASPER JOHNS *High School
Days* 1964 Sculpmetal on plaster
with mirror. Length 12 ins (58)

121 ALLEN JONES *Sun Plane*
1963 Oil on canvas, 96×108 ins
(74)

122 MALCOLM MORLEY *S.S.*
'Rotterdam' in Rotterdam 1966
Liquitex on canvas, 60×84 ins (94)

123 JAMES ROSENQUIST *F-111*
1965 Oil on canvas with aluminium,
10×86 ft (123)

124 NICHOLAS MUNRO *Seven Reindeer* 1966 Fibreglass, ht: 8 ft each (98)

125 BARBRO OSTLIHN *Gas Station, N.Y.C.* 1963 Oil on canvas (109)

126 (overleaf) JANN HAWORTH *Maid* 1966 Nylon, kapok, stocking 66×20 ins (43)

Index of artists and works

NOTE: Where a number appears before the title, the work was included in the exhibition at the Hayward Gallery, London (9 July to 3 September 1969). A † following the title indicates that the work is not reproduced. The numbers in brackets () refer to illustrations reproduced in this book.

17 'Nancy' collage for cover of *Art News Annual* 1968†. Collage on board, 13 × 20 ins. Coll. the artist

GEORGE BRECHT
Born Halfway, Oregon 1925. One-man shows Reuben Gallery 1959, Fischbach Gallery 1965. Published 'Water Yam' (scores for music, dance, events, etc). Many performances of plays and events New York and elsewhere

18 *Silence* (92) 1966. Letters on canvas, 8¾ × 14 ins. Galleria Schwarz, Milan

19 *No smoking* (93) 1966. Letters on canvas, 8¾ × 14 ins. Galleria Schwarz, Milan

20 *Chair Event* (14) 1969 realization of 1961 event-score. Chair with objects, 36 × 24 × 21 ins. Coll. the artist. Photo: Iain MacMillan

PATRICK CAULFIELD
Born London 1936. Chelsea School of Art and Royal College of Art. Travelled in Italy and Greece 1961 and 1963. Teaches at Chelsea School of Art. First one-man exhibition Robert Fraser Gallery 1965. Group exhibitions include 'The New Generation', Whitechapel Gallery 1964, Paris Bienniale 1965 and 1967, and São Paolo Biennale 1967. Lives in London

21 *Clothes Tree* (XII) 1969 realization of 1961 event-score. Clothes tree with objects, 77 × 29 × 29 ins. Coll. the artist. Photo: Iain MacMillan

22 *Greece Expiring on the Ruins of Missolonghi* (after Delacroix) (70) 1963. Oil on hardboard, 60 × 48 ins. Coll. Alan Power, London

23 *Sculpture in a Landscape* (65) 1966. Oil on hardboard, 48 × 84 ins. Arts Council collection. Photo: John R. Freeman

CHRISTO
Born Gabrovo, Bulgaria 1935. School of Fine Arts Sofia 1951–56. Later studies Prague and Vienna. Went to Paris 1958. One-man show Museum of Contemporary Art, Chicago 1969. Lives in New York since 1964

24 *Packed Armchair* (13) 1964–65. Armchair, plastic, cloth, polyethylene, ropes, 38 × 31¼ × 32 ins. Coll. the artist

JOHN CLEM CLARKE
Born Oregon 1937. Oregon State College, Mexico City College, University of Oregon. Served in Coast Guard. Several years in Europe. One-man show Kornblee Gallery, New York 1968. Lives in New York

25 *Liberty Leading the People* (after Delacroix) (69) 1968. Oil on canvas, 60 × 48 ins. Coll. Richard Brown Baker, New York

JESS COLLINS
Born Long Beach, California 1923. Closely associated with San Francisco poets. Has illustrated Robert Duncan's poems. Exhibited San Francisco Museum of Art 1968. Lives in San Francisco

26 *Tricky Cad* (78) 1959. Newspaper collage, 19 × 7 ins. Los Angeles County Museum of Art, Gift of Mr and Mrs Bruce Conner

JIM DINE
Born Cincinnati 1935. University of Cincinnati, Boston Museum School, Ohio University. Moved to New York 1959. 'The House', Judson Gallery 1959. Staged several Happenings 1960. One-man shows Reuben Gallery 1960, Martha Jackson Gallery 1962, Sidney Janis Gallery 1963, 1964, Robert Fraser Gallery since 1965

27 *Paint Box No.* 1 (56) 1961. Watercolour, 14⅛ × 10⅝ ins. Coll. Dr Hubert Peeters, Bruges

28 *Four Rooms* (5) 1962. Oil on canvas, with chair, 72 × 180 ins. Sidney Janis Gallery, New York. Photo: Eric Pollitzer, courtesy Sidney Janis Gallery

29 *Black Bathroom No.* 2 (7) 1962. Oil on canvas with china wash-basin, 72 × 72 ins. Art Gallery of Ontario, Toronto. Gift of Mr and Mrs M.H. Rapp, 1966

30 *Toaster* (26) 1962. Oil on canvas and toaster, 100 × 80 × 7 ins. Whitney Museum of American Art, New York. Courtesy of the Albert A. List family. Photo: Geoffrey Clements

31 *A Nice Pair of Boots* (115) 1965. Cast aluminium, painted, 16 × 11 ins each. Coll. Robert Fraser, London

32 *Saw Horse Piece* (VI) 1968–69. Paint, canvas, wood, 44 × 144 × 43 ins. Coll. the artist. Photo: John Webb

ROSALYN DREXLER
Born New York State 1926. Former professional wrestler. Publications include *I Am a Beautiful Stranger* (novel) and *Home Movies* (play, awarded Obie Award 1964 for season's most distinguished play in New York). Shows Kornblee Gallery. Married to painter Sherman Drexler. Lives in New York

33 *The Overcoat* (120) 1963. Liquitex, oil and collage on canvas board, 12 × 9 ins. Allen Memorial Art Museum, Oberlin College, Ohio

OYVIND FAHLSTRÖM
Born São Paulo, Brazil 1928. Swedish/Norwegian parents. Went to Sweden 1939. Studied art history and archaeology 1949–52. Wrote plays and poetry in Stockholm 1950–55. Married Barbro Ostlihn 1960. Settled New York 1961. First variable paintings 1962–64. Showed Venice Biennale 1964, 1966 ('Dr Schweitzer's Last Mission'). One-man shows Janis Gallery 1967, 1969. Lives in New York and Stockholm

34 *Performing Krazy Kat No. 2, Sunday Edition* (III) 1963–64. Tempera on paper on canvas, 52 × 34 ins. Coll. Frederic and Siena Ossorio, Greenwich, Conn.

35 *Performing Krazy Kat III* (81) 1965. Variable painting, tempera on canvas and metal with movable magnetic elements, 54½ × 36½ ins. Coll. Robert Rauschenberg

36 *Green Pool* (79) 1968–69. Variable structure in plexiglass pool with dyed water, 6 × 21 × 42 ins. Sidney Janis Gallery, New York. Photo: Geoffrey Clements, courtesy Sidney Janis Gallery

CHARLES FRAZIER
Born Morris, Oklahoma 1930. Choinard Art Institute 1948–49, 1952–56. One-man shows Kornblee Gallery 1963, 1965, Dwan Gallery 1965

37 *American Nude* (101) 1963. Bronze, ht 7¾ ins. Coll. Dr and Mrs Leonard Kornblee, New York. Photo: Jay Cantor

JOE GOODE
Born Oklahoma City 1937. Choinard Art Institute 1959–60. One-man shows Dilexi Gallery, Los Angeles

1962, Rowan Gallery, London 1967, Kornblee Gallery, New York 1968. Lives in Los Angeles

37a *Shoes, shoes, shoes*† 1966. Construction, $41 \times 53\frac{1}{2} \times 36$ ins. Coll. Charles Cowles, New York

RICHARD HAMILTON
Born London 1922. Royal Academy Schools 1938–40, 1946–47, Slade School 1948–51. Devised and designed 'Growth and Form' exhibition, ICA London 1951. Devised and designed 'Man, Machine and Motion' exhibition, Newcastle-upon-Tyne and ICA London 1955. Participated in 'This is Tomorrow' exhibition at Whitechapel Gallery, London. Designed typographic version of Marcel Duchamp's *Green Box*, published 1960. Lecturer in Fine Art Department, University of Newcastle since 1953. Retrospective exhibition Hanover Gallery 1964. One-man show Robert Fraser Gallery 1969. Lives in London

38 *Just What Is It that Makes Today's Homes so Different, so Appealing?* (3) 1956. Collage, $10\frac{1}{4} \times 9\frac{3}{4}$ ins. Coll. Edwin Janss, Jr, Thousand Oaks, California

39 *Epiphany* (82) 1964. Cellulose on panel, 48 ins diam. Coll. the artist

40 *Toaster* (25) 1967. Aluminium and perspex relief on photo on panel, 36×36 ins. Coll. the artist

41 *I'm Dreaming of a White Christmas* (XVII) 1967–68. Oil on canvas, 42×63 ins. Coll. the artist. Photo: John Webb

JANN HAWORTH
Born Hollywood, California 1942. University College of Los Angeles 1959–61, Slade School, London 1962–63. First one-man exhibition Robert Fraser Gallery 1966. Exhibited 'Il Tempo dell'Immagine', Museo Civico, Bologna 1967. Lives in England and married to Peter Blake.

42 *Mae West* (43) 1965. Mixed media, $28\frac{1}{4} \times 22\frac{1}{2} \times 25$ ins, Robert Fraser Gallery, London. Photo: Iain MacMillan

43 *Maid* (126) 1966. Nylon, kapok, stocking, 66×20 ins. Robert Fraser Gallery, London

44 *L.A. Times Bedspread* (II) 1965. Fabric, 78×100 ins. Private collection. Photo: John Webb

ALEX HAY
Born Valrico, Florida 1930. Florida State University 1953–58. Moved to New York 1959. Performance with Judson Dance Theatre and in concert 1962–64. Assistant stage manager, Merce Cunningham world tour 1964. Devised theatre dance pieces including 'Topsail' 1966 and 'Grassfield' 1966 (9 Evenings, New York). One-man shows Kornblee Gallery 1967, 1969. Lives in New York

45 *Toaster* (24) 1964. Oil on canvas, 92×73 ins (overall). Coll. the artist. Photo: Jay Cantor

46 *Label* (16) 1967. Spray lacquer and stencil on canvas, 37×60 ins. Coll. Robert Rosenblum, New York. Photo: Eric Pollitzer

47 *Graph Paper* (XIII) 1967. Spray lacquer and stencil on canvas, $87\frac{5}{8} \times 68$ ins. Kornblee Gallery, New York

48 *Floorboard*† 1968. Fibreglass and aluminium, 11 ft, 7 ins. $\times 4 \times 1\frac{1}{4}$ ins. Coll. Mr and Mrs John W. Weber, New York

49 *Paper Bag* (32) 1968. Paper, epoxy, fibreglass, paint, $60 \times 29 \times 17\frac{3}{4}$ ins. Whitney Museum of American Art, New York. Photo: Geoffrey Clements

DAVID HOCKNEY
Born Bradford, Yorkshire 1937. Bradford College of Art 1953–57, Royal College of Art 1959–62. Taught Maidstone College of Art 1962–63, University of Iowa 1963–64, University of Colorado 1965–66, University of California, Los Angeles 1966–67. Lived Santa Monica, California 1968. First one-man exhibition Kasmin Gallery 1963. Numerous prizes for graphic work. Lives in London

50 *Typhoo Tea* (XVI) 1962. Oil on shaped canvas, 78×30 ins. Coll. Bruno Bischofberger, Zurich. Photo: John Webb

51 *Henry Geldzahler and Christopher Scott* (75) 1969. Acrylic on canvas, 84×120 ins. Harry N. Abrams family collection, New York

ROBERT INDIANA
Born New Castle, Indiana 1928. Herron Art Institute, Indianapolis 1945–46, Art Institute of Chicago and Skowhegan School of Painting and Sculpture, Maine 1949–53, Edinburgh College of Art 1953–54, London University 1954. One-man shows Stable Gallery 1962, 1964, 1966. Lives in New York

The American Dream I (84) 1961. Oil on canvas, $72\frac{1}{8} \times 60\frac{1}{8}$ ins. The Museum of Modern Art, New York. Larry Aldrich Foundation Fund. Photo: Eric Pollitzer

52 *The Demuth Five* (VIII) 1963. Oil on canvas, 64×64 ins. Coll. Mr and Mrs Robert C. Scull, New York

53 *Mother and Father* (Jacket) 1963–67. Diptych, oil on canvas, 72×60 ins each panel. Coll. the artist

JASPER JOHNS
Born Augusta, Georgia 1930. University of South Carolina, Columbia. Moved to New York 1952. One-man shows Leo Castelli Gallery since 1958. One-man show Whitechapel Art Gallery 1964. Lives in New York

54 *Flashlight* (27) 1958. Papier-mâché and glass, $8 \times 3\frac{1}{2} \times 3$ ins. Coll. Robert Rauschenberg. Photo: Walter Russell

55 *Painted Bronze* (IX) 1960. Painted bronze, $5\frac{1}{2} \times 8 \times 4\frac{3}{4}$ ins. Coll. Mr and Mrs Robert C. Scull, New York

56 *Lightbulb* (28) 1960. Painted bronze, $4\frac{1}{4} \times 6 \times 4$ ins. Coll. the artist. Photo: Rudolph Burckhardt

57 *Painted Bronze* (55) 1960. Painted bronze, $13\frac{1}{2} \times 8$ ins diam. Coll. the artist

58 *High School Days* (118) 1964. Sculpmetal on plaster with mirror, Length 12 ins. Coll. the artist. Photo: Rudolph Burckhardt

59 *Flag*† 1969. Lead relief, 17×23 ins. Gemini G.E.L., Los Angeles.

60 *The Critic Smiles*† 1969. Lead relief, 23×17 ins. Gemini G.E.L., Los Angeles

61 *High School Days*† 1969. Lead relief, 23×17 ins. Gemini G.E.L., Los Angeles

62 *Lightbulb*† 1969. Lead relief, 38×17 ins. Gemini G.E.L., Los Angeles

63 *Slice of Bread*† 1969. Lead relief, 23 × 17 ins. Gemini G.E.L., Los Angeles

RAY JOHNSON
Born Detroit, Michigan 1927. Art Students' League and Black Mountain College. Studied 1945–48 with Josef Albers, Robert Motherwell, Mary Callery and Ossip Zadkine. Showed 1949–52 with American Abstract Artists, New York. Founder-organizer New York Correspondence School. Showed Reuben Gallery 1959–62. One-man shows Feigen Gallery 1968, 1969. Lives on Long Island

64 *Elvis Presley No.* 1 (50) 1955. Collage, 15 × 11½ ins. Coll. William Wilson, New York. Photo: Eric Pollitzer

65 *Elvis Presley No.* 2 (49) 1955. Collage, 15⅜ × 11½ ins. Coll. William Wilson, New York. Photo: Eric Pollitzer

66 *Homage to Magritte* (62) 1962. Collage, 13¼ × 6½ ins. Coll. Harry Torczyner, New York. Photo: Malcolm Varon

67 *Alain Delon Match*† 1966. Collage, 19¼ × 13½ ins. Richard Feigen Gallery, New York

68 *Bridget Riley's Comb* (60) 1966. Collage, 24½ × 13⅛ ins. Richard Feigen Gallery, New York. Photo: Geoffrey Clements

69 *Mondrian* (61) 1967. Collage, 18½ × 14 ins. Coll. David Bourdon. Photo: Geoffrey Clements

70 *November Letter*† 1967. Collage, 20⅜ × 13½ ins. Richard Feigen Gallery, New York

71 *Shirley Temple I*† 1967. Collage, 24⅜ × 15 ins. Richard Feigen Gallery, New York

72 *Shirley Temple II* (47) 1967. Collage, 18 × 20½ ins. Richard Feigen Gallery, New York. Photo: Geoffrey Clements

73 *Guess Who's Coming to Dinner?* (48) 1968. Collage, 17 × 20½ ins. Richard Feigen Gallery, New York. Photo: Geoffrey Clements

ALLEN JONES
Born Southampton 1937. Hornsey College of Art 1958–59, Royal College

of Art 1959–60. Lived in New York City 1964–65. Tamarind Lithography Fellowship, Los Angeles 1966. First one-man exhibition Arthur Tooth and Sons, London 1963. Lives in London

74 *Sun Plane* (121) 1963. Oil on canvas, 96 × 108 ins. Sunderland Art Gallery

La Sheer (119) 1969. Oil on canvas and perspex tiles on aluminium, 72 × 60 ins, steps 18 × 50 ins. Richard Feigen Gallery, New York

75 *Two Timer*† 1968–69. Oil on canvas and perspex tiles on aluminium, 90 × 60 × 18 ins. Richard Feigen Gallery, New York.

EDWARD KIENHOLZ
Born Fairfield, Washington 1927. Washington State College, Pulman, Whitworth College, Spokane, E.W.C.E., Cheney, Wash. Major works include 'Roxy's', 1963, 'Back Seat Dodge – 38', 1964, 'Barney's Beanery', 1965. Showed 'Roxy's' Dokumenta, Kassel 1968

76 *Walter Hopps, Hopps, Hopps* (76) 1959. Construction, 78 × 34 ins. Coll. Edwin Janss, Jr, Thousand Oaks, California

77 *The Portable War Memorial* (95) 1968. Environmental construction with operating coke machine, 9½ × 8 × 32 ft. Coll. Mr and Mrs Monte Factor, Los Angeles

R.B. KITAJ
Born Ohio 1932. Studied at the Cooper Union Institute, New York and Academy of Fine Arts, Vienna. Came to England in 1958. Visiting professor at the University of California, Berkeley 1968. One-man shows with Marlborough in London and New York. Lives in Oxford and London

78 *In Our Time.* Series of fifty screen prints (87) 1969. 31 × 22 ins. each. (a) *Four in America* by Gertrude Stein (b) *Fighting the Traffic in Young Girls* Marlborough Fine Art (London) Ltd (c) *Articles and Pamphlets* by Maxim Gorky

KAY KURT
Born Dubuque, Iowa 1944. Clarke College and University of Wisconsin,

Madison. Shows Kornblee Gallery, New York. Lives in Germany

79 *Ever Eat Anything that Made You Feel Like Saturday Night on Tuesday Afternoon?*† 1968. Oil on canvas, 60 × 144 ins. Coll. Harry Kahn, New York

80 *For All Their Innocent Airs, They Know Exactly Where They're Going* (108) 1968. Oil on canvas, 60 × 144 ins. Coll. Roy R. Neuburger, New York. Photo: Jay Cantor

ROY LICHTENSTEIN
Born New York 1923. Studied Art Students' League with Reginald Marsh 1939. Ohio State College 1940–43. Free-lance designer and painter Cleveland, Ohio 1951–57. Taught New York State University Oswego 1957–60 and Rutgers University 1960–63. One-man shows Leo Castelli Gallery since 1962. One-man show Tate Gallery 1968. Lives in New York

81 *Mr Bellamy* (72) 1961. Oil on canvas, 56 × 42 ins. Coll. Vernon Nikkel, Clovis, New Mexico. Photo: Frank J. Thomas

Keds (117) 1961. Oil on canvas, 48½ × 34¾ ins. Coll. Mr and Mrs Robert B. Mayer, Winnetka, Illinois. Photo: Rudolph Burckhardt

Bathroom (12) 1961. Oil on canvas, c. 40 × 65 ins. Coll. Karl Ströher, Munich

On (23) 1962. Oil on canvas, 28 × 18 ins. Coll. Ben Birillo, New York

82 *Handshake* (23) 1962. Oil on canvas, 32 × 48 ins. Coll. Mr and Mrs Victor W. Ganz, New York

83 *Eddie Diptych* (80) 1962. Oil on canvas, 44 × 52 ins (2 panels). Coll. Mr and Mrs Michael Sonnabend, Paris. Photo: Eric Pollitzer

Ice Cream Soda (106) 1962. Oil on canvas, 64 × 32 ins. Coll. Myron Orlovsky, South Salem, New York. Photo: Rudolph Burckhardt

85 *Art* (51) 1962. Oil on canvas, 36 × 68 ins. Coll. Robert and Jane Meyerhoff, Baltimore. Photo: Rudolph Burckhardt, courtesy Leo Castelli

86 *Woman in Armchair* (68) 1963. Magna on canvas, 68 × 48 ins. Coll. Mr and Mrs M. Boulois, Paris. Photo: Rudolph Burckhardt

87 *Mustard on White* (104) 1963. Magna on plexiglass, 24 × 32 ins. Coll. Mr and Mrs Victor W. Ganz, New York. Photo: Rudolph Burckhardt

88 *Composition II* (21) 1964. Magna on canvas, 56 × 48 ins. Coll. Mr and Mrs Michael Sonnabend, Paris. Photo: Rudolph Burckhardt

Little Big Painting (58) 1965. Oil on canvas, 68 × 80 ins. Whitney Museum of American Art, New York. Gift of the Friends of the Whitney Museum of American Art. Photo: Geoffrey Clements

88a *Modern Sculpture with Velvet Rope* (38) 1968. Brass and velvet rope, two parts: 83¼ × 26 × 15 ins; 59 × 26 × 15 ins. Coll. Galerie Sonnabend, Paris

89 *Cathedral series: six lithographs after Monet* (VII) 1969. Lithographs, 47 × 33 ins. each. Gemini G.E.L., Los Angeles. Photo: copyright Gemini G.E.L.

RICHARD LINDNER
Born Hamburg 1901. Studied Nuremberg and Munich 1924. Left Germany 1933. Lived Paris till 1939. Escaped to USA 1941. Illustrations for *Fortune*, *Vogue*, *Harper's Bazaar*, etc. for many years. One-man show Kestner Gesellschaft, Hanover and elsewhere 1969. Lives in New York

90 *Banner No. 1†* (untitled) 1964. Satin, vinyl and felt, 96 × 48 ins. Multiples Gallery, New York

91 *Banner No. 3†* (untitled) 1968. Vinyl, 84 × 50 ins. Multiples Gallery, New York

MARISOL
Born Paris 1930. Venezuelan parentage. Ecole des Beaux Arts, Paris 1949. Moved New York 1950. Art Students' League, New York 1950. The New School, Hans Hofmann School 1951–54. Showed Venice Biennale 1968. Lives in New York

92 *Love* (100) 1962. Plaster and Coca-Cola bottle, 8¼ × 6¼ × 4 in. Coll. Mr and Mrs Tom Wesselmann. Photo: Jack Mitchell

93 *Henry* (74) 1965. Construction, 67 × 31 × 16½ ins. Coll. Mr and Mrs S. Brooks Barron, Detroit. Photo: Geoffrey Clements

MALCOLM MORLEY
Born London 1931. Graduated Royal College of Art 1954. Rome Prizewinner (Abbey Minor) 1957. Taught Royal College 1956 and in USA since 1961. Shows Kornblee Gallery. Lives in New York

94 *S.S. 'Rotterdam' in Rotterdam* (122) 1966. Liquitex on canvas, 60 × 84 ins. Coll. H. Marc Moyens, Alexandria, Virginia. Photo: Courtesy Kornblee Gallery, New York

ROBERT MORRIS
Born Kansas City 1931. University of Kansas City 1948–50. California School of Fine Arts, San Francisco 1951. Hunter College New York 1961–62. Asst. Professor Hunter College since 1967. One-man shows Dilexi Gallery, San Francisco 1957–58, Green Gallery, New York 1964–65, Leo Castelli Gallery since 1967, Eindhoven Museum 1968, Galerie Sonnabend, Paris 1968. Lives in New York

95 *37 Minutes 3879 Strokes* (59) 1961. Pencil on paper, 24⅜ × 19½ ins. Coll. Samuel Wagstaff Jr, Detroit. Photo: Joseph Klima Jr

96 *Untitled sculpture* (29) 1963. Wood and rope, 5⅜ × 15¾ × 3½ ins. Coll. Samuel Wagstaff Jr, Detroit. Photo: Joseph Klima Jr

97 *Three Rulers†* 1963. Wood construction. Harry N. Abrams family collection, New York

NICHOLAS MUNRO
Born London 1936. Studied Chelsea School of Art. Teaches Swindon School of Art. First one-man show Robert Fraser Gallery 1968. Lives near Newbury, Berks.

98 *Seven Reindeer* (124) 1966. Fibreglass, ht: 8 ft each. Robert Fraser Gallery, London. Photo: Gordon Young

99 *Bags of Money†* 1966–67. Fibreglass and paint, 18 × 30 × 30 ins. Coll. Alan Power, London

CLAES OLDENBURG
Born Stockholm, Sweden 1929. Lived New York 1929–32, Oslo 1933–36, Chicago 1936–56. (B.A. Yale 1950). Apprentice reporter, City News

Bureau of Chicago, 1950–61. Studied Art Institute of Chicago 1953–54. Moved to New York 1956. Worked Paris and Italy April–December 1964, London August–December 1966. Lives in New York

Bedroom Ensemble I (1) 1963. Mixed media construction, 10 × 17 × 20 ft. Coll. the artist

100 *Giant Gym Shoes* (XI) 1963. Painted plaster, wire and cloth, 14½ × 8½ × 32⅛ ins. Private collection. Photo: John Webb

101 *Strawberry – Three Pies from Javatime* (109) 1963. Painted plaster, metal and porcelain. Pie, 4¼ × 6 × 9 ins; porcelain plate, 9⅜ ins diam.; metal fork, 7¼ ins long. Private collection. Photo: John Webb

102 *Platter with Pieces of Ham†* 1963. Painted plaster and wire. 7 × 32 × 21 ins. 8 × 5 ins. Private collection

103 *Charms Candy Bar†* 1963(?) Painted plaster and wire, wood base, 4¾ × 6½ × 16½ ins. Private collection

104 *Soft Typewriter* (17) 1963–64. Vinyl, kapok, cloth, plexiglass, 9 × 27½ × 26 ins. Private collection. Photo: Hans Hammarskiöld, courtesy Robert Fraser Gallery, London

Wall Switches (22) 1964. Wood, formica and metal, 48 × 48 × 12½ ins. Coll. Mr and Mrs Harold Ladas, New York. Photo: Sidney Janis Gallery, New York

Model for Bathroom (11) Installation shot of one-man show at Janis, March–April 1966. Corrugated paper and enamel. Coll. Karl Ströher, Munich. Photo: Geoffrey Clements, courtesy Sidney Janis Gallery, New York

105 *Five Studies for Cigarette Butts* (112) 1966. Plaster on plexiglass, 7½ × 18 × 18 ins. Coll. Dr H. Peeters, Bruges. Photo: Hans Hammarskiöld

106 *Wall Switches Replica No. 1 (Brown)†* 1969. Wood, 48 × 48 × 12½ ins. Coll. the artist

107 *Bedroom Ensemble II†* 1969. Construction, 10 × 17 × 20 ft. Sidney Janis Gallery, New York. Photo: Geoffrey Clements, courtesy Sidney Janis Gallery

108 *Ironing Board with Shirt and Iron* (X) 1964. Vinyl, nylon, wood, 67½ × 80 × 24 ins. Coll. Mr and Mrs Michael Sonnabend, Paris

BARBRO OSTLIHN

Born Stockholm 1930. School of Industrial Design and Royal Academy of Art, Stockholm. Married to Oyvind Fahlström. Lives in New York and Stockholm.

109 *Gas-Station NYC* (125) 1963. Oil on canvas. Coll. Daniel Cordier, Paris

EDUARDO PAOLOZZI

Born Edinburgh 1924, of Italian parentage. Edinburgh College of Art 1943, Slade School 1944–47. Lived in Paris 1947–50. Taught at Central School of Arts and Crafts 1949–55, and at St Martin's School of Art 1955–58. Visiting teacher at Hochschule für Bildende Künste in Hamburg 1960–62, and at University of California, Berkeley 1968. First one-man exhibition Mayor Gallery 1967. Participated in 'This is Tomorrow' at the Whitechapel Gallery, London 1956. Exhibited Venice 1952, 1960 (Bright Foundation Sculpture prize), São Paolo 1957, Middleheim 1959, and Kassel 1959, 1964. Lives in England.

110 *Tower for Mondrian* (64) 1963–64. Painted aluminium, $95\frac{3}{4} \times 71\frac{1}{4} \times 16\frac{1}{4}$ ins. Hanover Gallery, London. Photo: Howard's Studio

PETER PHILLIPS

Born Birmingham 1939. Birmingham College of Art and Royal College of Art 1955–62. First one-man exhibition Kornblee Gallery, New York 1965. Lives in Switzerland, shows with Galerie Bischofberger, Zürich

111 *Custom Painting No. 5*† 1965. Oil on canvas. 68×120 ins. Galerie Bischofberger, Zürich

112 *Star/Card/Table* (46) 1962. Oil on canvas, 30×33 ins. Private collection

MEL RAMOS

Born Sacramento, California 1935. San Jose State College 1954–55. Sacramento State College 1955–58. One-man shows Paul Bianchini Gallery New York 1964, 1965. Lives in Sacramento

113 *The Phantom*† 1964. Oil, 36×18 ins. Coll. Charles Cowles, New York

114 *The Pause that Refreshes* (99) 1967. Oil on canvas, $48 \times 48 \times 48$ ins. (triangular). Coll. Wenninger, Frankfurt

Val Veeta (107) 1965. Oil on canvas, 48×60 ins.

ROBERT RAUSCHENBERG

Born Port Arthur, Texas, 1925. Kansas City Art Institute 1946–47. Academie Julien, Paris 1947. Studied with Albers at Black Mountain College 1948–49. Art Students' League, New York 1949–50. Travelled Italy and North Africa 1952–53. Worked with Merce Cunningham Dance Troupe 1955–63 (designer and technical director). 1st Prize Venice Biennale 1964. One-man shows include Betty Parsons Gallery 1951, Leo Castelli since 1958, Whitechapel Art Gallery 1964, Stedelijk Museum Amsterdam 1968. Lives in New York

115 *Winter Pool* (34) 1959. Combine painting, $88\frac{1}{2} \times 58\frac{1}{2}$ ins. Coll. Mr and Mrs Victor W. Ganz, New York. Photo: Rudolph Burckhardt

116 *Pail for Ganymede* (30) 1959. Construction, $13 \times 6 \times 5$ ins. Coll. the artist. Photo: Michael Katz

117 *Art Box* (54) 1962–63. Construction, $30 \times 16 \times 12$ ins. Coll. the artist. Photo: Soichi Sunami, courtesy Museum of Modern Art, New York

LARRY RIVERS

Born New York 1923. Professional saxophonist 1940. US Army 1942–43. Studied composition Julliard School of Music 1944–45. Began painting 1945. Studied with Hans Hofmann 1947–48 and William Baziotes 1948 at New York University. One-man show Jane Street Gallery, New York 1949. Shows Tibor de Nagy Gallery, New York since 1951. Sojourns in London 1961, 1964 (one-man show Gimpel Fils). Retrospective Jewish Museum New York 1965. Lives in New York

118 *Mr Art* (Portrait of David Sylvester) (71) 1962. Oil on canvas, 72×52 ins. Marlborough-Gerson Gallery, New York. Photo: O.E. Nelson

119 *Webster and Cigars* (111) 1964–66. Construction, $13\frac{1}{4} \times 16 \times 13\frac{1}{4}$ ins. Marlborough-Gerson Gallery, New York. Photo: O.E. Nelson

120 *OK Robert OK Negro* (73) 1966. Spray paint, pencil, collage, $23\frac{1}{2} \times 19\frac{3}{4}$ ins. Private collection. Photo: John Webb

JAMES ROSENQUIST

Born Grand Forks, North Dakota, 1933. University of Minnesota 1951–55. Art Students' League New York 1955–58. One-man shows Green Gallery 1962, 1963, 1964 and with Leo Castelli since 1965. Lives on Long Island

121 *Silhouette II* (103) 1962. Oil on canvas and masonite, 41×47 ins. Coll. Mr and Mrs Horace Solomon, New York. Photo: Rudolph Burckhardt

Untitled (4) 1963. Oil on canvas, with projections, 78×78 ins. Harry N. Abrams Family Collection, New York

122 *Untitled* (44) 1964. Oil on canvas, 92×78 ins. Leo Castelli Gallery, New York

123 *F-III* (123) 1965. Oil on canvas with aluminium, 10×86 ft. Coll. Mr and Mrs Robert C. Scull, New York. Photo: Rudolph Burckhardt

EDWARD RUSCHA

Born Omaha, Nebraska 1937. Studied Choinard Art Institute, Los Angeles. Publications include 'Sunset Strip', 'Various Small Fires and Milk', 'Nine Swimming Pools', 'Some Los Angeles Apartments', 'Twenty-Six Gasoline Stations'. One-man shows Ferus Gallery, Los Angeles 1963, 1964, 1965, Iolas Gallery, New York 1967, Irving Blum Gallery, Los Angeles 1968. Lives in Hollywood, California

124 *Noise, Pencil, Broken Pencil, Cheap Western* (I) 1963. Oil on canvas, $77 \times 66\frac{1}{2}$ ins. Coll. Mr and Mrs Thomas G. Terbell, Jr, Pasadena

125 *Dimple* (91) 1964. Drawing, $10\frac{1}{4} \times 12\frac{1}{2}$ ins. Robert Fraser Gallery, London. Photo: Brompton Studio

126 *Jelly* (89) 1964. Drawing, $10\frac{1}{2} \times 12$ ins. Coll. John Lennon, London. Photo: Brompton Studio

127 *Automatic* (90) 1964. Drawing, $12\frac{1}{2} \times 11$ ins. Robert Fraser Gallery, London. Photo: Brompton Studio

128 *Business* (88) 1964. Drawing, $10\frac{1}{4} \times 12\frac{1}{2}$ ins. Robert Fraser Gallery, London. Photo: Brompton Studio

129 *Glass of Milk Falling* (105) 1967. Oil on canvas, 20×24 ins. Coll. Hobson Harrell, Palos Verdes, California

129a *Broken glass* 1968. Oil on canvas. Iolas Gallery, New York

130 *Hollywood* (37) 1969. Lithograph, $40\frac{3}{4} \times 12\frac{1}{2}$ ins. Iolas Gallery, New York

GEORGE SEGAL

Born New York 1924. B.A. Art Education New York University 1950. M.F.A. Rutgers University, N.J. 1963. Taught in New Jersey High Schools 1957–63. Showed Hansa Gallery, New York from 1956 and Green Gallery from 1960. With Janis Gallery since 1965. Lives in Brunswick, N.J.

131 *Cinema* (35) 1963. Plaster figure and illuminated plexiglass, 118×96× 39 ins. Albright-Knox Art Gallery, Buffalo, N.Y. Gift of Seymour H. Knox

Woman Shaving her Leg (9) 1963. Plaster figure and bathroom, 63×65 ×30 ins. Mr and Mrs Robert B. Mayer, Winnetka, Illinois. Photo: courtesy Sidney Janis Gallery

132 *The Butcher Shop* (94) 1965. Plaster figure in shop environment, 94×99×48 ins. Art Gallery of Ontario, Toronto. Gift from the Women's Committee Fund 1966. Photo: Ron Vickers Ltd

COLIN SELF

Born Norwich 1941. Studied at Slade School 1961–63. Visited USA and Canada 1962 and 1965. First one-man exhibition Piccadilly Gallery 1965. Teaches Sheffield and Norwich Colleges of Art. Lives in Norwich

133 *Cinema 3* (39) 1964. Pencil and collage, 15×22 ins. Coll. J. Kirkman, London

134 *Cinema II* (41) 1965. Pencil and collage, 15×22¼ ins. Coll. J. Kirkman, London

135 *Cinema SI* (40) 1964. Wood, upholstery, paper and lacquers, 24×24 ins. Coll. the artist. Photo: Brompton Studio

136 *Empty Cinema* (42) 1966. Pencil, pen and ink, 22×29½ ins. Marlborough Fine Art (London) Ltd

RICHARD SMITH

Born Letchworth, Herts. 1931. Luton and St Alban's Schools of Art and Royal College of Art 1948–57. Harkness Fellowship in the USA 1957–59. Taught at St Martins School of Art 1961–63. Lived in New York 1963–65. Taught at University of Virginia 1967. Lived in California 1968. First one-man exhibition at Green Gallery,

New York 1961. Retrospective exhibitions at Whitechapel Gallery 1967, Jewish Museum, New York 1968. Lives in Wiltshire

137 *Flip Top* (114) 1962. Oil on canvas, 84×68 ins. Coll. Martine Franck, Paris

138 *Gift Wrap* (113) 1963. Oil on shaped canvas, 80×208×33 ins. The Peter Stuyvesant Foundation. Photo: A. C. Cooper Ltd

139 *Cash Register* (18) 1965. Oil on canvas, 48½×49¼×14½ ins. Richard Feigen Gallery, New York

140 *Cash Register* (19) 1965. Oil on canvas, 48½×49¼×15¼ ins. Richard Feigen Gallery, New York

WAYNE THIEBAUD

Born Meza, Arizona 1920. Sacramento State College, California. Cartoonist, designer, advertising director 1938–49. Design consultant California State Fair 1950, 1952, 1955. Chairman, Art Dept, Sacramento State College 1951–60. Produced eleven educational films. Professor of Art, University of California. Lives in Sacramento

141 *Pie Counter* (110) 1963. Oil on canvas, 30×36 ins. Whitney Museum of American Art, New York. Larry Aldrich Foundation Fund. Photo: Geoffrey Clements

142 *Booth Girl* (36) 1964. Oil on canvas, 72×48 ins. Allan Stone Gallery, New York

143 *Woman in Tub* (6) 1965. Oil on canvas, 36×60 ins. Coll. Marie Christophe Thurman, New York

JOE TILSON

Born London 1928. Worked as carpenter and joiner 1944–46. Studied St Martin's School of Art 1949–52, and Royal College of Art 1952–55. Awarded Prix de Rome 1955. Lived Italy and Spain 1955–57. Taught St Martin's School of Art 1958–63. Visiting fellow at King's College, University of Durham 1963. Has executed murals for British section at the Milan Triennale, Clapham County Secondary School and the Royal Garden Hotel, London. First one-man exhibition AIA London 1961. Exhibited Venice Biennale 1964. Lives in London

144 *A–Z, A Contributive Picture* (66) 1963. Construction, 92×60×4 ins. Coll. the artist

Nine Elements (85) 1963. Kandy, pearl and acrylic on wood relief, 102×72 ins. Private collection

145 *Colour Chart A* (57) 1967–68. Polyurethane on wood relief, 24×33 ×2 ins. Marlborough Fine Art (London) Ltd

146† Transparency, *The Five Senses, Sight*
Transparency, *The Five Senses, Smell*
Transparency, *The Five Senses, Taste*
Transparency, *The Five Senses, Touch*
Transparency, *The Five Senses, Hearing* 1969. Screen on vacuum-formed acrylic sheet, 58×58×2 ins. Marlborough Fine Art (London) Ltd

ANDY WARHOL

Born Philadelphia 1930. Carnegie Institute of Technology, Pittsburgh. Moved to New York 1952. Films include *The Chelsea Girls, Empire, Sleep, Lonesome Cowboy*. One-man shows include Ferus Gallery, Los Angeles 1962, Stable Gallery 1962, Leo Castelli since 1964. Retrospective, Moderna Museet Stockholm 1968

147 *Popeye* (77) 1961. Casein on canvas, 68¼×58⅛ ins. Coll. Robert Rauschenberg. Photo: Walter Russell

148 *A Boy for Meg* (83) 1961. Oil on canvas, 72⅞×52⅝ ins. The International Art Foundation. Gift of Mr and Mrs Burton Tremaine

149 *100 Soup Cans* (98) 1962. Oil on canvas, 72×52 ins. Albright-Knox Art Gallery, Buffalo. Gift of Seymour H. Knox

150 *4 Campbell's Soup Cans* (97) 1962. Oil on canvas. Coll. Mr and Mrs Leo Castelli. Photo: Rudolph Burckhardt

151 *Gold Marilyn Monroe* (45) 1962. Synthetic polymer paint silk-screened and oil on canvas, 83¼×57 ins. The Museum of Modern Art, New York. Gift of Philip Johnson

152 *Green Coca-Cola Bottles* (XIV) 1962. Oil on canvas, 82¼×57 ins. Whitney Museum of American Art, New York. Gift of the Friends of the Whitney Museum of American Art

153 *Dance Step – (Tango)*† 1962. Acrylic on canvas, 72×54 ins × depth of box 6½ ins. Garick Fine Arts Inc., Philadelphia

154 *Elvis I and II* (V) 1964. Silkscreen on acrylic and aluminium on canvas, 2 panels: 82×82 ins. each. Art Gallery of Ontario, Toronto. Gift from the Women's Committee Fund 1966

155 *Campbell's Soup*† 1965. Oil, silkscreened on canvas, 36⅛×24 ins. Leo Castelli Gallery, New York

156 *Campbell's Soup* (96) 1965. Oil, silk-screened on canvas, 36⅛×24 ins. The Museum of Modern Art, New York. Philip Johnson Fund

157 *Mona Lisa* (67) 1963. Silkscreen on canvas, 43¾×29⅛ ins. Metropolitan Museum of Art, New York Gift of Henry Geldzahler, 1965

ROBERT WATTS
Born Burlington, Iowa 1923. Graduated University of Louisville 1944, Columbia University 1951. Art Students' League 1946–48. Worked as mechanical engineer till 1953, taught engineering Rutgers University 1952–53 and in art department. Rutgers University since 1953. One-man show Paul Bianchini Gallery 1966

158 *BLT Sandwich*† 1966. Painted wax in solid plexiglass, 7¾×7½×2 ins. Coll. Paul Bianchini, New York

159 *Duchamp*† 1968. Neon and perspex, 13¾×41⅝×7⅛ ins. Galerie Ricke, Cologne

TOM WESSELMANN
Born Cincinnati 1931. Graduated Hiram College, Ohio. Studied Art Institute of Cincinnati and Cooper Union, New York. One-man shows Tanager Gallery 1961, Green Gallery from 1962, Janis Gallery since 1966

160 *Great American Nude No. 48* (2) 1963. Construction and mixed media, 84×108×36 ins. Dayton's Gallery 12, Minneapolis

161 *Great American Nude No. 44* (XV) 1963. Collage painting with radiator and telephone, 81×96×10 ins. Coll. Mr and Mrs Robert C. Scull, New York

Bathtub Collage No. 1 (8) 1963. Construction and mixed media, 48×60 ins. Coll. Karl Ströher, Munich. Photo: Rudolph Burckhardt, courtesy Sidney Janis Gallery

162 *Interior No. 3* (10) 1964. Construction and mixed media, 66×52×9 ins. Coll. Dr H. Peeters, Bruges. Photo: Rudolph Burckhardt, courtesy Sidney Janis Gallery

163 *Still-life No. 54* (31) 1965. Plastic (illuminated), 48×60 ins. Coll. Mr and Mrs Michael Sonnabend, Paris. Photo: Shunk-Kender

164 *Bedroom Painting No. 1*† 1967. Oil on canvas, 68½×95¾ ins. Galerie Saqqarah, Gstaad